ROMAN BAROQUE PAINTING

ELLIS WATERHOUSE

ROMAN BAROQUE PAINTING

A LIST OF THE PRINCIPAL PAINTERS
AND THEIR WORKS
IN AND AROUND
ROME
with an Introductory Essay

PHAIDON

PHAIDON PRESS LIMITED
LITTLEGATE HOUSE, ST. EBBE'S STREET, OXFORD
FIRST PUBLISHED 1976
© 1976 BY PHAIDON PRESS LIMITED
ISBN 0 7148 1701 5
PRINTED IN GREAT BRITAIN BY
R. & R. CLARK LTD., EDINBURGH

CONTENTS

INTRODUCTION

THE original edition of this book appeared in 1937, 'printed for subscribers to The British School at Rome', as an occasional volume annexed to the Papers of that institution, of which I was Librarian at the time the book was written. Five hundred copies were printed and a substantial number of these were distributed in exchange with learned Societies, whose publications were exchanged with the British School. The subject was then considered of little general interest and I in fact paid for a considerable proportion of the costs of publication myself. The book has now become extremely scarce and it has been reported to me that it has been stolen from a surprising number of University libraries. The lapse of more than thirty years has, however, brought a great increase in the information about the painting of the seventeenth century in Rome which is available today and I was not willing to allow it to be reprinted anastatically, as is too much the fashion of these times, with the other volumes of Papers of the British School. The valuable body of the book, its lists, have now been enlarged and expanded as fully as possible so that I hope they may serve the student of today in the same way that the original lists were designed to serve the student of the thirties. In a 'Note to the lists' I have explained the principles on which they have been compiled.

It has not been easy to decide what to do with the preliminary text. One can hardly recapture the spirit in which it was written more than thirty-five years ago and do it all over again. But the fashionable alternative of treating it as a sacred text and merely adding some modest notes of correction does not seem to me acceptable. I have therefore corrected positive mistakes, and modified certain points of view—usually uncharitable ones!—which the passage of the years has led me to think ill-founded. The result is a compromise, but it is not discreditable to be unwilling to tinker excessively with youthful works.

I repeat, with feelings of gratitude which have increased over the years, what I wrote in the introduction to the first edition: 'It would be impertinent if I were to list all the famous names to whose aid I am indebted for access to many of the pictures and frescoes which appear in the catalogue. I have met with great kindness at every turn. My debt is greatest to the British School at Rome, in whose liberal service I have been able to make these studies: greatest of all to Colin Hardie, its former Director, who has spared no effort of importunity to gain me access to works of art not readily available for inspection, has conveyed me to remote places, taken innumerable photographs, and been, as often as not, the companion of my labours. I am under deep obligation to the authorities of the Vatican; to the Marchese

Luigi Calabrini, for securing me access to many difficult collections; and to the photographic skill and patience of Signor Cesare Faraglia. Finally, I am grateful to Anthony Blunt for many pertinent observations, both on my manuscript and in front of the works with which it deals.'

For this revised edition I owe much to the friendship and discourse of the two scholars who have made the most valuable contributions to Italian Seicento studies during the last thirty years, Rudolf Wittkower and Francis Haskell; much also to Anthony Clark, who has made the Roman Settecento almost his own as a field of study; and most of all to Professor Italo Faldi, whose unfailing kindness in Rome has helped me to make the revision of these lists a pleasure and to keep me up to date.

<div align="right">E.K.W.</div>

THE LATER SIXTEENTH CENTURY

THE period of the High Renaissance in Rome, where the classical style of European painting reached its zenith, is comprised within the twenty years between the arrival of Raphael and Michelangelo in 1508 and the Sack of Rome in 1527. This disaster dispersed throughout Italy the unworthy remnant of the successors of Raphael, while the ageing Michelangelo—whose work on the *Last Judgment*, begun in 1534, was the first commission of importance after the Sack—continued to develop on anti-classical lines. Rome had little contact in these years with Venice and North Italy, where native tradition still flourished without Flemish or other foreign influence, and from 1535 until 1590 the history of painting in Rome is largely the history of Mannerism.

This history remains to be properly written, but it is of so relatively little importance for the understanding of Roman painting in the seventeenth century that a short account of it will be sufficient. There were two main currents of Mannerism in Italy: the Roman–Florentine (for most of the more important artists worked both in Rome and Florence), and the North Italian, which centred round the personality of Parmigianino. Both of these currents influenced Flanders at quite an early stage in their development, and by the middle of the century the Flemish Mannerists, who visited Italy in increasing numbers, began to react on their Roman–Florentine colleagues, effecting, in this indirect way, an interrelation of the Parmesan with the Roman–Florentine style, which does not seem to have occurred directly until rather later. The figure-style of Michelangelo, though not the mind which had conceived it, is of dominating importance in the earlier stages of Florentine and Roman Mannerism, which is a style designed for new decorative and social requirements to which Michelangelo was temperamentally averse.

It has been fashionable to explain Mannerism by brightly alluding to the Council of Trent, and it is true that the historical events which induced Paul III to summon the Council at Trent in 1545 brought about also a change in what was required from artists by both the Church and Society. For the first time in modern history, schism threatened the paramount and infallible position of the Church, and the complacency with which Renaissance society had taken the foundations of its structure for granted was disturbed. Once again, as in the Middle Ages, it became necessary for painters to play a propagandist part for the Church; but now it was not to the unlettered that their work had to appeal, but to the intellects of the highly educated. It is an age of elaborate fresco decorations, based on a programme to which the artist has contributed little. Between the painter and his patron often intervenes a literary

I

editor and producer; the best example is Annibale Caro—the literary factotum of the House of Farnese—who is responsible for the programme of the decoration in the twenty or so rooms of the Palace of Caprarola, which still remains the completest and most attractive monument of the Mannerist style. Hardly one of these rooms has a scheme which is intelligible to the simple mind unaided. In the historic series, which glorifies the exploits of the Farnese family, inscriptions help the observer; in others the wealth of mythological and symbolic allusion is so great that it must always have needed a cicerone to explain it.

Vasari preserves for us, in his 'Life of Taddeo Zuccaro' (ed. Milanesi, VII, pp. 115 ff.), Caro's programme for the Sala dell' Aurora at Caprarola, and from this and from Zucchi's own account of the scheme he painted in the Salone of the Palazzo Ruspoli in Rome (see F. Saxl, 'Antike Götter in der Spätrenaissance, etc.', *Studien der Bibliotek Warburg*, 1927) we can study sufficiently the springs of artistic inspiration in this Euphuistic age.

This attitude toward the subject-matter of painting is the one thing which is, to a certain extent, common both to Mannerism and to the seventeenth-century style. Scenes of biblical, saintly or political history are no longer treated in a generalized and descriptive manner, but are given an authoritative and dogmatic import, either by the way in which the story is portrayed or by being set in a series of elaborately didactic confection. More than half the surviving decoration in the Vatican is of this period, and one may cite as examples: Sala Regia (Political Triumphs of the Church), Museo Etrusco Sala III (eight scenes from the Book of Daniel), Museo Etrusco Sala II (sixteen scenes from the Life of Moses), Sale dei Paramenti (typological parallels between Old and New Testaments), Loggie of Gregory XIII (New Testament scenes with textual references), Sale dei Fuochi (two ceilings with stories from the Life of S. Gregory the Great, one with textual references). Many of these are set among the most elegant stucco frames, and all are disposed with a decorative ability and taste far superior to anything previously found in Italy. Indeed, for the history of decoration no period is more important, and it seems as though the painters, freed from the need for exercising much creative imagination, now turned their attention for the first time to decoration in the modern sense.

A new style, of a similar tendency, is found also in the decoration of chapels in churches. Formerly a single altar-piece, with the addition, perhaps, of large frescoes on the side-walls, provided the whole devotional material, but by the middle of the sixteenth century the whole available surface of the chapel, including the side-faces and vault of the outer arch, becomes reticulated with stucco-work, framing often as many as twenty panels filled with scenes or single figures, for the appearance of each of which in the series there is a definite and specific reason. The most complete surviving churches decorated in this style are S. Caterina dei Funari, S. Giovanni Decollato, S. Maria della Consolazione, and S. Spirito in Sassia, with parts of S.

Giovanni dei Fiorentini, S. Marcello, SS. Trinità dei Monti and the Araceli. A particularly beautiful—and in part baffling—decoration of this kind is to be found in the Cappella del Pallio in the Palazzo della Cancelleria, and cheaper and less decorative schemes, without much use of stucco, occur in some of the Oratories—Gonfalone, Crocefisso, S. Giovanni Decollato and S. Giuseppe dei Falegnami.

Palace decoration pursues a very similar course. The Farnese alone, who became, under Paul III, the great family in Rome in the middle of the century, adorned their walls, both at Rome and Caprarola, with allegorized and realistic records of the family history; and Francesco Salviati alone, among the artists of this age, covered whole walls with complex frescoed schemes, simulating the effect of tapestry, in which fresco garlands of fruits take the place of stuccoes (Farnese and Sacchetti Palaces). Both these are exceptions, and the general rule is to have frescoed friezes and ceilings, often broken up by stucco decoration into a great number of compartments, with a series of scenes from the lives of biblical, legendary and historical characters, often mixed up with an amusing variety of small panels of grotesques. The most popular figure—perhaps as a sort of typological champion of the Counter-reformation!—seems to be David. There are rooms decorated with scenes from his life in the Pecci-Blunt (Malatesta), Sacchetti and Mattei di Giove Palaces in Rome, as well as in the two most important country houses of this period—after Caprarola —the Palazzo Altieri at Oriolo and the Palazzo Caetani at Cisterna.

The taste which is often displayed in the arrangement of these decorative schemes is very infrequently reinforced by more painterly virtues. With the exception of Salviati, about whom there lingers something of the combined largeness and delicacy of the Renaissance, and the earliest frescoes of Baroccio in the Casino di Pio IV— which, from being more or less inaccessible to artists, had no effect on contemporary painting—the whole output of these fifty years in Rome is of a surprisingly even mediocrity. The basic figure, a perversion from Michelangelo, suggests the text-book on Anatomy, but has been elongated so as to give it a certain elegance: it is posed to display interesting muscular movement or strain, rather than for narrative aptness, and it is swathed in draperies of pale, and not infrequently watered, tints. The subject is only very rarely set on the front plane, which is often occupied by quite irrelevant introductory figures, which do their best to distract attention from the principal theme (Salviati's *Presentation* and *Birth of the Virgin* in S. Marcello are perhaps the most exaggerated examples). Indeed, the favourite pattern for a Mannerist altar-piece is to have a few half-length figures of no narrative importance in the foreground—some of them with their backs toward the spectator—and then some steps leading to a comparatively distant plane, on which the main action takes place, generally somewhat off centre.

It is difficult to feel sure just when this stock Mannerism began to become *démodé*. Taddeo Zuccaro, who died comparatively young in 1566, left a great deal of his

reputation and only a slender amount of his talent to his brother Federico, who died honoured and respected over forty years later. But Federico did little important work in Rome after 1590 except the frescoes in his own house, which are intended as a sort of recapitulation and justification of Mannerist aesthetic (see Werner Körte, *Der Palazzo Zuccari in Rom*, 1935). When he was summoned to Spain in 1585, to work in the Escorial, he seems to have been, in European report and now that Titian was dead, the most famous artist in Italy; but his work there was a fiasco, and we may surmise that, on his return to Rome about 1589, he found already existing a general dissatisfaction with the old Mannerist style and an approval of the new, eclectic, fashion. Consequently, in his senile way, he tried to produce, but without much success, a sort of pre-Raphaelite eclecticism of his own: *e.g.* the side frescoes of the S. Hyacinth Chapel in S. Sabina (soon after 1594), and the Bellinesque *Adoration of the Kings* in Lucca Cathedral (engraved in 1595).

In summing up the period from 1530 to 1590 we may say that its importance for the study of later painting in Rome lies in the great advance made in decoration and in the foundation, about 1577, of the Academy of S. Luke, of which Muziano and Federico Zuccaro were the earliest heads. Founded with a charter from the Pope, who appointed a Cardinal as its protector, the Academy of S. Luke marks the appearance in artists of a consciousness of their enhanced position in a new order of society. It also indicates a sense, among the artists of Rome, that they formed a metropolitan school. Its squabbles and its discussions resemble those of later institutions formed on the same model, and it is an important constant in the background of artistic life in Rome in the seventeenth century. From 1577 onwards we have in Rome the first school of painting in modern times which was judged in its own day by 'academic' standards, and in which success depended, to a large extent, on 'official' recognition.

Before treating of the revolutionary changes introduced by Annibale Carracci and Caravaggio, it will be necessary to pursue, in summary fashion, the faint trickle of an anti-mannerist style which persisted in Rome throughout the sixteenth century, and flowered, in the last decade, into a dowdy eclecticism of its own in the person of Giuseppe Cesari, better known as the Cavaliere d'Arpino. For—owing to the conservative taste of Clement VIII (1592–1605)—Cesari's was the official 'court' style during those very years when Annibale and Caravaggio were doing their best work in Rome, and he continued doing work for reactionary patrons until his death in 1640.

At the beginning of the sixteenth century the only important painter in Rome who had not had a Florentine training was Sebastiano del Piombo. Though he assimilated his manner successively to those of Raphael and Michelangelo, he retained until his death in 1547 a good deal of the richness of his native Venetian colouring and of the depth of Venetian shadows—two qualities incompatible with the Mannerist style. A year or two after his death there came to Rome as a young man Gerolamo

Muziano, who smacked also of the Venetians, though his art was drawn from the less pure springs of Brescia. This painter, though he adapted his compositions not a little to the mannerist pattern, always remained out of the main current. From the very first he seems to have taken many of his types from Sebastiano, and he is fond of strong, rosy pinks and a certain ample spacing for his groups which recall Venice. But it was not only in these early affinities that Muziano went counter to the prevailing Roman tradition: in his later years, in the 1570's, he came into at least indirect contact with Titian's works through the engraver, Cornelius Cort. Cort engraved the pure Roman Mannerists, Titian, and—not least remarkable—a series of romantic forest landscapes, usually inhabited by an unobtrusive S. Jerome, from drawings by Muziano. He was also present in person in these years both in Venice and Rome, and seems to have acted as a sort of artistic pedlar. These landscapes are extraordinarily Titianesque in feeling, and it is a great pity that Muziano did hardly anything comparable in oils or fresco, though the storm-tossed forest in the background of his *Rest on the Flight* in S. Caterina della Ruota is a remarkable achievement. It was this aspect of his work which made him popular with the Flemings who flocked to Rome in these years. Karel van Mander (in Rome 1575–6) especially admired him, and it is not without significance that, later, Rubens should have owned and valued one of his works. Indeed, Muziano marks the beginning of a continuous landscape tradition in Rome and stands at the head of the line which reached its fullest distinction in Claude and Gaspard Dughet. He found his immediate successors in the Brills, Matthew and Paul, the latter of whom finished off the background of Muziano's *SS. Jerome and Romuald* with hardly distinguishable fidelity.

The Flemings had first been employed only to do the small accessory panels of landscape which had become *de rigueur* in any elaborate Mannerist decorative scheme, but, in the time of Gregory XIII, they came into their own, and Matthew Brill, about 1580–2, painted a whole series of rooms with landscape friezes and wall-frescoes in the upper floors of the Torre de' Venti in the Vatican. The finest of these rooms, all fairly small, has two walls covered with wide, sweeping prospects of Rome and the Campagna of astonishing breadth. Clouds of purple intensity gather and sweep over huge tracts of hill and plain and stream. Here, for the first time, painters discovered the grand pictorial qualities of the Roman Campagna.

The only artist of any note, other than Muziano, who remained aloof from the Mannerists was of a younger generation—Scipione Pulzone of Gaeta (1550?–1598). He is chiefly familiar as a distinguished portraitist with a touch of often Flemish minuteness, but his few religious compositions stamp him as the first of the Roman eclectics. Venturi has pointed out his transformation of material taken from Raphael and Correggio in the two *Holy Families* in the Borghese and Doria Galleries, and his most ambitious religious composition, the *Assumption of the Virgin* in S. Silvestro al Quirinale (signed and dated 1585; a later variant in S. Caterina de' Funari) has a

depth of colour and even a certain physical type which recall Sebastian del Piombo. But one can find no further evidence of a Roman eclectic style before the advent of Giuseppe Cesari.

It is one of the mysteries of art-history how this flabby painter acquired his position for a decade or so, and that quite early in his life, as the *doyen* of Roman artists. Youthful precocity had something to do with his rise to fame, and he first appears as a typical Mannerist apprentice in the style popular under Gregory XIII and Sixtus V. He must have realized in the middle 1580's—perhaps soon after the accession in 1585 of Sixtus V—that Mannerism as a style had run dry, and I would place in these years the numerous copies he is known to have made after the 'old masters': the 1650 Borghese catalogue records five copies after Titian, and he is also known to have copied Raphael. About 1589–90 is the date of his first big work in his characteristic manner, the fresco decoration of the ceilings of the chancel, the chapter house and the sacristy of the Certosa di S. Martino at Naples. These are no longer Mannerist works at all except in so far as the complex planning of the general surface with a great variety of scenes is a Mannerist characteristic. They are bright and gay in colour, with strong shadows, and have almost Venetian landscapes; the elongated Michelangelesque figures have given way to flabby creatures wrapped in voluminous draperies and, in the larger fresco of the *Crucifixion* (more or less faithfully repeated in 1591 at S. Atanasio in Rome), a completely new and eclectic style has been developed. It is hard to analyse anything so characterless, but it seems to be compounded of the least valuable qualities of Correggio, Titian and Raphael. It curiously recalls, at a very much lower artistic level, the eclectic style which the young Vandyck developed, thirty or forty years later, by selecting from the works of these same masters. Indeed, Vandyck seems actually to have taken something from Cesari before he came into direct contact with greater Italian painters, for Vandyck's *Taking of Christ* (Prado and Corsham Court) seems derived from Cesari's favourite composition of the same subject (Borghese, Accademia di S. Luca, etc.). It will not be necessary to pursue the career of Cesari d' Arpino to the bitter end, for it changed little after the 1590's, when his best work was done—the Olgiati Chapel in S. Prassede and the frescoes of the *Activities of Women in the Old Testament* in a room in the old (Aldobrandini) part of the Palazzo Chigi. During these years Clement VIII (Aldobrandini) gave to Cesari most of the important artistic commissions, or only gave them to others on his advice. Later his types get sweeter and more vacuously 'Raphaelesque', and some of them, with the infusion of a little vigour, would turn readily into some of Maratti's women, so that he seems to have remained a slight influence in the academic tradition which persisted throughout the rise of the pure baroque style. It is also worth noting that, in addition to his 'grand' style, this imitative creature took the bread out of the mouths of the Flemings by developing also a finicky, Flemish, style for small panels with Saints or mythological scenes.

This account will be enough to show that, when Annibale Carracci was summoned to Rome in 1595 by Cardinal Odoardo Farnese, he found Mannerism dying and the more intelligent patrons prepared for an eclectic and traditional style which the native artists were too feeble to produce.

Further knowledge of Cesari d' Arpino suggests, however, that up to about 1595 his work showed a degree of promise which to some extent justifies his reputation. But this promise was not fulfilled.

ANNIBALE CARRACCI

I HAVE hitherto seemed content to describe Annibale Carracci as an 'eclectic', but his style, in his Roman period, is a great deal too personal and distinctive for so colourless a label. It is true that he refined his taste by successive enthusiasms for Correggio, Titian and Raphael; but Annibale's final style is far too classic to be comprehended by a name which suggests merely an intelligent compilation. In the Galleria of the Palazzo Farnese, which Annibale and his assistants were painting from about 1597 to 1604, he produced a work which, until the middle of the last century, has always been regarded, with the Sistine ceiling and the *Stanze* of Raphael, as the third of the great classic decorations of Rome. For its affinities are with these frescoes of the High Renaissance rather than with Pietro da Cortona's Barberini ceiling of only thirty years later. Except for its quality of beautiful decoration—which, in the last analysis, is largely due to different social requirements from his patron—it is hardly nearer to the Baroque style than is Raphael. The part played by Annibale Carracci in the development of Roman painting was to make current once again the serious and thoughtful style of the High Renaissance.

Except for his landscapes it will not be necessary to discuss any of Annibale's Roman works other than the Farnese Gallery. It was his one great achievement in these years, and, for all practical purposes, it is entirely the product of his own mind. Agostino Carracci probably provided the cartoons (now in the National Gallery, London) for the two big scenes in the middle of the sides of the ceiling, and there is no doubt that the execution of some of the frescoes is due to Domenichino and others, but the spirit and invention are everywhere Annibale's own.

The general theme, 'The Power of Love in Antiquity', was provided and orchestrated by an unnamed scholar, and Annibale illustrates it in a series of pictures conceived in pattern and spirit like Raphael's 'antique' interpretations of classical or biblical stories. The scheme is bound together and diversified by seated nudes—in the natural colour of flesh—which palpably derive from Michelangelo's figures on the Sistine ceiling, and Annibale's new contribution consists in framing the scenes to

look as if they were actually canvases in gold frames, in supporting the smaller ones with white figures imitating stucco, and in balancing these last with *tondi* in bronze-green grisaille set in panels, which are terminated at either side by imitation stucco herms. Its 'eclectic' nature consists in the open attempt at combining features drawn from the Sistine ceiling and the Loggie of Raphael, but they are put to such natural and harmonious uses, adapted with so much taste, and completed by novel inventions so suited to the decoration of a princely saloon, that a new style results, exempt from any charge of plagiarism. Indeed, probably few more completely successful decorated rooms exist.

The power of Michelangelo's intellect puts him beyond comparison, but we may compare Annibale with Raphael—two minds of perhaps fairly equal span and fairly equal capacity of absorption—and ask what is the difference which accounts for the eclipse in public favour of Annibale's style in the last century, and which accounts also for its popularity until that date.

This weighty difference between Raphael and Annibale is perhaps due almost entirely to what one may call their quantitative relation to the Antique.

It has never been doubted that the felicity of Raphael's mature style has its main-spring in Classical Antiquity. His imagination pictured the same beings as the greatest of the Greek and Latin poets, and for that reason, as Mr Berenson has noticed, he has caused the modern world to read even the Hebrew classics with an accompani-ment of Hellenic imagery. Yet no less complete than our conviction that Raphael drew his main inspiration from Antiquity is our inability to point to any single statue or relief of importance which he can be shown to have seen and copied. His affinities are all with works of art which the earth has yielded to excavators after his death, and herein must lie the secret of the truth of his vision of the ancient world. Just as Lessing could infer, from the debased virtues of the Laocoön, those qualities which we now know belong to Greek art of a greater and earlier age, so Raphael, from more trivial fragments, truthfully reconstructed Antiquity for himself. His faith and his imagination were not fettered by the inferior quality of the surviving remains.

Annibale Carracci was less fortunate. Between Raphael's death and his own maturity the soil of Rome and the Campagna had given forth innumerable statues: those dusty ghosts which haunt today the long corridors of Roman Palaces and Museums, but which, until the discoveries of the last century, gave a picture of Antiquity which our ancestors were content to admire and love. Annibale, seeking inspiration from the same source as Raphael, found his fancy numbed by the classical remains which he saw everywhere. His *Galatea*, unlike Raphael's, recalls a Roman copy of a Greek original, and his paintings fell out of our affection with the ancient statues to which they are akin.

It will thus be seen that what Annibale did for the succeeding century of Roman

painters was to sum up compendiously the results of the Renaissance and to establish the canon of a classical style, which was admirably adapted to decorate houses whose most expensive and princely adornments were classical statues. In doing this he made the ground ready for future development, not so much by personal initiative as by bringing to a uniform pitch of maturity all the elements of Renaissance painting. He established for the first time an academic norm, and his paintings are not tinged, as are those of Raphael, Correggio, Michelangelo or Titian, with an exuberant personal quality which derives from some incommunicable gift of genius.

Like all such men, Annibale was a devoted and efficient teacher, and what he had to teach was not, as it had been with Raphael, something which was beyond the powers of average competence. His pupils are never vulgar or incompetent, and they began their own careers with a level of accomplishment and an experience of studio training such as no group of scholars of an Italian painter had had before. A luminous example of the collaboration of master and pupils is provided by the series of six landscape lunettes with religious subjects painted by Annibale and certain pupils for the chapel of the old Palazzo Aldobrandini and now preserved in the Doria Gallery and these also provide a good sample of the ordered 'Landscape with figures' which was Annibale's other great contribution to Roman painting.

The Carracci derived the elements of their landscape style from Venice. The frescoes of Paul Veronese in the Villa Giacomelli at Maser and rare experiments by Tintoretto, such as the *Hylas* in the Colonna Gallery in Rome, are the stuff from which the Carracci landscapes originate, but there is a difference of intention. An earlier attempt by Giorgione to give figures and landscape an equal and interdependent importance had lost itself in the pursuit of romantic feeling, but the same intention was successfully carried out by Annibale Carracci without any overtones of sentiment. In his earlier landscape experiments (*e.g.* the two big landscapes in the Louvre) the influence of the Bassanos predominates; but he soon purified his manner of this rusticity, and in his Roman period produced paintings, grave or gay, in which the mood of the figures is exactly echoed by the scenery, and in which Man takes his place in Nature according to a formula revised to suit an age more sensitive to the picturesque. For the first time in Roman painting the order and rhythm of Nature are considered as worthy of study. A little later the Roman–Flemish and the Bolognese styles of landscape amalgamated, and in a small room in the Casino Ludovisi it is hard to tell which fresco is Paul Brill, which Viola, and which Domenichino.

The pupils of Annibale Carracci form the bridge which leads from the art of the sixteenth century to the Baroque, but before considering these, a contemporary of Annibale, a greater revolutionary character, requires attention—Caravaggio.

CARAVAGGIO

By a happy compensation of Providence, Caravaggio reached maturity at the very time when Annibale Carracci was perfecting the means for that large statement of half-truths which is the aim of academic art. A ruffian and a cut-throat, he possessed that combination of rude directness and swift intuition which his uneasy way of living required, and, for him, the painting of pictures was the statement of facts about which he was passionately inquisitive. These facts were chiefly the surface and texture of visible things, organic and inorganic, and he is the microcosm of an age which was beginning to question old generalizations and to conceive that one might arrive at a knowledge of truth by experiment.

A Lombard, with North Italian training, he first became a figure in the Roman world soon after 1590, and he fled from Rome in 1606, to die four years later, after brief spells of activity in Genoa, Naples, Malta and in Sicily. His earlier style, best represented by two pictures in the Doria Gallery—*The Rest on the Flight* and the *Penitent Magdalen*—though it appears as a mutation in the evolution of art in Rome, can be explained as the final development of a tendency implicit in painting in north Italy since the time of Giorgione and Lotto (see R. Longhi, in *Pinacoteca*, 1 (1928–9), pp. 258 ff.). But the imaginative and material treatment of the subject in these paintings is equally remarkable, and they constitute a quite new type of picture in the history of art. It will be necessary to consider in what this novelty consists.

The types, the colour, the lighting, and the way in which the subject is made interesting are all novel, and their common new quality can be described as 'realism' if we are content to put very strict limits to our definition of that abundantly misused word. The types are plebeian instead of the idealized-aristocratic types of the Carracci, or the idealized-intellectual ones of the Mannerists. The colour is deep, rich and varied, especially of stuffs, which are shewn as of particular tints and particular textures. It would be easy for an expert to give a trade-name to any stuff and colour used in these early Caravaggios, whereas the draperies used by both the Mannerists and the Eclectics are usually of vague colour and always of uncertain weave. The lighting is quite particular also: carefully arranged in the studio and coming from a particular source, not nebulously diffused. The interest of the subject is made to rest in its homely probability, its actuality and earthliness, in contrast to the uncertain race and temper, the vague setting in time and place, with which previous painters had invested their sacred figures.

These tendencies go a long way towards 'realism' as the term is used today, and we have ample evidence of Caravaggio's realistic intentions. He kept a great pair of wings in his studio, which he attached with wax to the boys who sat as models for his Angels, and he was openly contemptuous of painters studying Raphael and the old masters, saying that Nature and the life around him provided all the models he

required for imitation. Yet he remains essentially a classical artist. He is always seeking the secret rules for the ways in which actual people naturally group themselves, and he seems quite early to have decided that, in order to translate these into a pictorial formula, he must show them in a closed space, illumined by a beam of light from a single source. The result is that, in all the later Caravaggios without exception, the figures appear in semi-darkness and the grouping is organized by deep pools of shadow and corresponding areas of strong light. It was this result, however, rather than the underlying intention of these experiments, which became popular with his imitators, none of whom seems to have had very much notion of what Caravaggio himself was aiming at. Consequently, when we speak of the Caravaggisti, we mean only those artists of the earlier seventeenth century who painted pictures with exaggerated contrasts of light and darkness or else the painters of tavern scenes and other plebeian subjects.

Caravaggio's influence on the history of painting in Europe was enormous, but it was less important in the Roman school than in any other. It contained the seeds of liberalism and anti-clerical suggestions which could not be tolerated in a school of painting which was consciously directed by the Church for its own ends. He was not of a temperament to take pupils, but his revolutionary ideas attracted a number of young artists to his style, chiefly foreigners and after he had left Rome for ever. It is to the eternal credit of Paul V and his nephew, Cardinal Scipione Borghese, that they patronized Caravaggio and extended their favour to his followers. But, on Paul V's death in 1621, Caravaggismo fades rapidly out of Rome. Orazio Gentileschi, the oldest of the Caravaggisti, and the only one who had been in direct relations with the artist himself, left Rome in 1621, to visit North Italy, France and England; Saraceni had gone to Venice about 1619 and died there the next year; Manfredi, of whom we know nothing certain, died about 1620–1; Vouet, Honthorst, Van Baburen, Rombouts, Janssen and Seghers all left Rome about the time of Paul V's death, and the greatest of the Dutch Caravaggisti, Terbrugghen, had already left in 1614. Le Valentin alone remained in Rome, but, except for one experimental commission for S. Peter's (1630; the Vatican *Martyrdom of SS. Processus and Martinianus*), he painted no pictures for public exhibition. Painters like Caroselli, Tommaso Luini ('il Caravaggino') and Baglione had too little of Caravaggio in their hodge-podge make-up to count. But the style had then found followers in Naples, North Italy and Sicily; Spain, France and Holland were producing works of half-digested Caravaggismo, and even the little centres on the outskirts of the Roman territory had their local Caravaggesque painters (Paolini at Lucca, Andrea Polinori at Todi, Riminaldi at Pisa, etc.).

Though Caravaggio's most whole-hearted imitators were foreigners, his innovations were not without effect on some of the scholars of Annibale Carracci. Domenichino, it is true, seems hardly to have been affected at all; but Guido Reni painted at

least one Caravaggesque altar-piece (the *Crucifixion of S. Peter* now in the Vatican Gallery), and Lanfranco, the most enterprising of the Carracci scholars, and the only one who carried over his activities and kept his pre-eminence in the baroque style, very sensibly modified his painting along Caravaggesque lines.

THE DECORATION OF PALACES IN THE FIRST QUARTER OF THE SEVENTEENTH CENTURY: AGOSTINO TASSI

BEFORE coming to the baroque period proper, we must still pass in survey the decoration of a number of palaces in the reigns of Paul V and Gregory XV (1621–3). This was partly conditioned by a change in the planning, which, instead of one enormous 'Galleria', arranged a series of smaller state rooms of more or less equal magnificence.

These palaces may be divided into three groups:

(A) The two huge palaces built for the Borghese—the Papal Palace on the Quirinal and the neighbouring Rospigliosi-Pallavicini Palace, built for Cardinal Scipione Borghese.

(B) The Verospi, Ginnasi, Mattei di Giove and Costaguti Palaces, decorated chiefly by pupils of the Carracci.

(C) The Lancellotti Palace and the Casino Ludovisi decorated by Tassi and Guercino in collaboration.

It will be simpler to take first the second group, in which we can study how the sixteenth-century custom of having the whole ceiling covered with a variety of scenes in separate compartments gave way to a new style—the 'quadro riportato'—which was current for only about twenty years, and which finally, in the natural course of evolution, gave way to the baroque style.

The old type of 'Galleria', with multiple scenes, persisted for a short time in the seventeenth century, but never on such an ambitious plan as at the Palazzo Farnese, and generally painted by secondary artists. There are two such rooms in the Palazzo Mattei di Giove, one with Joseph scenes painted by Cristoforo Roncalli, and a second in which stories from the Life of Solomon by the young Pietro da Cortona are inserted among trellises and garlands, with lunettes of the Mattei properties by Paul Brill. A room of this sort in the Palazzo Costaguti, painted by Cesari d'Arpino, was demolished at the end of the last century, and the only ceiling by an artist of any note, that by Albano in the Palazzo Verospi, is transitional between the old and the new form of decoration.

This new form, of which the most famous and familiar example is Guido's *Aurora* in the Casino Pallavicini, consists in framing the flat centre of the ceiling with handsome stuccoes into a square or rectangular panel, and painting within this frame a picture in fresco designed, from the point of view of perspective, like an easel picture. Hence the expression 'quadro riportato'—a transferred picture—which is applied to this kind of painted ceiling. It is an obviously artificial principle, completely at variance with the illusionistic tendencies of seventeenth-century aesthetic, which were already beginning to make themselves felt, and it was consequently destined to only a short spell of popularity. The centre picture of Albano's ceiling in the Palazzo Verospi, *Apollo and the Seasons*, is of this kind—a rectangular fresco with oval medallions, also in stucco frames, at either end—and, though the curved part of the ceiling is also covered with Raphaelesque single figures and tiny grisaille scenes, the general principle, which is modelled on the Psyche room at the Farnesina, is apparent.

It was only a slight step from this to the single picture in the centre of the ceiling with the curved part left bare. The Palazzo Mattei contains the finest series: Albano's *Jacob's Dream*, and the *Jacob and Rachel* and *Isaac blessing Jacob* done under his direction; two by Lanfranco and two by the old-fashioned Gaspare Celio, *The Passage of the Red Sea* and *Jupiter and the Giants*. The decorative absurdities of the style are apparent in Lanfranco's fresco in the Palazzo Ginnasi, and Guido Reni, in addition to the *Aurora*—which is the most successful example of a short-lived vogue—has also painted a pretty variation in the Sala delle Dame in the Vatican with three 'quadri riportati' in succession, two of them circular (1608-9; see J. Hess, in *Illustrazione Vaticana*, Anno V, no. 15, pp. 649 ff.).

The Palazzo Costaguti illustrates the transition from the second to the third group of palaces. The two early Lanfranco ceilings, *Hercules and Nessus* and *Galatea* (the second fell to powder in 1805, but an oil replica exists in the Doria Gallery), are of the 'quadro riportato' type, and I agree with Dr Hess that the Domenichino *Car of Apollo* was originally of the same sort. These were painted about 1610. Some time towards the end of the next decade, when this style was becoming *démodé* and Tassi's architectural inventions were the vogue, the stucco frame from the last was removed, the whole ceiling converted into an expanse of sky, and Tassi added the balcony surround, while Domenichino himself put in the additional figures. To this later style also belong the Guercino and Tassi room (*Armida carrying off Rinaldo* surrounded by a balcony of twisted columns with birds, etc.), and the small room with *Justice and Peace* surrounded by twisted columns (Tassi and Lanfranco).

The principal figure in the history of decoration at this time is certainly Agostino Tassi, whose importance has only been made clear again in Dr J. Hess's valuable monograph (published for the author, 1935, at 15 Herzog Heinrichstrasse, Munich). He plays an important rôle also in the first group of palaces—the Quirinal and the Rospigliosi-Pallavicini, but such uncertainty at present prevails about the authorship

of what is left of the latter, and less important, palace's fresco decoration, that the Quirinal alone can be taken into account.

In the Quirinal there were only friezes, with no ceiling frescoes: in these Lanfranco, Saraceni, Antonio Carracci and Orazio Gentileschi all played some part; but the planning of the whole series seems due to Agostino Tassi. The most remarkable, and the only important ones for our purpose, are the friezes on the long sides of the Sala dei Corazzieri, which are worth some description.

This room was used for the reception of foreign, and sometimes exotic, Princes. Though two ovals with scenes from the Life of Moses are inserted in either wall, the main frieze consists in a feigned balcony with arched openings and windows giving onto an open loggia behind. Inquisitive Chinese and other amusing figures look down from these arched openings as if onto the throng in the Hall below, and the perspective is calculated to give the illusion of real spectators. This frieze dates about 1616, which seems to be about the date of the revival of an interest in illusionism in Roman decoration (see J. Hess, *Agostino Tassi*, pp. 10 ff. and Plate III).

This interest in illusionism spread apace, and was developed along different lines in the third group of palaces, whose decoration dates from the years of Guercino's stay in Rome, during the short Pontificate of the Bolognese Gregory XV (1621–3; Ludovisi). Here too Tassi is found in conjunction with Guercino, and his inspiration is based partly, perhaps, on the mid-sixteenth century trellis-decorations at the Villa Giulia and in the downstairs courtyard at Caprarola, and partly on the ancient twisted columns which were still, in the opening years of the seventeenth century, used as an iconostasis at S. Peter's. In the roof of one room at the Palazzo Lancelloti the fresco makes it appear as a balconied aviary, open to the sky: in the two Guercino and Tassi rooms at the Casino Ludovisi the perspective is arranged so that the illusion is only valid from special points in the room, and in the upper room the lighting on the balcony above the twisted columns is arranged with the most artful ingenuity.

Dr Hess has shewn that Tassi was the product of Giulio Parigi's studio in Florence, and thus, to a large extent, of the stage. It was stage-setting and the elaborate 'perspectives' required for triumphal entries, marriage celebrations and similar festivities which first demanded this type of illusionism, and it was Tassi who brought this quality over into serious decoration. After the 1620's he was too arthritic to do much painting himself; but he certainly worked for Urban VIII, and probably did a good deal more than we know as an artistic impresario. He was himself only a painter of very second-rate attainment; but he can claim priority in introducing a seed which grew to flower, under very different inspiration, with Pietro da Cortona. Bernini and Borromini.

URBAN VIII (1623–44)

IN 1623 Cardinal Maffeo Barberini was elected Pope and took the title of Urban VIII, and the twenty-one years of his Pontificate are the crucial period of the rise and perfecting of the Baroque style in Rome. This style owes its origin in general to a new conception of the function of art introduced by the Jesuit Order, and in particular to the interpretation and fulfilment of that conception by Urban VIII and his family. For, during the rule of their kinsman, the three Barberini Cardinals and D. Taddeo Barberini, Prefect of Rome, vied with one another as patrons of the arts. Many of the great buildings which make modern Rome memorable date from these years, and the student is fortunately better provided with published documentary material for research for this period than for any other in the seventeenth century (see list of Oscar Pollak's works in the Bibliographical Note).

A century of training and controversy had established the Jesuit Order as the intellectual and missionary army of the Catholic Church. Never before had those qualities of mind and heart which go to the making of great banking firms and business houses been used for the welding and refining of a Church army, and the economy and military discipline which the Jesuits had perfected by the seventeenth century can only be paralleled by the great international business interests of modern times. It is significant that one of Urban VIII's first acts in 1623 was to publish the Bull of Canonization of S. Ignatius Loyola, and he and Cardinal Antonio Barberini shewed themselves especially friendly to the Order on the occasion of its first centenary celebration in 1639. Hardly less significant was another early act of Urban VIII, which was to modify the charter of the Academy of S. Luke, and one of the new provisions of 1627 is: 'In religious works the decree of the Council of Trent is to be observed, that nothing should be painted containing false teachings or repugnant to the Holy Writ or to the traditions of the Church.'(See Missirini, *op. cit.*, p. 92.)

The Jesuits had always been aware that the Arts were among the most useful servants of the Church, and their preaching requirements had already necessitated a revolution in the planning of churches. But with painting they had at first employed only second-rate Mannerists, in a rather medieval manner, for their domestic needs. Niccolò Pomarancio and others were commissioned to paint the churches of their German and English missionary colleges with the most revolting scenes of saintly martyrdom, in order that the youthful teachers who should proceed to these heretical countries might be early habituated to the worst that the future could hold in store for them. Only the frescoes in the first of these churches (S. Stefano Rotondo) remain, but the others are preserved in engravings.

Soon, however, they became aware that the co-operation of the finest artists of their time would be necessary to supplement the effect of their teaching in Catholic

countries, and it is no accident that the three principal pioneers of the Baroque style—
El Greco, Rubens and Bernini—were all in close relations with the Jesuit Order.

El Greco, who began, perhaps as a dilettante, in the icon style of his Cretan
ancestors, strengthened his hand but confused his mind by partly assimilating some-
thing from Titian and Correggio. He next went through a phase of Mannerism, to
gain preferment at the Spanish Court, and it was only after he had settled in Toledo,
a disappointed man, and come into contact with Jesuit intellectuals, that he matured
the pure Baroque style of his later years. From about 1600 until his death in 1614
he produced the first baroque pictures in Europe, but Toledo was no longer a centre
of the arts, and his work was without much effect on the generations which
immediately followed.

In the same way, Rubens' Italian education (1600–8) was remarkably eclectic. He
copied everyone—Titian, Correggio, the great paintings of Rome, and Caravaggio
and Baroccio as well—and he was an accomplished Mannerist painter before he left
Italy. In Flanders he became closely associated with the Jesuits and practised their
'Exercises', and from about 1620 onwards—when he painted the great altar-pieces
(now in Vienna) and other decorations for the Jesuit Church at Antwerp—he
composed his pictures along wholly Baroque lines.

About the same time (c. 1621–2), the young Bernini executed the bust of the
Jesuit, S. Robert Bellarmine, for his monument in the Gesù at Rome, and his friend-
ship with the Order, especially with its later General, Padre Oliva, continued until
the end of his life. In Bernini, who also practised the 'Exercises', the Jesuits helped to
form the most inventive mind of the century in all the arts of painting, sculpture and
architecture. He was always faithful, consciously or unconsciously, to their artistic
programme through his whole life, so that it will be necessary to begin by explaining
the nature of this Jesuit aesthetic, which is the intellectual subsoil from which the
Baroque style springs.

The Council of Trent had urged a rigorous supervision of the treatment of religious
subjects in art and a drastic purgation of the pagan or frivolous tendencies of Renais-
sance humanism, and, at the same time, the iconoclastic tendencies of Calvin and his
followers encouraged the Church to make use of the arts as anti-Protestant propa-
ganda. But the Bolognese style of the Carracci was too coldly classical and Caravaggio
too dangerously realistic, so that a new mode of illustration was needed, which would
convince the spectator of the reality of the supernatural and encourage and direct
ecstatic faith.

An instructional method of achieving these ends was the practice of the 'Exercises'
of S. Ignatius—in which the visual imagination plays an important part—under the
direction of a spiritual supervisor, and countless people of all classes were already
under their spell. The Jesuits conceived that painting, sculpture and music might be
used as impersonal supervisors along the same lines. Ecstasy, movement and such

mystery as might be consistent with dogma were to prevail in religious painting. Ecstasy, as the result of spiritual obedience and careful direction, was one of the principal effects of the 'Exercises': it brought the individual once more into communion with the Divine, without the danger of heresy, with which individual religious emotion is so often associated. Saints are constantly shewn in this encouraging condition: SS. Teresa, Rose of Lima, Francis Xavier and countless others (for their iconography, see Emile Mâle, *L'Art religieux après le Concile de Trente*); and the spectator was thus directed and assisted towards the same goal. Movement is necessary as the physical corollary of ecstasy. But swooning figures do not form the static and stable basis for a classical composition: they need the supplementary movement of assisting Angels, astonished spectators, flights of Putti or an agitated landscape. Mystery is added usually by twilight or a flickering grid of light which moulds the whole scene into an emotional unity. Hardly an altar-piece in Rome shews the figures in more than a half-light, and one can understand why Poussin's early bid for public employment, the *Martyrdom of S. Erasmus*, with its clear noontide glare, made impossible any further Church commissions.

The Jesuits also appreciated to the full the latent advertising possibilities of Art. Not only was the communion of the individual with the divine assisted by painting, his feeling of self-importance—and hence his capacity for public service—was enhanced by being constantly made aware of the power of the Papacy, and of the splendour and magnificence of the Faith to which he belonged. This is the second psychological root of the Baroque style, and that element in it which later secularized it, out of Rome, into the perfect art for an absolutist Court, in which it reached its final development. It was this aspect of the Jesuit aesthetic which especially appealed to Urban VIII.

At the time of his accession Urban had certainly not formulated very clearly his artistic programme. Like all the Popes of this century, he patronized artists who were, as he was himself, of Florentine extraction, and it was perhaps this accident which first introduced to his notice the young Bernini. He at once took Bernini into his service, where he soon acquired a sort of position of *arbiter artium*, which he retained to the end of his life. But he was at first less successful in finding suitable painters. Many years before (in 1605) he had employed the Florentine, Passignano, on the family chapel in S. Andrea della Valle, and the earliest commissions after he became Pope—a series of altar-pieces for S. Peter's—went to Passignano, Ciampelli (another Florentine of similar training), Le Valentin and Poussin, whose style did not please, and Andrea Sacchi, who alone of this group entered the Barberini household. A less important commission, but one of greater significance for the history of art, was the decoration, in 1624–6, of the Church of S. Bibiana.

In the reconstruction of this small church, Bernini was employed as sculptor and architect. One half of the fresco decoration of the upper walls of the nave was given

to Ciampelli, and the other, to that veteran's surprise and distaste, to a young painter, also of Tuscan extraction, Pietro da Cortona, who had been introduced to the Pope by his patrons, the Sacchetti.

To the Sacchetti, in whom the house of Barberini has latterly become merged, and especially to Marcello Sacchetti must go much of the credit for discovering and employing those artists who formed the earliest generation of pure Baroque artists. About 1620–6 they employed Lanfranco on the family chapel in S. Giovanni dei Fiorentini. Pietro da Cortona entered the Sacchetti household in 1623, was introduced to Urban VIII and employed on his first important work (at S. Bibiana) in 1624–6, and from 1627 to 1629 directed the decoration and building of the Villa Sacchetti (later Chigi) at Castelfusano, the first important private house built and decorated in the new reign. In this work Pietro employed, among others, Sacchi and Camassei, who entered the Barberini household almost immediately afterwards. It is perhaps worth adding that the Sacchetti collection, unlike most other Roman collections, still exists fairly intact among the store-rooms and galleries of the Galleria Capitolina.

The S. Bibiana frescoes are now sad wrecks, but they reveal a new style, very different from any which had existed before and surprisingly unlike the later and more familiar Pietro da Cortona. By studying them and Sacchi's *Miracle of S. Gregory* (now in the Chapter House of the Canonica of S. Peter's), which dates 1625–7, we shall have the clue to what the youngest and most intelligent painters were doing at the beginning of the Pontificate of Urban VIII. These two works also mark the rise of the two diverging currents of pictorial style in the Roman seventeenth century. For Pietro da Cortona, together with Bernini, pursues the novel and forward, or Baroque, current; while Sacchi, always in opposition to Bernini and later patronized almost solely by Cardinal Antonio Barberini, follows a more austere and classical tradition, which reaches its full height only in the next generation, in his pupil, Carlo Maratti.

The two principal sources of inspiration in the S. Bibiana frescoes seem to be Raphael and the Antique. Large figures with slow, expressive gestures, such as occur in Raphael's cartoons, are set in measured groups before carefully studied classical architecture. There are a good many learned accessories—fasces, standards, tripods— obviously drawn with antiquarian zest, and revealing very much the same spirit that was to inform the grave art of Poussin throughout his whole career. More easily visible and less damaged than these frescoes are three canvases which Pietro painted between 1624 and 1630: the *S. Dafrosa* altar-piece (1626–7; also in S. Bibiana), the *Adoration of the Shepherds* in S. Salvatore in Lauro, and the most ambitious of all his early works, *The Sacrifice of Polyxena* in the Capitoline Gallery. There is much less of Raphael in these. They all share the murky, twilit gloom, which may, perhaps, be a legacy from Caravaggio. In the second picture, two putti, who hang as if

suspended on wires, are taken straight from Domenichino; but the most significant thing is the pattern, like an antique frieze, of *The Sacrifice of Polyxena*, where the figures are set against a background of buildings and cypresses. This is modified by a romantic rhythm which makes the picture resemble the setting from an opera. Three figures—Hecuba, Polyxena and Neoptolemus—each the centre of a separate group, appear as if singing against one another. Here is to be seen the arrival in Roman painting of the attempt to organize into a unity a variety of stresses of equal intensity, which is one of the principles of Baroque balance and composition.

Andrea Sacchi, who was three years younger than Pietro da Cortona, developed more rapidly. The *Miracle of S. Gregory* of 1625-7 shews his fully matured style, and his first public work, the high altar-painting in S. Isidoro (of soon after 1622), though still revealing a good deal of the influence of his master, Albano, is a mature and finished work.

Sacchi, through his training with Albano, had a thorough grounding in Bolognese classicism. To the end of his life his admiration for Raphael was so overpowering as to be almost an obsession, which made him, in later life, nervously reluctant to produce compositions of his own which might be unworthy of that great exemplar. But what he admired in Raphael was something profounder than those fine, if superficial, qualities which influenced, for a short time, the young Pietro da Cortona. Sacchi admired in Raphael both the extraordinary spiritual unity of his figure compositions, in which all the figures are moved by a related rhythm which binds them to a common interest, and the aptness with which clearly defined varieties of emotion are portrayed. And it is this preoccupation with just how individuals would feel on a precise occasion which allies the *Miracle of S. Gregory* with the *Disputà*. This same interest alienated him from the Baroque style in general and from Bernini in particular, whose interpretations of mood tend always towards the Jesuit ideal of the generalized and the vague. It is only in the depth and richness of the colour that this picture resembles Pietro's *Sacrifice of Polyxena*, and in the next decade this almost Venetian quality dies out of Roman painting for want of nourishment. Beauty of colour and of surface, which always interested Sacchi, are too sensual attractions to fit in readily with the Jesuit ideal.

The 'Galleria' at Castelfusano, painted under Pietro da Cortona's direction, shows the decorative style of the new age as still very imperfectly developed at the end of the 1620's. The single frescoes are too repainted to be of interest, but the general planning of the room survives intact. This shews no suggestion of the novelties of the next decade, and it is clear that the designer was inspired in its arrangement by no unifying decorative impulse. The perspective of the single scenes is always that of the 'quadro riportato', and they are divided from one another in the centre strip by imitation stucco dolphins at either side of a medallion containing a sign of the zodiac, and in the side strips by similar medallions above a pot of flowers set in a panel

between herms. The scenes on the side strips have frames to simulate easel pictures.
The subjects in the centre of the ceiling are Allegories of Rome and the Seasons, the
Sun and the Moon: along the sides they are a panorama of Republican History.

The first years of Urban VIII saw painted another work in fresco, by an artist of
the older generation, which is of much greater importance: Lanfranco's cupola in
S. Andrea della Valle, of 1625–8. This is the first great work of Baroque decoration
in Rome: the first large field covered with innumerable figures bound together into
a luminous unity. This is achieved actually by the rays of light which proceed from
the figure of Christ, which is painted in the lantern. Bellori fully realized the impor-
tance of this great work, its ultimate dependence on Correggio, and that it served as
the model for the painting of future cupolas in Rome. His words, with their musical
analogy, sum up admirably the new Baroque decorative ideal, which insists on an
effect of unity covering a multitude of particulars. He says (p. 372): 'Thus this paint-
ing has rightly been likened to a full choir (*una piena musica*), in which all the sounds
(*tuoni*) together make up the harmony: because, at the moment of hearing, no
particular voice is listened to in particular, but what is lovely is the blending and the
general cadence and substance of the singing (*l'universale misura e tenore del canto*).'

Ninety years before, Correggio had painted, in the cupola of Parma Cathedral, a
fresco from which Lanfranco admittedly drew his inspiration, and it is true that the
mere form of a cupola, unless divided into compartments, compels a certain unity
to the composition. But Lanfranco's originality rests on what he has added to
Correggio and how he has organized and distributed the possibilities of unifying
design which the form of cupola provides. The centre of the cupola in S. Andrea
della Valle—which is the largest in Rome after S. Peter's—is pierced to form a
lantern, and it is on the circular roof of this lantern that Lanfranco has placed his
figure of Christ, the source of all his light. In order to emphasize this effect and, at
the same time, preserve the light intact before its diffusion over the whole surface,
a thick wreath of foliage, supported by Putti, is set round the rim of the lantern-
opening—a device whose justification can be decorative only. The first mass of the
heavenly host is thus seen in half-shadow, as if the thick foliage prevented more light
from reaching them, and a fuller light is cast only over the outer row of figures. All
these deliberate accents are Lanfranco's own and not found in Correggio, and to him
must be given the credit for having painted the first decoration to illustrate the
aesthetic theories of the new age. If we compare Lanfranco's fresco with those in the
ceiling of the apse of the same church which Domenichino, his fellow-pupil under
Annibale Carracci, was painting at the same time—accomplished, academic works,
set at angles and on parts of the wall for which they are wholly unsuited—the
difference between the old and the new can be clearly demonstrated.

Lanfranco was also employed by Urban VIII, and painted frescoes of great distinc-
tion in S. Peter's in the next few years. Even in its present fragmentary and wrecked

condition the *Christ walking on the water* (1627–8: now in the Aula della Benedizione) is one of the grandest designs since Raphael, but the frescoes in the Chapel of the Pietà (1629–32) do not sustain the promise of new invention. Perhaps they did not please. At any rate, Lanfranco departed to Naples the next year, where he introduced the new style and remained until 1646, the year before his death, when he returned to Rome to paint the apse fresco in S. Carlo ai Catinari, which is almost the perfection of airy luminosity.

The first years of the decade 1630–40 are occupied by two works of major importance—the beginning of the decoration of the Palazzo Barberini, and the building and decorating, at the expense of the Pope's brother, Cardinal Antonio Barberini Senior, of the Church of the Cappuccini (1631–8; S. Maria della Concezione).

The payments to both Sacchi and Camassei for work in the new Palazzo Barberini begin in 1629. The first big ceiling fresco, *La Divina Sapienza*, was given to Sacchi, and it seems as if Camassei was at first commissioned to paint the ceiling of the great hall, but was later ousted by Pietro da Cortona. For the short period from about 1629 to 1634 Camassei appears to have been thought one of the brightest hopes of the Barberini group of painters. But he did not live up to this promise. Originally a pupil of Domenichino, he had shown signs of grasping the needs of the new dynasty, but family troubles and a lack of native invention made him sink soon into a merely provincial position, and his one serious achievement, the *Pietà* in the Cappuccini, is only a handsome and tardy example of the Bolognese classic tradition.

The *Divina Sapienza* of Sacchi (probably 1629–33) is a very serious and considered work, though disappointing. The fresco covers the whole ceiling of the room, but contrives to give the impression of an enormous easel picture, and indeed the composition is more familiar in the later oil variants which Sacchi himself painted, where he cut out most of the enormous and terrifying globe, which is also largely absent from Teti's engraving. It is, however, the first ceiling decoration based on a new type of allegorical programme.

This programme (first fully published by G. Incisa in *L'Arte*, xxvii, 1924, pp. 65 ff.) is derived from the Book of Wisdom, and involves eleven allegorical figures, marked by their appropriate attributes, and placed in an ingenious grouping in the heavens, the whole forming a Triumph of the Divine Wisdom. This Triumph-conception, transferred from Emperors and Generals to abstract ideas in the service of the Church, is very characteristic of the new age and reaches its perfection—and almost its perfection of allegorical absurdity as well as of decorative beauty—in the great ceiling fresco which Pietro da Cortona painted, in the second half of the 1630's, for the main hall of the same Palace. This latter programme was supplied by Francesco Bracciolini and, compendiously stated, it represents: The Triumph of Divine

Providence and the achievement of her ends through the spiritual and temporal activities of the Papacy in the time of Urban VIII!—an unpromising enough subject, which led to astonishing results.

Sacchi's fresco, which gives anyone sitting in the room a decided feeling of discomfort, must be accounted a failure—and he seems to have realized this, and that his art was unsuited to grand decoration in fresco. This increased his nervous self-criticism to such an extent that the last years of his life were spent in inventing excuses to avoid starting on the decoration of the nave of S. Luigi dei Francesi, which his loyal patron, Cardinal Antonio Barberini, had insisted on commissioning from him. But more successful were the four pictures (now in the Museo Storico-Artistico of S. Peter's) which he painted in 1633–4 for the altars in the Grotte Vaticane at the base of the four great pillars which enclose the crossing.

Between 1631 and 1638 the new Church of the Cappuccini was provided with altar-pieces by the fashionable or coming painters of the day. The old school was represented by Guido, Domenichino, Lanfranco (two pictures), Alessandro Turchi and Baccio Ciarpi—the last a Florentine artist whose chief distinction is that he was one of the first teachers of Pietro da Cortona. The pattern of Ciarpi's picture, the *Agony in the Garden*, seems probably taken from Venice—a minor point that is not without interest. The younger generation was represented by Sacchi (two pictures), Camassei and Pietro da Cortona.

The builder of the Cappuccini, Cardinal Antonio Barberini Senior, also undertook, at the same time, the first rebuilding of the Church in the Collegio di Propaganda Fide. Here he employed for the altar-pieces Camassei (who appears to have been instructed only to modify the design of a fresco by Vasari in the Vatican), Carlo Pellegrini, who produced a strange *Conversion of S. Paul*, which is said to have been designed by Bernini, and a young painter from Pistoja, Giacinto Gimignani, whose *Adoration of the Kings* (1634) shews new, though archaistic, tendencies—a rather Raphaelesque pattern and a North Italian delight in the texture and colour of stuffs. For some reason Gimignani does not seem to have pleased the Barberini, and this isolated work, which anticipated Romanelli in certain qualities of that artist's style, is the only one that he painted under Barberini patronage.

Pietro da Cortona's *Rape of the Sabines* in the Capitoline Gallery provides an admirable example of the easel pictures of this decade. The principles of the composition are the same as in the earlier *Sacrifice of Polyxena*, but they have been further developed, and the less gloomy light makes the planning clearer. Three main groups stress against one another in the composition, and minor groups in the middle distance carry the threads of the pattern inwards. It is a perfect sample of the new style, the paradigm of what was to become the Court art of Europe in the eighteenth century. After the decline of Poussin's following in France it became one of the models of academic subject-painting, and only a few years before the French

Revolution it was copied to form the *clou* of the decoration in a room in the Château Borely at Marseilles!

By 1635, after twelve years of reign, Urban VIII and his family knew what they wanted from the arts, and painters had been trained to supply their needs. Bernini's baldacchino in S. Peter's had been completed in 1633, and it was probably in the same year that Pietro da Cortona was commissioned to design the ceiling fresco for the great hall in the Palazzo Barberini, whose complicated theme has already been described. Pietro had been elected Principe of the Academy of S. Luke in 1634, probably began to paint the Barberini ceiling in 1635, and completed it—after an absence in North Italy for all of 1637—at the end of 1639. It marks the apex of the first Baroque style in Rome.

The unity of swing and effect of the design as a whole is even clearer in this fresco than it is in Lanfranco's cupola, though the actual subject-matter is broken up into a variety of separate scenes. The triumphant main figure, and the group above it, which centres round the Papal and family symbols, are superficially isolated from the surrounding mythological scenes by a broad architectural frame, which, in reality, serves only to isolate the single scene at one end which has to appear upside down from the main aspect. All the other groups are bound together by figures sweeping over and behind this architectural border. It is as if a whole crowd of figures had swept into the room through the open roof and arranged themselves all over the air-space at the top of the hall. Everything is in movement, and one might conceive that a strong current of air would sweep the whole crowd in or out again, according to its direction. Nothing like this had been painted before, and Pietro himself never again attempted so bold a piece of illusionism. He still felt it necessary, however, to have the architectural framework, with very elaborate corners, conceiving the hall as an enclosed space with a covering, however open or flimsy, between the floor and the sky.

At about the same time as the family palace was being decorated with this justification of Urban VIII's policy in allegorical terms—and a more material demonstration was also supplied by cartoons for tapestries, in part also by Pietro da Cortona, shewing Urban VIII's main public works—new decorations were planned for the Vatican. For the last time, before the neo-classic period, a new series of rooms was constructed in the Papal Palace. Urban VIII completed the block—already begun by Gregory XIII—behind the central compartment of the second Loggia, by a series of frescoed rooms leading from the Sala di Constantino towards the Sala del Concistoro. He planned these rooms as a sort of philosophy of medieval Papal history, explaining and justifying the rise of the States of the Church.

Though they are now isolated from one another by modern 'improvements', defaced by restoration, and little visited from being adapted to domestic uses, the general intention of these rooms is still clear. The Sala di Carlo Magno (now the

ante-room to the Appartamento della Guardia Nobile) was painted in 1635–7 by Abbatini, one of Bernini's men-of-all-work, with scenes from the career of Charlemagne which had a special bearing on the history of the Patrimony of the Church, and the Sala della Contessa Matilda (now used to house the accumulated Sacristy property of the Sistine Chapel) has large frescoes by Romanelli, shewing the actions of the Countess Matilda of Tuscany which led to the increase of the Patrimony. These were painted from 1637 to 1642, and were supplemented by decorations by Abbatini. Beyond the Sala di Carlo Magno a further series of rooms was added, with queer decorations which may be due in part to Agostino Tassi, which contain representations of all the buildings in Rome built or improved during the Pontificate of Urban VIII.

Romanelli, whose handsome frescoes—his best works—in the Sala della Contessa Matilda have just been noticed, was the latest of the Barberini protégés, and was continuously employed during the remaining years of Urban's rule. In 1639 he had been precociously elected Principe of the Academy of S. Luke through Cardinal Barberini's influence, and after the Pope's death he followed the exiled Barberini to Paris, where they found him numerous patrons at the French Court. He remained pampered by the Barberini into old age, long after his style of painting had deteriorated into an ineffectual formula. He had entered Pietro da Cortona's studio in the early thirties, and a superficial devotion to the prettier elements in Raphael led him to be called 'Raffaelino'. He was never 'modern' in the sense that Pietro is, but blended a rather charming archaism with the new gestures and the new draperies which Bernini's statues had made popular. There is little that is original in him, but Sandrart tells us that he was notably pious, and that an agreeable personality earned him employment. His work in Paris gives him an importance he would otherwise have lacked, as providing a liaison between France and Italy for some elements of the new style in a watered formula more palatable than the austerities of Poussin. The ceiling of several rooms which house the later classical collections in the Louvre are still painted with his rather flaccid inventions, conventionally arranged as if Pietro's Barberini ceiling had never existed.

From 1639 until 1647 (well into the next reign) Pietro da Cortona was absent in Florence, painting the great series of rooms in the Pitti Palace. His absence was certainly not due, as has been suggested, to jealousy of the young Romanelli, but it left Sacchi, the enemy of Bernini and the representative of the opposite camp, as the *doyen* of the Barberini painters in Rome. Missirini (p. 112) gives us some indication of the opposing groups in the Academy of S. Luke at this time: 'The chief question in debate was whether large paintings and ones full of incident should be preferred, or pictures containing a few figures only. . . . Pietro da Cortona supported by word and practice the side of the large pictures, and it was in vain that his opponents countered that the eye grew weary in looking at a great crowd and failed to find that

peace and repose which alone would please and content it.' And the comparison with a Tragedy is emphasized, 'in which, the greater the effect produced by the minor characters, the more deserving it is of praise'—an analogy which shews how closely the ideas of Baroque composition and design were bound up with the stage.

Though the death of Urban VIII in 1644 causes a sharp cleavage in the history of patronage, one important work bridges the whole decade—the redecoration of the Lateran Baptistery (S. Giovanni in Fonte) under the general direction of Sacchi, from about 1641 to 1649. Sacchi, free to demonstrate his opposition views on decoration in the last great work undertaken by the Barberini, set about to illustrate that painting should be judged by intellectual standards rather than by the show it made, with characteristic indirectness.

Disliking fresco as a method which did not allow of endless refinements and corrections in the studio, Sacchi farmed out the large narrative frescoes to Camassei and Gimignani and gave the remaining small fresco to his favourite pupil, on whom he set great hopes, Carlo Maratti. This is the first appearance in public of the man who was to succeed Bernini as artistic dictator in Rome, but Maratti seems to have worked here only from a cartoon by Sacchi. For himself Sacchi reserved the series of eight canvases illustrating the *Life of the Baptist*, which were to hang high up in the lantern, eluding scrutiny and producing no decorative effect whatever.

It was a curious answer to Pietro's Barberini ceiling, but I have little doubt that Sacchi intended these eight canvases to be the commensurate antagonist of that work. Their compositions are measured with extraordinary deliberation, the varieties of human expression have been studied with amazing care, and yet it is only the accident of their having been taken down to be cleaned, and consequently photographed, that enables us to estimate their quality at all. It is characteristic of Sacchi's quixotic and unpractical nature to have painted his masterpiece chiefly for his own eyes and those of God alone!

It is interesting that there should have been a revival, during Sacchi's domination in the 1640's, of the old-fashioned traditions of the Carracci school. Public commissions are given to *retardataire* painters who use the old Bolognese patterns and confine their novelty to skill in representing the silk of stuffs or the porcelain of flesh, like Sassoferrato, or to the twilight subtleties of silvery shadows, like Cerrini. Sassoferrato's charming picture let into the ceiling of the Sacristy of S. Francesco de Paola, with its quiet tempo and lovely stucco frame, dates from 1641, and 1643 is the date of the same artist's only other public commission in Rome, the *Madonna del Rosario* in S. Sabina, a picture of surprising merit, even though it has won excessive popularity with the devout. Cerrini's two pictures for the side altars of S. Carlino alle Quattro Fontane (1642–3: commissioned by Cardinal Francesco Barberini), which now hang in a dark passage behind the church, have a remarkable poetic quality of tone and shew the deliberate imitation of Bolognese models. Almost exactly the

same mood—a reaction against the rather frantic movement of Cortona and Bernini —pervades the 1641 frescoes of Giacinto Gimignani in S. Carlo ai Catinari, where the stuffs are like Sassoferrato, and the figures are disposed like Domenichino or Poussin.

INNOCENT X (1644–55)

In 1644 Urban VIII died, and was succeeded by Innocent X of the rival house of Pamphily. The Barberini went into exile, and Romanelli with them: Pietro da Cortona remained in Florence until 1647: Sacchi continued slowly with the Lateran Baptistery, and painted *The Death of S. Anne* in S. Carlo ai Catinari, a serious and impressive work which was unveiled in 1649; and, after a brief period of eclipse, Bernini regained his undisputed predominance at the Papal Court.

The eleven years of Innocent X's rule form something of a pause in the development of the Baroque style. The Pope is said to have been a rather mean patron of the arts, and he certainly had no clear artistic policy, except perhaps a certain antagonism to the previous rule.

Perhaps the most interesting innovation of the next five years is due to Bernini working in conjunction with the faithful Abbatini. In the vault of the Cappella Pio in S. Agostino, which was designed by Bernini soon after 1643, Abbatini has painted a *Glory of Angels* in which golden rays of stucco mingle with the painting. This mixture of stucco and painting was further developed in the Cornaro Chapel in S. Maria della Vittoria, completed in 1647, where Bernini, with his swooning S. Teresa and the watching figures in the balconies, produced his greatest triumph in illusionistic chapel decoration. Here, too, Abbatini executed Bernini's design, but this combination of stucco and painting had little following in Rome. It was taken up, however, in Germany and Austria, and led to some of the richest flights of rococo fancy.

Just as the Barberini family palace had been the most conspicuous domestic decoration in Urban VIII's reign, the completion of the Palazzo Pamphily, in the Piazza Navona, and the building of the Villa Pamphily by D. Camillo, the Pope's nephew, were the principal secular commissions under Innocent X. The Villa Pamphily was under construction from about 1644 to 1652, but painting played only a minor part in its decoration. All that is now left from this period are two rooms with frescoes by Grimaldi, one of which is almost completely ruined. A new tendency is, however, apparent in one of these—a return to pure landscape.

We have already mentioned the rooms in the Torre de' Venti in the Vatican which had been decorated by Matthew Brill with landscape frescoes in the time of Gregory

XIII. This romantic Flemish style gave way in Rome, under the Carracci, to a more classical and ordered manner, but the two tendencies persisted side by side: the Flemish tradition which sought inspiration from the wildness and accidents of Nature, and the Venetian–Bolognese style which arranged Nature as a fitting background for quiet groups of figures. The most lovely examples of the Bolognese tradition in fresco are the three early works of Domenichino now removed from the wall and hung as easel pictures in the Palazzo Farnese, but here the figures are still fairly large. The canvas lunettes by Annibale and his scholars in the Doria Gallery give perhaps the best idea of the grave ordonnance of classic setting used for small figures. From the first of these Bolognese styles springs Nicolas Poussin, from the second, Claude Lorraine.

What is remarkable in the four Grimaldi frescoes in the circular centre room of the Villa Pamphily is that they contain no figures at all. They do not form an important part of the room's decoration, but fill the fancifully shaped spaces over the doors with naturalistic views of the Campagna, arranged with very little distortion from Nature, but emphasizing her more tranquil moods. The wilder and grander aspects of Nature, in accordance with the Flemish tradition, are more favoured, however, by Gaspard Dughet—often called Gaspard Poussin—who appears also to have worked in the Villa Pamphily, though nothing by him remains there today.

Dughet was also among the painters who decorated a series of rooms in the Palazzo Pamphily from about 1645 to 1653. These rooms had been built some time before and, in order to preserve the handsome ceilings already existing, the painting was confined to friezes—an old-fashioned mode of decoration which had survived for the same reason in the Palazzo Patrizi, whose interesting friezes still await study.

Apparently the Tassi room in the Palazzo Pamphily already existed, so that the artists of the 1645 to 1653 decorations are Camassei (an old Barberini artist rescued from prison and neglect by the Pamphily, who died soon after), Gaspard Dughet, Giacinto Brandi and Giacinto Gimignani. Dughet's 'frieze' shows a single landscape on each of the sides of the room, framed to look like a picture. They illustrate the wilder aspects of shore, river or mountain scenery, and mark the beginnings of a love of the picturesque which was to have such a momentous effect on English taste. It is worth noting that the other great protagonist of the picturesque, Salvator Rosa, returned to Rome about this time, where he chiefly remained until his death.

The same love for the picturesque is found in the large landscapes, adorned with figures relating to Carmelite legends, which Dughet painted between 1647 and 1651 on the walls of the Church of S. Martino ai Monti. Pietro Testa perhaps collaborated in the figures, and Grimaldi also painted two large companion landscape frescoes in the series. But this whole scheme of church decoration is something of an oddity, due to the particular taste of the existing General of the Carmelites, and it did not become a model for later experiments.

On the whole the *détente* in invention, which had set in after the completion of the Barberini ceiling and was probably helped by Pietro da Cortona's long absence in Florence, continued throughout the whole reign of Innocent X. Even the archaizing tendencies of the end of Urban VIII's reign persist, as can be seen in Preti's fine frescoes of 1650–1, in which he deliberately apes Domenichino, and in Romanelli's tepid decoration in the Palazzo Lante of about 1653.

Pietro da Cortona, on his return to Rome in 1647, was busy for four years on the cupola and pendentive frescoes of the Chiesa Nuova, in which he did little but paint variations on Lanfranco's cupola-design in S. Andrea della Valle. But from 1651 to 1654 he was engaged on a more important task—the decoration of the ceiling and the ends above the windows of the great 'Galleria', designed by Borromini, in the Palazzo Pamphily.

It may not be without importance that Pietro da Cortona's first great ceiling was painted for a room designed by Bernini, and his second for one planned and partly decorated by Borromini. The first is magnificent and overwhelming, the second airy, poetical, and full of a lightness which almost makes the first seem heavy. In a long and narrow room, like this Pamphily Gallery, it would be impossible to paint a ceiling fresco with the urgent unity of the other, so that Pietro was content, at the outset, to divide the whole ceiling-space into sections and to represent in these a variety of separate scenes from the life of Aeneas, the fabled progenitor of the House of Pamphily.

Indeed, to judge also from his work in Florence, Pietro da Cortona in his later years seems to have been chiefly concerned to perfect in refinement the architecture of his decorations. Innocent X demanded no implications of power or policy from his painters, but only that the effect should be splendid and elegant. The various scenes from the *Aeneid* are separated from one another either by sky alone or by borders of great refinement, which the figures do not overstep. The central square shews two separate scenes, one at either side, and the central part of it is furnished with only a few figures ingeniously stressed—just enough to prevent the rhythm from falling into two halves, but with no attempt at an effect of unity. The opulent types shew that Pietro had been looking again at Raphael and the Antique, and almost all the figures have the slight smile of actors playing an agreeable part. The finest inventions are the caryatids who support the golden oval frames and the Putti who play with flowers—tulip, rose, lily and iris—and the ingenious groupings in the awkward spaces over the end windows. Enormous decorative talent is what is in evidence. In the twenty years since the Barberini ceiling the assertion of power and divine mission has given place to the assertion of taste.

The other remarkable event of the early 1650's is the emergence as a painter of Carlo Maratti, a pupil of Sacchi, who began by carrying on his master's teaching without either Sacchi's excessive self-criticism as a designer or his finer qualities as a

painter. But Maratti's earliest works are distinguished pictures, especially the *Adoration of the Shepherds* of 1650 in S. Giuseppe dei Falegnami and the *S. Augustine* of a year or two later in S. Maria dei Sette Dolori. His fresco in the small cupola in the Alaleona Chapel in S. Isidoro, of 1652, with its few figures in Raphaelesque poses, with no ingenious distortions, amounts almost to a retrograde innovation!

One other work of importance was begun in the later years of Innocent X. Niccolò Sagredo, the Venetian Ambassador in Rome from 1651 to 1656, had the Church of S. Marco entirely remodelled and redecorated in the Baroque style. The work appears to have lasted from about 1653 until 1659, and it gave their first public employment to several of the second generation of Pietro da Cortona's pupils— Lazzaro Baldi, Ciro Ferri and Guglielmo Cortese. The other artists employed were Maratti, Canini, Fabrizio Chiari, Mola (who was also much employed by D. Camillo Pamphily until a quarrel led to the destruction of the best works he had painted for that Prince), and, finally, Allegrini, an indifferent survivor of the tradition of Cesari d'Arpino, who had been employed, no doubt cheaply, by Innocent X on the minor rooms in the Palazzo Pamphily.

ALEXANDER VII (1655–67)

INNOCENT X cannot be said to have left any very definite stamp on the arts of his time, and, except for Pietro da Cortona's ceiling, the most remarkable decorations executed for the Pamphily family were commissioned by D. Camillo after Innocent's death. But his successor, Alexander VII (Chigi), of the great family for whom Raphael had painted the Farnesina, was a more conspicuous patron of the arts, although his preferences were inevitably governed at times by local patriotism.

A native of Siena, two Sienese were among the first artists to whom he gave employment, both scholarly adherents to the older style—Raffaello Vanni, whose father had held the new Pope at his christening, and Bernardino Mei. Both were employed in the Pope's restorations in S. Maria della Pace and S. Maria del Popolo.

Bernini inevitably retained his position as principal Court sculptor and architect, though Pietro da Cortona, as distinguished an architect as he was painter, was employed by the Pope at the beginning of his reign for the remodelling of S. Maria della Pace. Pietro's position as chief painter seems also to have remained unquestioned, though he executed comparatively little in his later years and in the sixties was much hampered by gout.

Pietro was put in charge of the decoration of the Quirinal Gallery, which was executed under his supervision and where he was supposed himself to be going to paint the ceiling fresco, which was never begun. This gallery has now been divided

into three separate State Rooms, and the trappings of nineteenth-century Royalty do not improve an effect which must always have been rather heavy. The two big end frescoes were given to Mola and Maratti, and the smaller ones were allotted to Grimaldi, Canini, Fabrizio Chiari, Filippo Lauri, and four pupils of Pietro da Cortona of the younger generation, Guglielmo Borgognone, Lazzaro Baldi, Ciro Ferri and Carlo Cesi, as well as to Jan Miel, a Fleming, and two German brothers, Giovanni Paolo and Egidio Scorr. In this praiseworthy but unfortunate attempt to harness all the available talent to one great scheme, all the painters but the first two executed alternate ovals and rectangles along the upper part of the side walls, forming a sort of monster frieze. But the decoration does not hang together well, and the only really remarkable work is Mola's big *Joseph revealing himself to his Brethren* on one of the end walls. This is large and Raphaelesque in planning and of considerable grandeur.

Mola, a Protean character, had first appeared in Rome in the later 1640's with a style of pronouncedly Venetian leanings. He is the first of a succession of painters who had formed their style in North Italy before coming to Rome, and brought new life into the rather stagnant Cortonesque tradition and formed the second Baroque style in Rome in the latter half of the century. He is often slovenly, and is extremely variable in style. If the long room in the Palazzo Pamphily at Valmontone with romantic trees against a late afternoon sky and Giorgionesque gallants and ladies on a balcony be partly his, he is responsible, together with Dughet, for one of the prettiest pieces of unpretentious decoration of the century. But most of his work at Valmontone is known to have been destroyed. His best certain work was done for the Chigi—though most of the pictures listed in the old Chigi Inventories have vanished—and his masterpiece is the *S. Bruno*, belonging to the Incisa della Rocchetta Collection—as romantic a Titianesque picture as could be wished for in this century and one which he popularized in numerous repetitions.

Towards the close of the fifties, D. Camillo Pamphily commissioned some frescoes in his palace at Valmontone which are among the most remarkable of the century. Unfortunately they were largely ruined in the last war. The secondary room, perhaps by Mola, has already been mentioned, but the four main rooms, frescoed with Allegories of the Four Elements of Fire, Air, Water and Earth, are the important part of the decoration. The last two (though parts of *Water* are very fine) are conventionally planned, and the remarkable rooms are *Fire* and *Air*, painted respectively by Francesco Cozza and Mattia Preti between 1658 and 1662. Both are tall, square rooms, and the whole ceiling is treated as a single unit without any feigned architectural compartments. The background of the whole ceiling is sky, which, in *Fire*, is of a twilight blue, and in *Air* of a dizzy white. A single Personification occupies the middle of the ceiling, and the side slopes show separate groups of figures, which enlarge upon the main theme.

Preti, who is more familiar to students as a Neapolitan painter especially prolific in Malta, has already been noticed for his archaizing frescoes in S. Andrea della Valle. At Valmontone, though the figures are less refined than at S. Andrea, he has found his own style, and produces a decorative effect of remarkable authority. The side slopes of the ceiling are covered with Divinities driving chariots (inspired perhaps by Guercino)—Aurora, Apollo, Diana (and Endymion), and Luna, the last two involving a curious distinction. The elaborate corners of the Cortonesque mode are changed for standing figures of Fortune, Time, Love and Fame upon pedestals, at whose feet a pair of figures reclines.

Cozza's fresco is even more remarkable, and has all the refinement that Preti lacks. His figures form a series of friezes along the edge of the ceiling, with stone corners, rocks or trees for the irregular angles: a remarkable combination of the traditional and the unconventional. For Cozza was a pupil of Domenichino, and was hardly tinged with the novelties of the Baroque style of Pietro da Cortona. He is allied in some qualities with Sassoferrato, but has a genius far less restricted; and he likes the same poetical half-tones and silvery effects. When seen in competition with more 'modern' painters, as in the Palazzo Altieri, where his delicate *Summer* and *Winter* have been surrounded by vulgar Marattesque figures, his poetic charm is apparent, but he is obviously incapable of competing with the trumpet tones of the prevailing style.

It was in 1667, after the completion of Valmontone, that D. Camillo Pamphily ordered the decoration for the Library of the Collegio Innocenziano, which balances the Palazzo Pamphily on the opposite side of the Church of S. Agnese. This remarkable decoration seems to have escaped notice from even the early Guides, and is by Cozza after he had come somewhat under the influence of Preti while working at Valmontone. The room is the same shape as the great halls at Valmontone, and the ceiling is covered in much the same way as in the Preti fresco there, but with a greater multitude of figures. There are groups of figures in the corners, and the whole surface of the sky is alive with groups, arranged with something of Preti's dashing decorative effect, but with Cozza's delicate, silvery colour. It is almost a rival, in a classical mode, to Pietro da Cortona's great Barberini ceiling, and the failure of the old tradition to serve such purposes is apparent in the degree of its decorative inferiority. It is hardly less complex in programme than Pietro's ceiling, combining a great wealth of mythological and allegorical figures with the various Pamphily and Aldobrandini symbols, but the whole effect is crowded and over-weighted.

Much of the other official work in these years was done by the two most original of Pietro's younger pupils: Lazzaro Baldi and Guglielmo Cortese. Both were employed in the pictorial restoration of the Lateran which Alexander VII undertook to supplement Borromini's rebuilding of the Basilica under Innocent X, and Baldi is found again in conjunction with Borromini in the curious little edicule of S.

Giovanni in Oleo, remodelled about 1658. Cortese, perhaps the most talented and original of Pietro's pupils, painted, in conjunction with Ciro Ferri, his most slavish imitator, in S. Prassede in the early sixties. At the same time yet another of Pietro's pupils, Paolo Gismondi, painted the Sacristy of S. Agnese a Piazza Navona and most of the Church of S. Giovanni a Porta Latina.

Between 1661 and 1666 Alexander VII also built and decorated the principal church in the two villages of Castel Gandolfo and Ariccia, in the latter of which the Chigi still have their family palace. At Castel Gandolfo, about 1661, Pietro da Cortona painted the picture for Bernini's high altar, and the side altars were allotted to Cortese and Giacinto Gimignani. The two latter were also employed at Ariccia, in 1664–6, together with Gimignani's son, Ludovico, three Sienese—Vanni, Mei and Emilio Taruffi—and Alessandro Mattia, a painter of the Cozza–Sassoferrato tradition, who seems to have been a sort of household artist attached to the Chigi family and came from their principality of Farnese.

From 1664 to 1666 Pietro da Cortona, now a gouty old man, painted his last elaborate work, the ceiling of the nave of S. Maria in Vallicella. The subject is ill-suited to a ceiling, and Pietro has made the best of a difficult commission, but it adds nothing new.

In the meantime, however, a new star had appeared on the horizon, destined to be the perfecter of the second Baroque style. Giovanni Battista Gaulli, generally called Baciccio, was a painter, like Mola, formed in North Italy. He came from Genoa, and first earned public fame with a picture painted in the early 1660's, which now hangs over the altar in the Sacristy of S. Rocco. But it is painted in a style quite unlike that evolved by Baciccio in later years, for Bernini, whose creative powers did not wane with declining executive vigour, took the young artist under his protection and moulded his mind anew. He was employed by the Chigi on a number of private commissions, and one large picture remains at Ariccia, while two others are now in the Galleria Nazionale. He also painted the portraits of the Pope and his brother, D. Mario Chigi, and he and Maratti are the only Italian portrait painters of real distinction who worked in Rome in the seventeenth century.

THE SUCCESSORS OF ALEXANDER VII
(1667–1700)

AFTER Alexander VII, the shorter rule of his successors, their feebler personality, or their lesser interest in the arts, make Papal patronage of much less importance for the history of style. Clement IX (Rospigliosi; 1667–9) was followed by Clement X (Altieri; 1670–6), and both were partial to Maratti, but the most notable patrons at

the beginning of these years were Prince Camillo Pamphily, his wife, the Princess of Rossano, and the Society of Jesus.

Already in 1666 Baciccio seems to have been attached to the Pamphily household, and his lovely early works—the pendentive frescoes in S. Agnese (1668–71) and the *S. John in the Desert* of about 1670 in S. Nicola dei Tolentini—were both executed for that family. Also due to Pamphily munificence was the new church designed by Bernini for the Jesuit Novitiate—S. Andrea al Quirinale, probably the most studied Baroque building in Rome. The building of this church was completed about 1668, and Guglielmo Cortese, whose brother was a Jesuit and also a painter, executed his masterpiece for the high altar. At the same time the Church of S. Nicola dei Tolentini was the theatre for the first work in Rome of two painters from Lucca of Venetian training, who were inseparable as long as both lived—Giovanni Coli and Filippo Gherardi. In 1672 also, Baciccio began his fourteen-year labours in the Gesù with the cupola, but as he did not start on the revolutionary ceiling until 1676, their notice will be deferred until later.

The short rule of Clement IX was too troubled by political events to give the Pope much time for artistic commissions, and Clement X also was not much interested in art, except in so far as it served the needs of immediate piety. Indeed, he seems never to have troubled to visit the family Altieri Palace, which was being transformed during his reign into the magnificent building it now is.

The additions which he made to the catalogue of the Saints did, however, compel Clement X to some artistic patronage. In 1671 he canonized SS. Luis Beltran, Rose of Lima, Philip Benizzi, Francesco Borgia and Gaetano Thiene, and the Altieri Chapel in S. Maria sopra Minerva has an altar-piece by Maratti which includes all these Saints, as well as some incidental frescoes by Baciccio. In the following year or two, chapels were dedicated in the same church to the first two of these Saints, and Baciccio painted the picture for the altar of S. Luis Beltran and Baldi the altar-piece and other paintings for the Chapel of S. Rose of Lima. Baldi was also employed on the picture for the Canonization in 1672 of S. Pius V, which still remains in the Minerva, in blackened condition, and his *Appearance of the Virgin to S. Gaetano Thiene*, now in S. Silvestro al Quirinale, belongs no doubt to the same series of commissions.

But the Altieri family was more interested than the Pope in commemorating itself by artistic works. In 1671 Clement X had sanctioned a limited cult of the Blessed Ludovica Albertoni, a kinswoman of Cardinal Paluzzi Altieri, who dedicated chapels in her honour in S. Maria in Campitelli and in S. Francesco a Ripa, where Baciccio painted the picture behind Bernini's swooning figure of the Beata. The frescoed decoration of the remodelled Palazzo Altieri also dates from about 1673 onwards. Cozza's frescoes were surrounded with allegorical figures and borders in the new mode: the great hall had an enormous fresco by Maratti, illustrating the

'Clemency' of Clement X, and the Bolognese Domenico Maria Canuti painted the ceiling of a smaller room with a rather baffling allegory within a border of fanciful *quadratura* architecture.

The large Maratti fresco—the rest of the room remains uncompleted owing to some disagreement between artist and patron—introduces a new phase in grand decoration. The fresco is flat on the ceiling and fully contained within a frame, so that there is no suggestion of illusionism. The two *modelli*, still preserved in the Palazzo Altieri, show as clearly as the fresco that the perspective convention is conceived rather for a large wall-painting than for a ceiling. But what it lacks in illusionism is compensated by the ample rhythmic sweep of the design, which curls upwards and inwards into the picture field. It is the first example in Rome of the finally completed 'grand style', the style which was to be for a century the idiom of cultured Court art in Europe, and whose echoes still linger to this day in the ceilings of provincial theatres. If one can forget all those qualities which go to make Raphael a great artist, one can see in this fresco of Maratti's the essentially 'Raphaelesque' character of the figure style. Missirini (p. 156), quoting the Cavaliere de' Rossi, gives a fair but unflattering estimate of Maratti's style: '. . . a languid painter, in whose works it is equally difficult to find revolting defects or enchanting beauties. Never faulty in drawing, but never vigorous, the expression of his figures is always vaguely indicated rather than definite, and his colour is languid, without telling qualities or the vitality of truth. He continually talked of Raphael with enthusiasm and urged the study of him, but he never imitated him himself.' Yet the truth is that Maratti certainly imagined that he was imitating Raphael, and the novelties in his style can properly be described as a Raphaelizing of the Baroque idiom. Pietro da Cortona's fluttering draperies, which emphasize the nervous movement of his figures, have disappeared. There are relatively few figures, and the main swing of the composition is carried forward by the deliberate poses of the arms, legs and bodies of these single units. It is a method which can be easily appreciated and easily taught—an international artistic language admirably fitted for the allegorical utterance of political or ecclesiastical generalizations, and lacking personal or national colour.

At almost exactly the same date that Maratti was painting the Altieri ceiling— about 1674 onwards—Baciccio painted the ceiling of the nave in the neighbouring Church of the Gesù, in which we can study the pure Roman, or Jesuit, style as opposed to the international formula of Maratti.

Baciccio was elected Principe of the Academy of S. Luke in 1674, and began his work on the nave ceiling of the Gesù in 1676. We have no evidence whetherBaciccio himself, Padra Oliva—the General of the Jesuits—or Bernini, who was a sort of adviser to both, was mainly responsible for the novel invention of this ceiling; but it is worth remarking that the general planning—which is especially visible in the *modello* in the Spada Gallery—resembles Bernini's Chair of S. Peter. There can be

no doubt that all three contributed ideas to the scheme, but, since we lack positive knowledge, we may give the credit to Baciccio himself.

The roof of the nave is first laid out with a stucco frame of almost the identical shape that Maratti uses for the Altieri ceiling, but whereas Maratti uses his frame to contain his figures, Baciccio employs it only to give his figures something to burst out from, and to organize the swirls and transports of his celestial companies. It is impossible from the ground to feel absolutely certain in all cases of what is painting and what is stucco, and the ceiling of the church is equated with the Heavens. Forty years had had to elapse before any development of the decorative implications of Pietro da Cortona's Barberini ceiling occurred, and it needed the pressure of the Jesuit ideal of transporting the worshipper in ecstasy into the very Heavens themselves. Bernini's all-stucco ceiling in the Church of the Jesuit Novitiate (S. Andrea al Quirinale) is a more intimate application of the same intention. The two Cherubs who are tobogganing down the lantern to fill up the gaps left for them in the otherwise perfect ring at its base, shew the same desire to aid the worshipper, to the best of the architect's ability, to uninterrupted communion with God. The tortured flicker and flutter of Baciccio's draperies are in strong contrast with Maratti's measured and ample folds, and Baciccio's painting, unlike Maratti's, is of enormous personal distinction.

At the same time there were still adherents to the old-fashioned method of dividing ceilings up into compartments according to the pre-Jesuit traditions of the Church. About 1675 the Crociferi had the ceiling of their church—S. Maria in Trivio—painted by Antonio Gherardi, a pupil of Mola with a largely Venetian training, and the influence of Paul Veronese is obvious in the architecture of some of his compositions, though not in their colour. Venetian colour is apparent, however, in the contemporary ceiling of S. Croce dei Lucchesi of 1674 onwards, where Giovanni Coli and Filippo Gherardi also use the same formula of a number of compartments. But they soon graduated into a more Baroque style, while retaining their Venetian colour, and the ceiling of the great Gallery of the Palazzo Colonna (1675–8), where various exploits from the career of Marcantonio Colonna mingle together on the enormous ceiling of a room otherwise decorated with gilt and mirrors, is the forerunner of many similar ceilings in the palaces of nobles throughout the rest of Europe. The remarkable ceiling by Canuti and Haffner in SS. Domenico and Sisto, which is of this date, is a curious Bolognese importation into the Roman scene.

Maratti's pre-eminence does not seem to have been quite so irrefutably established in the middle seventies as it was later to become, since a picture of the *Martyrdom of S. Blaise* by Brandi was preferred to his in S. Carlo ai Catinari. Brandi, the only direct pupil of Lanfranco who was active in Rome, had already painted a number of altar-pieces, but began to be popular at about this date, largely owing to his comparative cheapness and the expedition with which he carried out his commissions.

He could sweep in large ceilings—as at S. Carlo al Corso or S. Silvestro in Capite—with speed and adequacy, and he sometimes produces an altar-piece with a queer, realistic brutality and a superficially Caravaggesque lighting, which makes him an almost original figure for his time. His most interesting achievements of this kind are the three pictures of the Passion, painted in the decade 1675–85, in one of the Chapels in S. Andrea al Quirinale.

The enormous increase in the number of private chapels being decorated in the last quarter of the century, and the rivalry in artistic munificence of numerous bene-factors, produced an interesting result, which is significant of the time and of great value to the historian of painting. In 1674 appeared the first edition of the Abate Titi's *Studio di pittura, scoltura et architettura nelle chiese di Roma*, which was republished, under varying titles and with the necessary additions, until the final edition of 1763. An incredible spate of Guide-books followed it, but this is the first complete Guide to Rome whose predominant interest is in the names of the artists and patrons responsible for the various works in the churches, and the first to indicate that spirit of dilettantism which is the sure sign of an artistic period approaching its close. The additions made to the second edition of 1686 show the enormous amount of work done between 1675 and 1685, and no recent paintings, however young or trivial the painter, escape the attention of the vigilant cicerone.

About 1675 the tradition of Maratti finally ousted, in public fashion, that of Pietro da Cortona, and of Pietro's surviving pupils only Ferri and Baldi still shew their master's influence. In the decade of 1675–85 Baldi produced his masterpiece, the *Madonna del Rosario* in S. Anastasia, and it was probably in about 1680 that Ferri, painting in company with Calandrucci and Berrettoni, did his frescoes in the Villa Falconieri at Frascati. But the date of these is uncertain, and, if they are of about 1680, they are the swan-song of the Cortonesque style. Artists like Guglielmo Cortese changed their style completely to suit the new mode, and little of Cortona or his own individuality remains in his picture of 1677 in the SS. Trinità dei Pellegrini.

Meanwhile a new generation was coming forward. Giuseppe Ghezzi, a rough painter from the Marches, first appears about 1674, and between 1674 and 1683 a mixture of young painters and old failures painted the frescoes of the vaults of the side aisles and ambulatory of S. Carlo al Corso. None of them are names of any distinction, and few of them are much heard of in Rome again. Only Garzi and Ludovico Gimignani, the latter of whom had been taken into the Rospigliosi house-hold, were to become successful, though both are rather styleless artists in the Marattesque tradition, and their names are increasingly found as the painters of frescoes and altar-pieces during the next twenty years. In the early eighties more of Maratti's direct pupils begin to appear: Giuseppe Chiari, his sedulous ape, and Niccolò Berrettoni, his one follower of real promise, who met an early death in 1682, caused, it was said, by his master's jealousy.

Death had carried off Bernini in 1680, and with him the one serious intellectual force among the Roman artists of the seventeenth century. He was succeeded in the respect and opinion of the world by Maratti. Baciccio finished his work at the Gesù in 1683, and it was generally held by his contemporaries that his quality declined after Bernini's death. But Bernini's influence remained permanent with Baciccio. His *Death of S. Francis Xavier* in S. Andrea al Quirinale (before 1686) is a translation into pictorial terms of nearly the same material as lies behind Bernini's *S. Teresa* of forty years before, and the side paintings in the same chapel, which Baciccio was still at work on when he died in 1709, are singularly handsome works with Bernini figures against a romantic landscape, and show no decline in talent.

Only one new figure of serious importance emerges before the turn of the century —Fratell' Pozzo, a continuer of the Jesuit tradition. He was actually a member of the Society of Jesus, which thus appears, at the close of our period as at the beginning, as the intellectual driving force which occasioned and necessitated all the important stylistic experiments and advances of the seventeenth century. Padre Oliva, the veteran General of the Order and the great friend of Bernini, summoned Pozzo to Rome—on the advice of Maratti, it is curiously said—soon after Bernini's death. He was already a formed artist, and had given proofs of his talent in Lombardy and Piedmont, where his ingenious perspectives had transformed a small church into the semblance of a great cathedral. His first Roman work, interrupted for a time by Oliva's death, was to fresco the corridor in the Casa di S. Ignazio. This was painted between 1681 and 1685. From 1685 to 1690 he frescoed with success the apse and tribune of S. Ignazio, and from 1691 to 1694 he was at work on his greatest Roman achievement, the nave ceiling of the same church. This is the logical continuation of Baciccio's ceiling in the Gesù. Stucco has disappeared altogether, and the fresco comes right down to the great flat band of moulding which runs along the top of the side walls of the nave. The inevitable fact that such a vast surface, covered with figures in accurate perspective, can only be properly seen from one point, had probably prevented any previous experiment of this nature. Pozzo frankly admits this, and caused the proper point to be marked on the floor of the nave by a small circle of marble! It is the logical conclusion of the whole thesis of illusionism. The perfect illusion can only be perfect from one standpoint; but what is important is the perfection of the illusion, so the spectator must conform himself to that standpoint. One could not find a more pregnant illustration of the influence of dogma upon decoration.

Pozzo's ulterior importance lies in the fact that he spent the last years of his life, from 1702 onwards, in Vienna. The Prince of Liechtenstein was in Rome while Pozzo was at work on the ceiling of S. Ignazio, and took great interest in it, and Pozzo's greatest work in Vienna is the fresco in the hall of the Liechtenstein Palace, which had a great influence on subsequent decoration in Austria.

We know a great deal, from the 1686 Titi, of the work which was under commission in Rome in 1685–6. It is chiefly a succession of familiar names: Maratti, Brandi, Baldi, Garzi, Ghezzi, Gimignani, Chiari—and two new names, Giuseppe Passeri and Daniele Seiter. Passeri is said to have been Maratti's favourite pupil, and has a large and fluid style well suited to the rapid interpretation of Miracles and Legends; and Seiter, a Venetian artist of German extraction, went to Turin in 1688 and became Court Painter to the House of Savoy. A typical chapel of about 1686 is the Montioni Chapel in S. Maria di Montesanto, in which Seiter and Giuseppe Chiari collaborated with Maratti to produce a stately and frigid result. Perhaps the best of all the chapels under construction in these years—largely, perhaps, on account of its handsome marbles—is the Cybo Chapel in S. Maria del Popolo, in which Maratti again painted the altarpiece and Seiter and Garzi were responsible for the rest of the painted decoration.

Only one ceiling decoration of note dates from the later eighties, the amusing 'burst' which Filippo Gherardi painted alone (Giovanni Coli having died in 1680) on the ceiling of S. Pantaleo from 1687 to 1690. This shews obviously the influence of Baciccio, and is an efficient but relatively slight work. In the nineties much the same names occur as in the eighties, but Padre Pozzo's work in S. Ignazio is much the most important in the decade. Other work of some note was being done, however, and all the side chapels in S. Silvestro in Capite were completed and decorated by 1697. Here the painters were Giuseppe Ghezzi, Garzi, Chiari, Gimignani and a new and more important figure—Francesco Trevisani, another painter of Venetian training.

Trevisani marks the beginning of a new age, and succeeded Maratti, who died in 1710, as the leading artist in Rome. His sweet Madonnas and porcelainy children were sought after by all the noblemen of Europe, and the rather domestic interpretation which he gave to the queenly figures of Maratti reveals a new trend in Court taste. While Maratti's pupils, led by Giuseppe Chiari, moved in a direction which was to end in Neo-Classicism, Trevisani was the forerunner of an alternative style which can be called the Roman *rococo*.

BIBLIOGRAPHICAL NOTES

A. Early biographical sources for Roman seventeenth-century painters

BELLORI, GIOVANNI PIETRO

(1) *Le Vite de' Pittori, Scultori et Architetti moderni.* Parte prima. Roma, 1672. (Anastatic reprint, Roma, 1931).

This contains only the biographies of Annibale Carracci, Agostino Carracci, Domenico Fontana, Barocci, Caravaggio, Rubens, Van Dyck, Duquesnoy, Domenichino, Lanfranco, Algardi and Poussin.

(2) *Vite di Guido Reni, Andrea Sacchi e Carlo Maratti.* (From MS 2506 in the Municipal Library, Rouen.) Ed. Michelangelo Piacentini, Roma, 1942 (250 copies).

This contains the text only and the promised accompanying editorial volume has never appeared. The life of Maratti ends at 1695. This was later completed by another hand and published separately in:

(3) *Vita di Carlo Maratti pittore* ... Roma, 1732.

This was also published, after a good deal of second hand material, in an anonymous compilation produced by the bookseller, Fausto Amidei: *Ritratti di alcuni celebri pittori del secolo XVII, disegnati ed intagliati in rame dal Cav. Ottavio Lioni. Con le vite de' medesimi &c.* Roma, 1731.

MANCINI, GIULIO. *Considerazioni sulla Pittura.*

Vol. 1, Roma, 1956, contains an introduction on the various MSS. by Adriana Marucchi; and the text of the *Considerazioni* and the *Viaggio per Roma*.

Vol. 2, Roma, 1957, contains a life of Mancini and a commentary by Luigi Salerno.

Mancini died in 1630. Most of the *Considerazioni* (and most of it is irrelevant) was completed by 1620, but additions relating to living painters were made up to 1624. The *Viaggio per Roma* was written 1623–4 (see below under GUIDES).

PASSERI, GIOVANNI BATTISTA. *Vite de' pittori, scultori et architetti Dall' Anno 1641 sino all' Anno 1673.*

An excerpted text was published by Bianconi in two vols. in 1772. This has been entirely superseded by the full text, collating all MSS, edited with a most valuable commentary by Jacob Hess, and published for the Bibliotheca Hertziana as *Die Künstlerbiographien von Giovanni Battista Passeri*, Leipzig and Vienna, 1934.

PASCOLI, LIONE. *Vite de' Pittori, Scultori, ed Architetti moderni,* 2 vols., Roma, 1730.

An anastatic reprint, provided with a valuable index, was published in Rome, 1933. A later reprint is 1965. Pascoli's work was planned as a continuation of Passeri's. The 1730 edition is occasionally supplemented by his *Vite de' Pittori, Scultori, ed Architetti Perugini,* Roma, 1732; and a somewhat untidy MS. exists, of about 1736, for a further volume (Biblioteca Augusta, Perugia, 1383), of which the fullest account is that given by Eugenio

Battisti in *Commentari*, IV, 1953, 30–45. The only Lives in this which concern the present volume are those of Trevisani, which was fully used by Bodmer in his notice in Thieme-Becker, and F. Rosa

BALDINUCCI, FILIPPO. *Notizie de' Professori del Disegno da Cimabue in qua.* 5 vols., Firenze, 1681–1728 (and various later editions).
The last volume includes Camassei, Testa and Romanelli.

SANDRART, JOACHIM VON. *Academie der Bau- und Mahlerey-Künste von 1675.*
The most convenient edition of this is the reprint, edited by Dr A. R. Peltzer, Munich, 1925.

PIO, NICOLA. *Le Vite de' Ptttori, scultori ed architetti etc.*
A MS. of 1724 in the Vatican Library (Cod. Capponiana 257). Most of the earlier biographies are compilations: some have been published by L. Ozzola in *Archivio della R. Soc. Romana di Storia patria*, XXXI (1908). See also Anthony M. Clark, 'The Portraits of Artists Drawn for Nicola Pio', *Master Drawings*, V, 1967, 3–23.

B. Guide books

The very complex bibliography of the Roman Guide books, together with the early literature on the separate churches, is to be found in:

SCHUDT, LUDWIG. *Le Guide di Roma.* Vienna/Augsburg, 1930.

The few which call for separate notice, partly because annotated editions have been published, are:

MANCINI, GIULIO. *Viaggio per Roma.*
A MS. of 1623–4, first published ed. L. Schudt. Leipzig, 1923; later published with Mancini's *Considerazioni* . . . 1956 (see above).

CELIO, GASPARE. *Memoria delle Nomi dell' Artefici delle Pitture che sono in alcune Chiese, Facciate e Palazzi di Roma.* Napoli, 1638.
A facsimile of this excessively rare book, the first guide book of its kind to concentrate on the names of the artists, with commentary by Emma Zocca, Milano, 1967.

D'ONOFRIO, CESARE. *Roma nel Seicento.* Roma, 1969.
Annotated edition of a previously unpublished guide by Fioravante Martinelli, written *c.* 1660–5. Referred to in the lists as Martinelli.

MOLA, GIOVANNI BATTISTA. *Breve Racconto delle miglior opere d'Architettura, Scultura et Pittura fatte in Roma . . . l'anno 1663.*

A MS. published for the first time with a valuable commentary, by Karl Noehles, Berlin, 1966.

TITI, FILIPPO. *Descrizione delle Pitture, Sculture e Architetture esposte al pubblico in Roma.* Roma, 1763.
All the editions of Titi (the earliest is 1674) are valuable, but the 1763 edition is the latest and fullest of all the early guides to Rome. It has been reprinted anastatically, in two volumes, lately by Olschki, Florence.

CHATTARD, GIOVANNI PIETRO. *Nuova descrizione del Vaticano.* 3 vols., Roma, 1762.
This is the most compendious and completest of the Vatican guides and I have often given references to it.

Of modern guide books to Rome, the first to attempt to describe all the pictures in all the churches, is:
ANGELI, DIEGO. *Le Chiese di Roma.* Roma (1903).
This is a mass of errors, but its intentions were honourable, and I have found it so useful myself at odd points that I must mention it.

BUCHOWIECKI, WALTHER. *Handbuch der Kirchen Roms.*
Vol. 1, Vienna, 1967. The Four Patriarchal Basilicas (S. Giovanni in Laterano; S. Pietro in Vaticano; S. Paolo fuori le Mura; S. Maria Maggiore) and the Churches within the City wall from S. Agata to S. Francesco Saverio.
Vol. 2, Vienna, 1970. Churches within the City wall from Gesù Crocifisso to S. Maria in Monticelli. This attempts completeness and is backed by very high church authorities. Unlike its great exemplar, Paatz on the Churches of Florence, it gives no references. It it not as good as it should be.

A word of praise should also be given to the series *Le Chiese di Roma illustrate,* begun in the 1930's and continuing today. Over a hundred little volumes have been issued, some feeble, but a number very valuable, and some of the feeble ones are being replaced by better ones. These are quoted under single pictures in the catalogues.

The successive editions of the Touring Club Italiano's *Roma e Dintorni* (last revision 1962), although they make no claims to completeness, are valuable works of scholarship.

C. Archival material

A beginning has been made since this book was first published with the exploration and publication of archival sources, but an enormous amount remains to be done. The *Status Animarum* (archives in the Vicariato) have only been carefully explored so far for foreign artists working in Rome; for many parishes there are also necrologies which have hardly been examined at all.

POLLAK, OSCAR

(1) *Die Kunsttätigkeit unter Urban VIII.*
 Vol. 1, Vienna/Augsburg, 1928. Churches (except St Peter's), Palaces etc.
 Vol. 2, St Peter's and the Vatican. Vienna, 1931.
(2) *Italienische Künstlerbriefe aus der Barockzeit.* (Jahrbuch der preuszischen Kunstsammlungen,
 XXXIV, 1913, Beiheft.)

GARMS, JÖRG. *Quellen aus dem Archiv Doria-Pamphilj zur Kunsttätigkeit in Rom unter
 Innocenz X.* Rome–Vienna, 1972.

GOLZIO, VINCENZO. *Documenti artistici sul Seicento nell' Archivio Chigi.* Roma, 1939.
 Contains much that is useful but does not publish the *post mortem* Inventory of Cardinal
 Flavio Chigi, 1693.

ORBAAN, J. A. *Documenti sul Barocco a Roma.* Roma, 1920.
 This publishes some of the *Avvisi* and, in imperfect form (but without saying so), some
 of the Inventories, e.g. Barberini, Massimo, etc.
 Much work is being done on the Barberini Inventories by Mrs Lavin, Mrs Vivian and
 others, but no general publication has so far appeared.

D. General historical works

FORCELLA, VINCENZO. *Iscrizioni delle Chiese e d'altri edificii di Roma.* 14 vols., Roma,
 1869 ff.

PASTOR, LUDWIG, Freiherr von. *Geschichte der Päpste.* Freiburg in Breisgau, 1901 ff.
 (Also in a rather pedestrian but accurate English translation.)
 Much valuable material is published in the chapters on the artistic activities of the various
 Seicento Popes, beginning with Vol. XIII, part 2 (Urban VIII).

GIGLI, GIACINTO. *Diario Romano (1608–1670).* Roma, 1958.

HASKELL, FRANCIS. *Patrons and Painters.* London, 1963.
 The first half of the book is concerned with Rome in the Seicento, and it has an excellent
 bibliography.

MONTALTO, LINA. *Un Mecenate in Roma Barocca (Il Cardinale Benedetto Pamphily).*
 Firenze, 1955.

In this section should also be included:
MISSIRINI, MELCHIORRE. *Memorie per servire alla storia della Romana Accademia di S. Luca.*
 Roma, 1823.

In addition to the bibliography in Haskell mentioned above, there is a valuable bibliography in Hess's edition of Passeri, and there are exhaustive sectional bibliographies in various volumes of von Pastor.

E. Galleries and collections

For the only reasonably full, but uncritical, list of all the pictures possessed, at least in theory, by the Capitoline and the old Corsini Galleries—many of them now scattered through Government offices, provincial galleries and village churches—see:
BARBIER DE MONTAULT, Xavier. *Les Musées et Galeries de Rome*. Rome, 1870.

ACCADEMIA DI S. LUCA.
There are various small check-lists of the pictures, but the first partial attempts at scholarly listing of small parts of the collection have been in the catalogues of recent summer exhibitions:
(1) Italo Faldi. *Mostra di Antichi Dipinti restaurati delle Raccolte Accademiche*. 1968.
(2) Giovanni Incisa della Rocchetta. *Mostra di Ritratti di Accademici del Settecento e dell' Ottocento*. 1970.

BARBERINI, see GALLERIA NAZIONALE.

BORGHESE. Paola dell Pergola, *Galleria Borghese. I Dipinti*. vol. 1, 1955; vol. 2, 1959.
A full catalogue, based on all the Inventories: the pictures of the Roman school are catalogued in vol. 2. The Aldobrandini Inventory of 1626 is published in *Arte Antica e Moderna*. 1960, 425 ff. Other Aldobrandini and Borghese inventories are published in later numbers of the same periodical and in *Palatino*.

CASSA DEPOSITI E PRESTITI. Italo Faldi. *La Quadreria della Cassa Depositi e Prestiti*. Roma, 1956.
This is the sad relic of the Monte di Pietà gallery, parts of which had found their way to the Galleria Nazionale.

COLONNA. Guido Corti. *Galleria Colonna*. Catalogo, 1937.
Reprinted without change 1970. This gives references to the early inventories and is of real value; but it only catalogues the pictures in the Galleria, which is (occasionally) open to the public. The Colonna holdings of pictures in the rest of the Palace are considerable, but no printed catalogue has appeared since 1783.

CORSINI, see GALLERIA NAZIONALE.

DORIA. Ettore Sestieri. *Catalogo della Galleria ex-fidecommissaria Doria-Pamphily*. Roma, 1942.

This at least gives sizes, bibliographies and so on; but it makes no use of the early inventories, which exist in considerable abundance, and it does not mention the pictures which did not form part of the original trust.

GALLERIA NAZIONALE.

This is now divided up into three sections, in the Palazzo Barberini, the Palazzo Corsini and the Palazzo Venezia. At the moment the Roman Seicento pictures are concentrated in the Corsini (many of them in the Rooms of the Accademia dei Lincei). The early Corsini inventories still exist in possession of the family in Florence but have never been made accessible.

Only a few of the Baroque pictures have been seriously catalogued, and that for temporary exhibitions:

Caravaggio e i Caravaggisti. 1955.
Paesisti e Vedutisti a Roma nel '600 e nel '700. 1956.
Pittori Napoletani del '600 e del '700. 1958.

PALLAVICINI. Federico Zeri. *La Galleria Pallavicini in Roma.* Florence, 1959.

This catalogues and illustrates all the pictures in this not very accessible collection. It also publishes the 1679 Pallavicini inventory and the 1713 Rospigliosi inventory—which includes most of the pictures which survive in the Palace from the Rospigliosi collection.

MUSEO DI ROMA (Palazzo Braschi).

Its holdings are considerable but uncatalogued.

SPADA.

Federico Zeri. *La Galleria Spada in Roma.* Firenze, 1954. This publishes the early Spada inventories.

Porcella, A. *Le Pitture della Galleria Spada.* Roma (1932). This is a curiosity.

F. Recent 'coffee-table books'

These are in part, sometimes entirely, works of scholarship, but they are cumbersome and maddening and some are only available with considerable difficulty as they are 'Bank editions' and have not been put on the market.

LAVAGNINO, Emilio, ANSALDI, Giulio R., and SALERNO, Luigi. *Altari Barocchi in Roma.* Banco di Roma, 1959.

LUGLI, Giuseppe, SALERNO, Luigi, ZOCCA, Mario and others. *Via del Corso.* Cassa di Risparmio di Roma, 1961.

SALERNO, Luigi, *Piazza di Spagna.* Cava dei Tirreni, 1967.

PIETRANGELI, Carlo and RAVAGLIOLI, Armando. *Palazzo Braschi e il suo Ambiente*. Capitolium, Roma, 1967.

SALERNO, Luigi, DE CAMPOS, Deoclecio Redig and others. *Piazza Navona, Isola dei Pamphily*. Roma, 1970.

SALERNO, Luigi, SPEZZAFERRO, Luigi, and TAFURI, Manfredo. *Via Giulia*. Roma, 1973.

G. Modern literature on Roman Baroque Painting.

The two books, which are the foundations of later studies are:
VOSS, Hermann. *Die Malerei des Barock in Rom*. Berlin, 1924.
MALE, Emile. *L'Art religieux après le Concile de Trente*. Paris, 1932.

The subject is also treated at a certain length in the following:

DE RINALDIS, Aldo. *L'Arte in Roma dal Seicento al Novecento*. Roma, 1948.

GOLZIO, Vincenzo. *Seicento e Settecento*. Second edition, 2 vols. Torino, 1960 (with good bibliography).

WITTKOWER, Rudolf. *Art and Architecture in Italy 1600 to 1750*. Second edition. Penguin Books, 1965 (with very full bibliography).

and certain modifications of views put forward in the introduction to the present book will be found in:
WATERHOUSE, Ellis. *Italian Baroque Painting*. Second edition. Phaidon, 1969.

Monographs, or near-monographs, on single artists will be found in the lists. In 1937 I could only list one: there are now valuable works on Baciccio, Camassei, G. Chiari, Cortese, Mola, Pietro da Cortona, Pozzo, Maratti and Sacchi, and others are in the press for Lanfranco and Sacchi. Most of the articles in Thieme-Becker are too slight or too inaccurate to be of use, but the valuable ones are mentioned under the individual artists.
Finally, the great repository of bibliographical material from before the present century is:
SCHLOSSER MAGNINO, Julius. *La Letteratura Artistica* (translated). Second edition with additions by Otto Kurz. Florence/Vienna, 1956.

NOTE TO THE LISTS

In the following lists I have only included those painters who executed commissions of some importance for the decoration of churches or palaces in Rome. Painters whose work was more domestic, most of them foreigners to Rome, such as Claude and Cerquozzi, are not included, and for this reason I have also omitted the easel pictures of Gaspard Dughet and Filippo Lauri. Most of the painters fall into the category to which the lists of the first edition were limited, that they worked after the accession of Urban VIII in 1623 and were born before 1660. But I have added lists of a few younger painters (or, in some cases, bibliographical notes) to include all the immediate heirs of Maratti and most of those painters who received important commissions in the reign of Clement XI. I have only left out one painter, Lanfranco—the only direct pupil of the Carracci who was included in the 1937 book—because so much work on him is being done, or in the press, that my list would have been obsolete by the time it appeared.

My intention has been to collect into conveniently accessible form the useful and certain information about what still survives today of the painting of this period in the region for which it was painted. This is the area now known as Lazio, parts of which are still somewhat underexplored. I have only occasionally listed anything outside the frontiers of Lazio, and I have normally tried to include in the lists only those works whose attribution is either documented or attested by some early evidence. Very occasionally I have given way to the temptation of including an attribution of my own or of a valued colleague, but I have always indicated that it is only an attribution. If anything I have been a little more severe in this matter than I was in 1937, since attributions to these painters are made a good deal more recklessly today than they were forty years ago! The scholarship of these intervening years has added a great deal to the documentation and close dating of many works and I have tried to incorporate as much of this as possible. A certain number of blunders have been silently corrected, but the works it has been possible to add to the lists have been rather fewer than one would have expected. This revision has had to be done on occasional short visits and has not had the benefit the first edition had of constant residence in Rome: but I have tried to check where each painting is to be found today in each church, and a number of small iconographical changes will also be noted. As I said in 1937, no doubt much of interest remains to be found in the corridors and parlours within the Clausura of Convents.

I have tried to be pedantic in giving the subjects even of pictures covered with impenetrable grime. I have also referred to inscriptions with dates in the chapels

47

which contain pictures, even though these may sometime be misleading, since often they are the only evidence at present available. In a number of instances I have given the negative number of the GFN (Gabinetto Fotografico Nazionale), especially when no printed catalogue is available, and also of the Archivio Fotografico Vaticano (AFV). An enormously greater number of photographs is available today than in 1937, but public collections in England are not well provided with prints for this period.

When a painting or fresco does not appear in the 1674 edition of Titi's *Studio di pittura, scoltura, et architettura, nelle Chiese di Roma*, I have assumed that it was not yet painted. 'Before 1674' in these lists means that the painting is first mentioned in that book: in the same way 'before 1686' means that a painting is first mentioned in the 1686 edition of the same work, which is entitled *Ammaestramento utile e curioso di pittura etc.*

GUIDUBALDO ABBATINI (c. 1600/5–1656)

A native of Città di Castello, nothing is known of his earlier work when a pupil of Cesare d'Arpino. He became mainly an efficient and willing vehicle for Bernini's decorative ideas in fresco, as well as a general 'handy-man' for cleaning, colouring, marbling, gilding and painting topographical views, devotional pieces or architectural layouts. He did a good deal of miscellaneous decorative work and restoration in S. Peter's (O. Pollak, Urban VIII, II, 523–8, 615–16). He had little artistic personality, but much decorative ability, and Bernini discouraged any signs of independence.

Bibl.: Passeri.

Rome. GALLERIA NAZIONALE (Barberini). *Urban VIII.* (GFN, E, 34049.) Signed: *Guido Abbatino.* Formerly exhibited in the Galleria Spada. Based on a painted head, probably by Bernini (V. Martinelli, *Commentari* IX, 1958, 99 ff., where a similar portrait of *Innocent X* is also published).

S. AGOSTINO. 2 to L: Mixed fresco and stucco in vault: *Adoring Angels.* A good deal damaged. The Cappella Pio was planned by Bernini and built and decorated soon after 1643.

S. MARIA DELLA VITTORIA. L. Transept: mixed fresco and stucco on arch: *Angels adoring the Holy Spirit.* c. 1647.

S. PIETRO IN MONTORIO. 2 to L (Raymondi chapel): Decorative ceiling frescoes round Romanelli's central 'S. Francis'. Green and gold grisailles of *Allegorical figures* and *Scenes from the life of S. Francis.* Probably about 1642–4.

S. SPIRITO IN SASSIA. Sacristy: frescoes in grisaille on ceiling and side walls. On ceiling: *Angels adoring the Holy Spirit* (much redone). Around this and on side walls: *Scenes from the early history of S. Spirito.* [Plate 1.]
The sacristy was decorated for the Anno Santo of 1650 (Forcella VI, no. 1274). The historical scenes (of which only one is seriously effaced) are identified by inscriptions (Forcella VI, nos. 1275–88).

Vatican. SALA DI CARLO MAGNO. Most of the frescoes of the original decoration which have survived the 1768 restoration. Two of the big frescoes on the side walls: *Charlemagne confirms the possessions of the Church*; *Charlemagne receives the keys of S. Peter's tomb.* Above these, a frieze in twelve compartments of *Scenes from the life of Charlemagne.* 1635–7. For the documents see Pollak, I, 389. (AFV, XV, 8, 12–22.)

SALA DELLA CONTESSA MATILDA. The general decorative painted scheme round Romanelli's subject frescoes (*i.e.* frames, Arms, Herms, etc.): probably the execution of *Countess Matilda introduced to S. Anselm* (on Romanelli's design. AFV, VI, 33, 3). 1637–42. J. Hess, *Kunstgeschichtliche Studien*, 1967, I, 105 ff.

ONOFRIO AVELLINO (1674(?)–1741)

*A Neapolitan and pupil first of Luca Giordano and then of Solimena, both of whose works
he is said to have copied with ability. He settled in Rome well before 1720 and remained
there until his death. He is reputed to have had a good business as a portrait painter.*

Bibl.: Mattia Loret in *Capitolium*, Nov. 1934, 547–9; bibliography in *Dizionario
biografico degli Italiani*, IV (1962), 655.

Rome. S. FRANCESCO DE PAOLA. 1 to R: Fresco oval on ceiling: *S. Anne in glory.*
(GFN, C, 6246.) *c.* 1730–5.

 S. LORENZO IN LUCINA. Sala Capitolare. *Madonna enthroned with SS. John Nepomuk
and Michael.* Probably Avellino's earliest work in Rome and still strongly
reminiscent of Solimena.

 S. MARIA DELLE FORNACI. 2 to R: *The Trinity adored by SS. Felice de Valois and
Giovanni de Matha.* The altar was consecrated in 1737 (A. Federico Caiola,
S. Maria delle Grazie alle Fornaci, 1970, 58).

 S. MARIA DELLA LUCE. East wall to L of High altar: *S. Francesco de Paola.* The church
was redecorated about 1729. See *Mostra dei Restauri*, 1969, fig. 42. The attribution
was on the old frame.

BACICCIO (1639–1709)

*Giovanni Battista Gaulli, nicknamed Baciccio, was born in Genoa, where he seems to have
got his training before settling in Rome about 1657. Accademico di S. Luca in 1662, and
well-known as a portrait painter from the beginning, he was first patronized by the Chigi and
fell under the spell of Bernini about 1666. Encouraged by Bernini he visited Parma to study
Correggio in 1669 and became the most spectacular Roman decorator of the second half of the
century. Bernini was his constant mentor during his most productive years: after Bernini's
death in 1680, Baciccio modified his style towards the prevailing classicism of Maratti.*

Bibl.: Pascoli; Soprani-Ratti; Robert Enggass, *The Painting of Baciccio*, 1964, has full
catalogue, with bibliographical references, so that I have cut my references down
to a minimum; Catalogue of the Baciccio Exhibition, Oberlin, 1967; Hugh
Macandrew on Baciccio Drawings in *Master Drawings*, 1972 (vol. 10).

Ariccia. PALAZZO CHIGI. *The Blessed Giovanni Chigi.* 1671–2.
 Portrait of D. Mario Chigi. c. 1666–7.
Lanuvio. COLLEGIATA. 3 to L: *The Virgin fainting into S. John's arms, and the Magdalen*
as painted background to a wooden Crucifix. Studio work; *c.* 1675.
Rome. ACCADEMIA DI S. LUCA. *Concert of Angels.* Study for fresco in the Gesù.
 Birth of S. John Baptist. Variant study for picture in S. Maria in Campitelli.

Rest on the Flight. Study for Corsini picture.

Portrait of Clement IX. 1667–9.

CAPITOLINE. *Putto with Emblem of Giulio Gaulli.* 1686.

GALLERIA NAZIONALE (CORSINI). *Rest on the Flight. c.* 1669.

S. Ignatius in Glory. Study for Gesù fresco.

Prudence and Temperance; *Faith and Charity.* Studies for two of the S. Agnese pendentives.

Portrait of Clement IX. 1667–9.

Portrait of Bernini. Probably not *the* original of this design: for Baciccio's portraits of Bernini see Andrea Busiri-Vici, *Palatino*, 1967, 282–7.

Pietà. 1667. (GFN, E, 60538.) [Plate 3.] Acquired from the Incisa della Rocchetta collection in 1966.

MUSEO DI ROMA. *Portrait of Cardinal G. F. Ginnetti.*

SPADA. *Christ and the Samaritan.*

Triumph of the name of Jesus. Study for Gesù fresco.

S. AGNESE A PIAZZA NAVONA. Frescoes in pendentives of the dome: *Justice, Peace and Truth*; *Chastity*; *Faith and Charity*; *Temperance and Prudence.* 1668–72.

S. ANDREA AL QUIRINALE. 2 to R. Altar: *Death of S. Francis Xavier.* 1676; L. wall: *S. Francis Xavier baptizing.* 1705–9; R. wall: *S. Francis Xavier preaching,* 1705–9. [Plate 2.]

SS. APOSTOLI. Fresco on ceiling of nave: *Christ in glory receiving the Saints of the Franciscan Order.* 1707.

S. FRANCESCO A RIPA. 4 to L: *Virgin and Child with S. Anne.* Between 1674 and 1686. A good replica is in the Collegiata of Grotte di Castro.

GESÙ. Frescoes on ceiling of the nave: *Triumph of the Name of Jesus.* 1676–9 [Plate 4]; in the dome: *Glory of Heaven.* 1672–5; in the pendentives: *Evangelists, Fathers of the Church, Prophets and Lawgivers.* 1675–6; on the vault above the high altar: *Concert of Angels. c.* 1683; on the vault of the L. transept: *S. Ignatius in glory.* 1685. Galleria dei Marmi. *Modello* for apse fresco.

S. MARGHERITA IN TRASTEVERE. Altar to L: *Immaculate Conception with SS. Francis and Clare.* Early 1680's.

S. MARIA IN CAMPITELLI. L. wall, below the dome: *Birth of S. John Baptist. c.* 1698.

S. MARIA MADDALENA. 3 to L: *The Virgin presents S. Nicholas of Bari to Christ. c.* 1687–8.

S. MARIA SOPRA MINERVA. 2 to R: *S. Luis Beltran in ecstasy.* 1671–2.

Second chapel to R. of high altar. Frescoed lunette above the altar: *Trinity in Glory.* 1671–2.

S. MARIA DI MONTESANTO. Sacristy of 3 to L: frescoes on ceiling: *Holy Spirit and Cherubs with Instruments of the Passion*; fresco on wall: *S. James.* 1691–2.

S. MARTA AL COLLEGIO ROMANO. Fresco on pediment of façade: *God the Father. c.* 1672. Ruined.

Frescoes on the vault: *S. Martha in Glory* and *Four* (of the twelve) *figures of Virtues. c.* 1672.

The other two tondi and eight Virtues are by Paolo Albertoni and Girolamo Troppa.

S. NICOLA DA TOLENTINO. R. Transept: *S. John in the desert pointing to Christ. c. 1670.*

S. ROCCO. Altar in sacristy: *Virgin and Child with SS. Roch and Anthony Abbot. c. 1663–6.*

PALAZZO CHIGI. Salone d'Oro ceiling: *Diana and Endymion.* 1668.

COLLEGIO NAZARENO. *Putto with Emblem of Ludovico Gaulli.* 1695.

DIREZIONE GENERALE DEL FONDO PER IL CULTO. *Prudence and Temperance.* Study for pendentive in S. Agnese.

CONTE ANDREA BUSIRI-VICI. Two studies of *Apostles baptizing.*
 Portrait of Bernini (Palatino, 1967, 282 ff.).

MARCHESE ENRICO INCISA DELLA ROCCHETTA. *Portrait of Pope Innocent X.* 1671.

Vatican. PINACOTECA. *Concert of Angels.* Study for the fresco in the Gesù.

LAZZARO BALDI (*c.* 1623/4–1703)

A native of Pistoja and one of the first generation of Pietro da Cortona's pupils. His public work begins in the middle 1650's: Accademico di S. Luca, 1654; Principe of the Academy of S. Luke 1675. His manner altered little throughout a long and prosperous career, filled with distinguished, but never very important, commissions.

Bibl.: Pascoli; Pio; F. Tolomei, *Guida di Pistoja,* 1821, 152–3.

Bassano di Sutri. PALAZZO ODESCALCHI. *S. Antony of Padua's vision of the child Christ, with the Virgin.* (GFN, E, 38367.)

Rome. ACCADEMIA DI S. LUCA. Inv. 34. *Christ crowning S. Lazarus.* Inv. 150. *Saints in glory.* Probably studies for frescoes planned for the chapel in SS. Luca e Martina (*q.v.*).

CASSA DEPOSITI E PRESTITI. 31. *Joseph recounting his dream to his brothers.* (GFN, E, 36980.)

SPADA. 17. *Apollo and the Muses on Parnassus.*
 23. *A poet welcomed by Apollo to Parnassus.*
 37. *S. Giovanni di Dio succouring the sick in hospital.*
 42. *S. Gaetano Thiene* (?) *writing his rule.*
 370. *Solomon adoring idols.*

S. ANASTASIA. Behind high altar: *Adoration of Shepherds.* (GFN, E, 36147.)
 Frescoes on ceiling of tribune: *S. Anastasia in glory; Angel musicians. c.* 1674(?).
 L. transept altar: *Madonna del Rosario with SS. Catherine of Siena and Peter Martyr.* 1674–86.
 Chapel at end of R. aisle: L. wall: *S. Charles Borromeo giving alms; S. Charles administering confirmation.* R. wall: *Vision of S. Filippo Neri; S. Filippo fainting.* The chapel dates 1679 (Forcella, X, no. 79).

S. ANDREA DELLE FRATTE. Centre picture behind the high altar: *Martyrdom of S. Andrew.* (GFN, E, 20438.)

ORATORIO DEL CARAVITA. Frescoes on ceiling and in lunettes of porch: *Adoration of the Sacrament; Virtues; Scenes from the life of S. Francis Xavier.* Before 1674. Restored almost out of recognition.

S. CROCE DEI LUCCHESI. 1 to R: *S. Zita, giving water to a beggar, changes it into wine.* *c.* 1695. For the date, see Forcella, VII, no. 308.

GESÙ. Antesacristy. *Jesuit missionaries to Brazil martyred by pirates.* Modello for an altarpiece.

GESÙ E MARIA. Coro: *The Madonna dividing her girdle between S. Augustine and S. Monica in the presence of two male and two female Augustinian Saints.* See *Mostra di Opere d'Arte restaurate nel 1967*, Rome, April 1968, no. 12.

S. GIOVANNI IN LATERANO. 4 to R: fresco: *Vision of S. John on Patmos. c.* 1660–5.

S. GIOVANNI IN OLEO. Frescoes of scenes from the life of S. John: *S. John arrested; boiled in oil; drinking from a poisoned cup; dragged to martyrdom; Vision on Patmos.* *c.* 1658 (Forcella, XI, no. 303).

SS. LUCA E MARTINA. Altar to R: *Martyrdom of S. Lazarus.* 1681. (GFN, E, 67078.) Put up by Baldi himself to his name-saint; see Forcella VII, no. 846.

S. MARCELLO. 1 to R: *Annunciation.* 1674–86.

S. MARCO. 3 to L: R. wall: fresco: *S. Francis. c.* 1653–6. Most of it has disappeared from damp.

S. MARIA IN CAMPO MARZIO. L. transept: L. wall: *S. Benedict writing his rule;* centre, *S. Benedict watching S. Scholastica rapt to heaven;* R. wall: *Virgin and Child with an angel, S. Scholastica and another nun.* A 'modello' for the centre picture is reproduced in Voss, 277. This was commissioned from Baldi *c.* 1685; the two others were done a little later (cf. Additions to 1686 Titi, p. 434).

S. MARIA SOPRA MINERVA. (2) 3 to R: altar: *S. Rose of Lima holding Child Christ and adored by aborigines;* to L: *The Virgin, appearing to S. Rose in sleep, finds her saying her rosary;* to R: *S. Rose destroys heathen idols.* Frescoes (repainted) on ceilings: *S. Rose crowned by the Virgin* [Plate 6] and four *Figures of Virtues* in the pendentives. About 1671 (date of S. Rose's canonization): see Forcella, I, no. 1934. (GFN, E, 54099: 54236–7.)

S. MARIA DEL PIANTO. Altar to R: *Virgin and Child with SS. Antony of Padua, Francis and Francesca Romana.* Before 1674.

S. MARIA IN VALLICELLA. Two oval canvases over the choir balconies on the side walls of the tribune: to L: *Creation of the Angels;* to R: *Fall of the Angels.* Part of the decoration for the Anno Santo of 1700.

PROPAGANDA FIDE (I Re Magi). Canvas above the arch of the high altar: *Christ's charge to S. Peter.* Before 1674.

S. PUDENZIANA. 2 to R: L. wall: *Adoration of Shepherds* and lunette (? *Evangelists*). R. wall: *Adoration of Kings* and lunette (? *Evangelists*). Ceiling: *Virgin in glory.* Outer arch: *Annunciata* (L), *Gabriel* (R), and *Holy Ghost.* Datable 1690 (see Forcella, XI, no. 273).

S. SILVESTRO AL QUIRINALE. L. wall before the high altar: *S. Gaetano Thiene's Vision of the Madonna.* (GFN, E, 20269.)

SS. SUDARIO. Sacristy: *Nativity*; *Circumcision.* Published by A. Prampolini, *Bollettino d'Arte*, LIII (1968), 32 ff., as *c.* 1690: together with four other pictures formerly in the same church (*Agony in the Garden*; *Flagellation*; *Christ crowned with thorns*; *Christ falling under the Cross*), which are now, in a battered condition, in the Caserma dei Corazzieri al Quirinale.

PALAZZO DEL QUIRINALE. Galleria di Alessandro VII: three frescoes: *Creation of Adam and Eve* (oval: landscape by Gaspard Dughet) [Plate 5]; *Flood*; *Annunciation* (oval). 1657. See Norbert Wibiral, *Bollettino d'Arte*, 1960, 123 ff.

PALAZZO PALLAVICINI-ROSPIGLIOSI. Federconsorzi: *S. Luis Beltran converting a Peruvian prince* (GFN, E, 32306). The Saint was canonized in 1671.

Segni. CATTEDRALE. Sacristy: *Madonna and Child with a kneeling Pope and S. Bruno, Bishop of Segni.* Originally on the altar of 1 to R. The battered frescoes relating to the life of S. Bruno in 1 to R are less certainly by Baldi himself.

PIETRO PAOLO BALDINI

There appears to be a confusion between a Pietro Paolo Baldini (so-called) and a Pietro Paolo Naldini. For the Baldini who was a pupil of Pietro da Cortona see UBALDINI.

GIOVANNI BATTISTA BEINASCHI (1636?–88)

Also spelled 'Benaschi' etc. Born at Fossano (Piedmont) and at first trained locally and then under Pietro del Po in Rome. Recorded in Rome by 1660; he may have associated with Giacinto Brandi and certainly developed a great passion for the imitation of Lanfranco, whose drawings he imitated (W. Vitzthum and J. Bean, Bollettino d'Arte, XLVI (1961), 106 ff.). He may have made a first visit to Naples 1672–3 (nave ceiling of S. Maria degli Angeli) and finally settled there about 1679, where his frescoes in SS. Apostoli (1680) and S. Maria delle Grazie a Caponapoli form a link between Lanfranco and Giordano. He was a 'cavaliere' by 1678.

Bibl.: Pascoli and de Dominici (both in different ways unreliable); *Schede Vesme*, I, 1967, 109 f.

Rieti. MUSEO CIVICO. 30. *S. Gregory in glory.* (GFN, E, 46404.)

Rome. S. BONAVENTURA SUL PALATINO. 1 to L: *S. Michael overcoming Lucifer.* (GFN, E, 33430.) [Plate 7.] A *modello* was with the Hazlitt Gallery, London, in 1971. 2 to L: *Annunciation.* 1 to R: *Christ on the Cross between the Madonna and S. John.* All three probably date from soon after the Church was founded in 1675.

S. CARLO AL CORSO. Fresco on vault of 3rd bay of S. aisle: *Religion, Fortitude,*

Purity and Chastity. 1678. See G. Drago and L. Salerno, *SS. Ambrogio e Carlo al Corso*, 1967, 104.

s. MARIA DEL SUFFRAGIO. High altar: fresco *Assumption* above Ghezzi's altarpiece and fresco of *God and Angels* on ceiling. Probably 1675. Repr. L. Salerno etc., *Via Giulia*, 1973, fig. 244.

s. MARIA DEL SUFFRAGIO. ORATORY (disused). *Raising of Lazarus* and *Daniel in the lion's den.* Formerly on the side walls of the chapel of the high altar. Probably about 1675. They survive in the disused oratory (Matizia Maroni Lombardo and Antonio Martini, *Le Confraternite romane nelle loro Chiese*, 1963, 298). Repr. in L. Salerno etc., *Via Giulia*, 1973, figs. 79 and 246.

NICCOLÒ BERRETTONI (1637–1682)

The best of the first generation of Maratti's pupils, though he was a formed artist before he entered Maratti's studio, he is a painter of considerable sensibility and seriousness. He worked chiefly for private patrons and his few public commissions only begin about 1675, when he became an Accademico di S. Luca.

Bibl.: Pascoli; Anthony M. Clark, *The Connoisseur*, CXLVIII (Nov. 1961), 191–3.

Frascati. SCOLOPI. Convent. *Sposalizio. c.* 1675. [Plate 8.] Transferred in recent years from the high altar of S. Lorenzo in Piscibus, Rome, which is destined to be demolished. For the date see Forcella, x, no. 309.

VILLA FALCONIERI. Salone: what is left of the frescoes. *Homage to Venus* in the centre of the ceiling; two lunettes on the side walls, *Groups of men and women of the Falconieri family.* Probably late 1670's. Not much of the ceiling fresco (Voss, p. 347) survived the last war, and it and the rest of the room had been thoroughly restored in 1850 and 1910. In recent years ascribed to Maratti, but see A. M. Clark, *op. cit.*, 193.

Rome. S. MARIA DI MONTESANTO. 3 to R: Altar-piece, *Holy Family with S. Anne.* Oval fresco on ceiling: *God in Glory*; in the angles, *Putti with scrolls.* Fresco lunettes on the side walls: to L: *Meeting of Joachim and Anna*; to R: *Angel appears to Joachim.* 1679–82. Forcella, IX, no. 392, gives 1679 as the date of the chapel, and the 1686 Titi says that death prevented Berrettoni from finishing it.

PALAZZO ALTIERI. Salone Rosso: frescoes on ceiling. In centre *An Allegory of Passionate Love* in a setting of elegant grisailles; lunettes in centres of two sides, *Venus and Cupid* and *A Nymph with amorini and a ram.* The payments are 1675 (A. Schiavo, *Palazzo Altieri*, 1964, 105).

For the correct identification of the Berrettoni room (which I previously confused with a room frescoed by Canuti) see A. M. Clark, *op. cit.* Maratti may have had some general responsibility for the decorative layout: see F. Dowley, *Master Drawings*, IV (1966), 422 ff.

ANTON ANGELO BONIFAZI (fl. *c.* 1670) and
GIOVANNI FRANCESCO BONIFAZI (fl. *c.* 1680)

*Two brothers, natives of Viterbo, and both pupils of Pietro da Cortona or of Ciro Ferri.
Giovanni Francesco is distinctly inferior and I only list those pictures, identified by Faldi,
which can plausibly be attributed to Anton Angelo.*

Bibl.: Italo Faldi, *Pittori Viterbesi di Cinque Secoli*, 1970, 60 ff. and figs. 228 ff. and 335
(with complete bibliography).

Bomarzo. PALAZZO BARONALE. Frescoes in Salone (Faldi figs. 233–6).
Viterbo. MUSEO CIVICO. (9). *S. Leonardo surrounded by prisoners.* (GFN, E, 36130.)
On the back: *S. Leonardo in glory.* (GFN, E, 29212.)
 SS. FAUSTINO E GIOVITA. *Decollation of Baptist.* (Faldi, fig. 335.)
 PALAZZO ARCIVESCOVILE. *Madonna and Child with SS. Tommaso of Villanova and
William of Aquitaine.* Correctly identified by Faldi with a picture formerly in
S. Agostino, Viterbo, as jointly by Ciro Ferri and Bonifazi. The two hands are
even more clearly to be distinguished in the *modello* sold from Lord Methuen's
collection at Corsham in 1965 and last at Anon. sale, Sotheby's, 6 Dec. 1972
(82). The *S. William* is by Bonifazi (Faldi, figs. 230–1).
Calling of S. Matthew (Faldi, fig. 232).

GIOVANNI VENTURA BORGHESI (1640–1708)

*A native of Città di Castello, he became one of the last pupils of Pietro da Cortona, but
worked little in Rome, being summoned to Vienna soon after 1676 by the Empress Eleanor.
He worked for some time in Prague, but, after a brief return to Rome, settled in 1685 for the
rest of his life at Città di Castello.*

Bibl.: Giacomo Mancini, *Memorie di alcuni artefici del disegno ... in Città di Castello*,
vol. 2, Perugia, 1832, 197–208.

Rome. CAPITOLINE (Vestibule). *Martyrdom of S. Faustian.* Dated 1673.
 S. IVONE ALLA SAPIENZA. High altar: *S. Ivo besought by the poor to advocate their cause.*
Commissioned from Pietro da Cortona, who had finished only the top part at
the time of his death in 1669. It was completed by Borghesi after 1674; the altar
bears the arms of Innocent XI (1676–89).
 S. NICOLA DA TOLENTINO. l to R: side walls: to L: *Christ crowning the Virgin*; to R.
Birth of the Virgin. Soon after 1670.
 COLLEGIO DI PROPAGANDA FIDE. Chapel on first floor: a few battered *Putti* are all
that survives from a fresco of (probably) the Assumption. Executed after his
return from Prague and shortly before 1685. For painting the whole Chapel
Borghesi was made a Cavaliere by Innocent XI.

GIACINTO BRANDI (1621–1691)

From a family from Poli, but perhaps born in Rome: he is reputed to have been a pupil of Lanfranco, and was in Naples for some months 1638–9. He was a prolific painter of frescoes, altarpieces and mythologies, and is criticized by Pascoli for his often hasty execution. At his best he has a powerful and dramatic style and is fond of a beady eye with a pronounced white high-light. Principe of Accademia di S. Luca 1669–70.

Bibl.: Pascoli; de Dominici; Antonella Pampalone in *Dizionario biografico degli Italiani*, and *Commentari*, 1970, 306–15; Gabriele Borghini, *Commentari*, 1972, 385–93.

Ariccia. PALAZZO CHIGI. *Autumn.* 1659. (GFN. E. 27494.) In collaboration with Mario de' Fiori, who painted the fruit and flowers also in companion pictures by Maratti, Mei and Morandi (V. Golzio, *Documenti artistici . . . nell' Archivio Chigi*, 1939, 280).

Gaeta. DUOMO. Crypt: altar: *Martyrdom of S. Erasmus.* 1666.
 Frescoes on ceiling of crypt: *God and Cherubim*; *S. Erasmus in Glory* [Plate 10]; *Five Bishops and two female Martyrs*; *Putti* and *Ten figures of Virtues* on the triangles at the sides of the ceiling. 1663–6. The first two were largely destroyed by bombs. For the date, see D. Monetti, *Cenni storici sull' antica Gaeta*, 1869, 63; *Bollettino d'Arte*, x (1916), 170.

 SS. ANNUNZIATA. 2 to R: *Madonna and Child*. Probably painted during Brandi's stay at Gaeta 1663–6 (L. Salerno, *Il Museo Diocesano di Gaeta*, 1956, 34 and pl.).

Monteporzio Catone. S. GREGORIO. High altar: *S. Gregory in ecstasy before a picture of the Madonna*. The church was built and furnished 1666 ff.

Palombara Sabina. S. PIETRO. *S. Peter penitent*.

Poli. S. PIETRO. 3 to L: *SS. Hyacinth and Roch*. Almost completely repainted when the *Madonna del Carmelo* was added in 1677 (G. Cascioli, *Memorie storiche di Poli*, 1896, 243 ff.).

Rome. GALLERIA NAZIONALE (Corsini). (835) *David victorious after his fight with Goliath*.
 (534) *Drunkenness of Noah*. (Brogi 17143.)
 (2365) *Lot and his daughters*. (GFN, E, 44920.) Probably an early work.

 DORIA. 45 (195) *Hermit in penitence*.

 S. AGOSTINO. 5 to L: *S. John of Sahagun rescues a drowning child*. 3 to R: *S. Rita in ecstasy*. Both are in the 1674 Titi.

 S. ANDREA AL QUIRINALE. 3 to R: altar: *Pietà* [Plate 13]; L. wall: *Christ and S. Veronica*; R. wall: *Flagellation* [Plate 12]. Painted 1675 to 1682; see Francis Haskell, *Patrons and Painters*, 1963, 386–7.

 S. CARLO AI CATINARI. 2 to R: *Martyrdom of S. Blaise*. Commissioned by 1674 but painted later (GFN, D, 1843).

S. CARLO AL CORSO. Frescoes: on ceiling of nave: *Fall of the rebel angels*; above high altar: *S. Charles Borromeo in glory*; in vault of apse: *S. Charles among the plague-stricken*; on the ceiling of each transept arch: *Four Saints in glory*; in the pendentives of the cupola: *Jonah, Jeremiah, Daniel and Hosea*. 1671–9. For the dates see G. Drago-L. Salerno, *SS. Ambrogio e Carlo al Corso*, 1967, 63 ff.

S. FRANCESCA ROMANA. Sacristy. *Trinity with the dead Christ mourned by B. Bernardo Tolomei*. (GFN, E, 20175.)

(It is possible that the paintings on the side walls (GFN, E, 20179 and 20181) of 1 to R. may also be by Brandi.)

GESÙ E MARIA. Frescoes: ceiling of nave: *God receiving the Virgin into Heaven*; at either end: *Adoring figures from Old and New Testaments*; sides: *The Four Evangelists*. 1686–7.

High altar: *Coronation of the Virgin*. 1675–86.

2 to L: *Virgin and Child with S. Joseph*. Already recorded by G. B. Mola in 1663.

S. MARGHERITA IN TRASTEVERE. High altar: *Vision of S. Margaret in prison*. (GFN, E, 33428.) After 1686.

S. MARIA IN TRASTEVERE. Room behind sacristy: *Martyrdom of S. Frederic*. See *Commentari*, 1972, p. 391 (rep.).

S. MARIA IN VIA LATA. 1 to R: *S. Andrew adoring his Cross*. 1685. (GFN, E, 21482.) L. Cavazzi, *La Diaconia di S. Maria in Via Lata*, 1908, 138.

S. ROCCO. High altar: *S. Roch received into Heaven*. Before 1674. (GFN, E, 46972.) [Plate 9.] Now replaced on the high altar: for many years in a room behind the sacristy.

SCOLOPI (Parioli district). *Martyrdom of S. Lawrence*. 1674–86. Transferred (it is reported) from S. Lorenzo in Piscibus (altar to R. of high altar).

S. SILVESTRO IN CAPITE. Frescoes on ceiling of nave: *Assumption with SS. John Baptist, Silvester and other Saints, and Angels*. 1680–3. (GFN, E, 50055.) See J. S. Gaynor-I. Toesca, *S. Silvestro in Capite*, 1963, 81.

STIMMATE DI S. FRANCESCO. 1 to L: *The Forty Martyrs*. Already recorded by G. B. Mola in 1663. (GFN, E, 21478.) For a *bozzetto* at Geneva, see A. Pampaloni, *Commentari*, 1970, 307.

CASSA DEPOSITI E PRESTITI (45). *Bust of Magdalen*.

PALAZZO DORIA-PAMPHILY (Piazza Navona). Frieze in room on S. side of Galleria: Stories from Ovid: *Europa* (GFN. E. 45890) [Plate 11]; *Jupiter arguing with Juno, with Io below (as a cow)* (GFN. E. 45884); *Perseus rescuing Andromeda* (E. 45889); *Venus and Adonis* (E. 45881); *Saturn and a female figure (?)* (E. 45888); *Apollo and Hyacinthus* (E. 45886); *Polyphemus hurling rocks at Acis and Galatea* (E. 45892); *Mercury giving the apple to Paris* (E. 45887); *Polyphemus wooing Galatea* (E. 45891); *Medea and Aeson* (E. 45885); *Mars and Venus* (E. 45883); *Apollo and Daphne* (E. 45882). Formerly ascribed by a confusion to Camassei, these are documented as by Brandi 1646–53 (D. Redig de Campos, in *Piazza Navona*, 1970, 172).

PALAZZO PALLAVICINI-ROSPIGLIOSI. Pallavicini collection. (74) *Four cherub heads.*
(75) *Bust of Magdalen.*
(76) *Christ on the Cross and the Magdalen.*

PALAZZO TAVERNA. Seven large mythological compositions: *Battle between Centaurs and Lapiths*; *Venus asking Vulcan for arms for Aeneas*; *Minerva and the Liberal Arts*; *Fortune and the sleeping Endymion* (?); *Polyphemus, Acis and Galatea*; *The punishment of the Titans*; *Perseus turns Phineus to stone with the Gorgon's head.* Painted for the Gabrielli family in the later 1680's. The first four are reproduced by A. Pampalone, in *Commentari*, 1970, 310–11.

Valmontone. S. MARIA ASSUNTA. 1 to R: *Crucifixion.*

GIACINTO CALANDRUCCI (1645–1706/7)

A native of Palermo, he became a favourite pupil of Maratti and rather specialized in private commissions. His style has little individuality.

Bibl.: Pascoli; Dieter Graf, *Master Drawings . . . from Kunstmuseum Düsseldorf*, 1973, 7–15.

Frascati. VILLA FALCONIERI. Fresco on ceiling of a small room: *Allegory of Summer.* Identified as Calandrucci from a drawing at Düsseldorf. Cf. A. M. Clark, *The Connoisseur*, Nov. 1961, 193, and E. Schaar, *Festschrift Ulrich Middeldorf*, Berlin, 1968, 422–8.

Rome. S. ANTONIO DEI PORTOGHESI. 2 to R: altar: *Baptism*; frescoes in lunettes on side walls: to L: *Salome receives S. John's head*; to R: *Rest on Flight with child John*; on ceiling: *God the Father.* The chapel was under construction 1682–8; see Forcella, III, no. 1304.
High altar: *Virgin and Child with S. Anthony of Padua.* The patroness (Cimini) of 2 to R. undertook the high altar in 1687.

S. BONAVENTURA SUL PALATINO. 2 to R: *Virgin, Child and S. Anne, with S. Diego de Alcalà, B. Salvatore of Orta, and S. Pasquale Baylon below.* In the 1686 Titi. The process for the canonization of S. Pasquale was completed in 1679, but the ceremony did not take place until 1690.

S. MARIA DELL' ORTO. Fresco on nave ceiling: *Assumption.* Fresco on ceiling of 4th bay of R. aisle: *Risen Christ with Angels.* The date is given as 1707 by Thomas Poensgen, *Die Deckenmalerei in italienischen Kirchen*, 1969, 98, but Pascoli says Calandrucci spent his last few years in Palermo.

S. MARIA DEL SUFFRAGIO. 2 to R: R. wall: *Joseph's dream.* Listed in the 1686 Titi. Repr. in L. Salerno etc., *Via Giulia*, 1973, fig. 248.

S. MARIA IN TRANSPONTINA. 2 to L: *Elijah between S. Anthony Abbot and the B. Franco Carmelitano.* On the ceiling: *Elijah in glory* between two panels of *Putti holding symbols.* The altar was dedicated in 1690 (Forcella, VI, no. 1146). For the

early confusion of attribution between this and the Antonio Gherardi in 4 to L. see Amalia Mezzetti, *Bollettino d'Arte*, 1948, 174.

S. PAOLO ALLA REGOLA. 1 to L: *Vision of S. Anthony of Padua*. 2 to L: *Holy Family with SS. Anne, Joachim, Lawrence, infant Baptist and Angels*. The church is said to have been completed by 1701. (P. Giovanni Parisi, *S. Paolo alla Regola*, 1931, figs. 9 and 10.)

PALAZZO LANTE. Six narrow strips forming the ceiling of what are now two rooms: *Putti*; *Mercury*; *Ceres*; *Bacchus*; *Venus*; *Putti*. Probably from the 1680's and much repainted. They are identifiable from a number of drawings at Düsseldorf (Dieter Graf, *op. cit.*, p. 11).

ANDREA CAMASSEI (1602–1649)

A native of Bevagna, first recorded in Rome in 1626, where he studied under Domenichino and became one of the team of Barberini painters at the end of the 1620's. First recorded as Accademico di S. Luca in 1633. His early promise was never quite fulfilled and his style did not develop much beyond its base in Bolognese classicism.

Bibl.: Passeri; Pascoli; Attilio Presenzini, *Vita ed Opere del Pittore Andrea Camassei*, Assisi, 1880; Gemma di Domenico Cortese, *Commentari*, XIX (1968), 281–98; Ann Sutherland Harris, *Art Bulletin*, LII (1970), 49–70.

Castelfusano. VILLA CHIGI (formerly Sacchetti). There are payments to Camassei in 1628 for some part of the decoration of the Galleria on the second floor, but all the frescoes are so repainted that Camassei's contribution cannot be identified (G. Incisa della Rocchetta, *L'Arte*, 1924, 60).

Rome. GALLERIA NAZIONALE. *Hunt of Diana*. (GFN, E, 18775) and *Death of the children of Niobe*. (GFN, E, 18783.) [Plate 16.] Very large companion pieces: painted for the Barberini, probably in the 1630's and not later than 1644 (Harris, 59) (Magazine). *S. Eufemia in the lion's den*. (GFN, E, 18774); *S. Agnes refusing to worship idols*. (GFN, E, 18787.) Both these are also Barberini pictures; before 1644.

S. EGIDIO IN TRASTEVERE. High altar: *Madonna del Carmine giving the scapular to S. Simon Stock*. Probably about 1630 (Harris, 52). See G. Carandente in *Mostra di Restauri*, 1969, 26 (fig. 33).

S. GIOVANNI IN FONTE. Two large frescoes on the R. wall: *The Triumph of Constantine* and *The Battle of the Milvian Bridge*. Part of the general scheme of fresco decoration done under Sacchi's direction 1640–9; there are payments to Camassei in 1644 (Harris, 62).

S. MARIA DELLA CONCEZIONE. 3 to L: *Pietà*. About 1631. [Plate 14.]

S. MARIA IN VIA LATA. Fresco in vault of tribune: *Assumption*. Finished in 1642, but too repainted to matter.

PANTHEON. Room on first floor behind high altar: *Assumption*. Formerly 1 to L. Commissioned by Abate Pompilio Zuccarini (see Forcella, I, no. 1139). Cortese (p. 294) considers the picture on the L. wall of S. Maria in S. Marco to be a replica of this, and mentions a signed version in the Church of the Assunta at Cave di Palestrina.

PROPAGANDA FIDE. 1 to L: *Calling of SS. Peter and Andrew*. A picture of this subject is documented here as painted by Camassei in 1635; the present picture is a copy of Vasari (Harris, 56). Though accepted by Harris, I cannot believe it to be by Camassei.

S. SEBASTIANO ALLA POLVERIERA. High altar: *Martyrdom of S. Sebastian*. 1633. (GFN, E, 12282.)

PALAZZO BARBERINI (Galleria Nazionale part). Ceiling fresco: *God dividing the Angelic Hierarchies*. Probably completed by 1632 (Harris, 54). There are payments to Camassei 1629–38 (Pollak, I, 330). The ceiling of another room, *Parnassus*, is now only known from the engraving in (Tetius) *Aedes Barberinae*, 1647, 106.

PALAZZO DORIA-PAMPHILY (Piazza Navona). Fresco frieze in room between the Gaspard Poussin and the Tassi rooms: *Bacchus encounters Ariadne*; *he introduces her to Venus*; *Triumph of Bacchus and Ariadne*; *Sacrifice to Bacchus*. First payment 1648, the last (posthumous) 1654 (Cortese, 295).

Vatican. Pinacoteca. *S. Peter baptizing the Centurion*. One of the *modelli* (and this is one of the first instances in which such *modelli* are known) for the destroyed fresco of 1630–5 once in S. Peter's, where the tomb of Clement XIII replaced it (Photo Arch. Vat., VI, 35, 5). It remained in the Barberini collection until the sale (L'Antonina, Rome, 16–23, Jan. 1935, lot 262). For two other *modelli* see Cortese, 284–5, and Harris, 53.

GIOVANNI ANGELO CANINI (*c.* 1617–1666)

Pupil of Domenichino and trained in the Bolognese classical tradition, which he never altogether abandoned, though he moved later into the orbit of the Cortoneschi. Accademico di S. Luca 1636.

Bibl.: Passeri; Pascoli; Norbert Wibiral, *Bollettino d'Arte*, 1960, 129–30.

Rome. S. FRANCESCA ROMANA. Two frescoes in apse: *Martyrdom of SS. Nemesius, Olympius, Sempronius, Lucilla, Exuperia and Theodulus*. Indicated as lately done by Canini by G. B. Mola, 1663 (ed. Karl Noehles, 87). Titi and later writers wrongly gave them to Canuti (see Erich Schleier, *Arte Illustrata*, 1971).

S. GIOVANNI DEI FIORENTINI. 4 to L: L. wall: *Christ's charge to Peter*; R. wall: *Conversion of S. Paul*. Probably done soon after the ownership of the chapel changed in 1659 (Mgr. Emilio Rufini, *S. Giovanni dei Fiorentini*, 1957, 76).

S. MARCO. Two frescoes on the walls above the nave arcade: 2 to L: *S. Mark approves the plan of the Basilica*; 2 to R: *SS. Abdon and Sennen refusing to worship idols*. Payment 1659 (P. Dengel, *Palast und Basilica S. Marco*, 1913, 93*n*.).

S. MARIA MAGGIORE. Cappella Cesi (1 to L.): R. side wall: *S. Catherine disputing*. Perhaps from the 1660's.

S. MARTINO AI MONTI. 3 to L: *Holy Trinity with SS. Bartholomew and Nicholas*. 1644. [Plate 15.]

4 to R: *Martyrdom of S. Stephen*. Probably 1646.

For the dates see Ann Sutherland, *Burl. Mag.*, CVI (1964), 62 and 116 ff.

PALAZZO DEL QUIRINALE. Galleria di Alessandro VII: *Sacrifice of Isaac*. 1656–7. N. Wibiral, *op. cit.*, 129.

Sambuci. PALAZZO THEODOLI. Restored frescoes in several rooms. See Passeri-Hess, 340, *n*. 4.

Vatican. GALLERIA DELLE CARTE GEOGRAFICHE. Landscape frescoes at sides of Romanelli fresco of 1637.

DOMENICO MARIA CANUTI (1620?–1684)

A Bolognese, pupil of Guido Reni. He worked mainly at Bologna but visited Rome in 1672, when he became an Accademico di S. Luca. He remained there until 1676, when he returned to Bologna. His work in fresco in Rome was done with the assistance of the quadratura *painter, Enrico Haffner. Their two ceilings are the only examples of this specifically Bolognese style in Rome.*

Bibl.: Ebria Feinblatt, *Art Quarterly*, XV (1952), 45–64 (with bibliography); *op. cit.*, XXIV (1961), 262–82. The same author's book on Bolognese quadratura painting is in the press.

Rome. SS. DOMENICO E SISTO. Fresco on vault of nave: *Glory of S. Dominic* (jointly with Haffner). 1674–5.

Vault of apse: *Ecstasy of S. Dominic* and *Glory of Mary*. Probably 1672–4.

S. FRANCESCA ROMANA. Canuti painted (by 1675) an altarpiece for the altar of the B. Bernardo Tolomei. It is possible that this is the picture of *B. Bernardo Tolomei exorcizing a devil* lately moved from the convent to the L. wall of 1 to L. See *Mostra dei Restauri 1969* (XIII Settimana dei Musei 1970), Scheda 38.

PALAZZO ALTIERI. Fresco on ceiling of large room at the head of the stairs, facing the Gesù: *Glory of Jupiter and Rome* (?). In quadratura setting by Haffner, 1675–6. Listed in error in my first edition as by Niccolò Berrettoni.

PALAZZO PALLAVICINI-ROSPIGLIOSI. Pallavicini coll. (99) *Pietà*. Already listed as Canuti in 1679.

GIOVANNI DOMENICO CERRINI (1609–1681)

A native of Perugia. At some unascertained date he was made a Papal knight and became known as 'il cavaliere Perugino'. He came young to Rome and is said to have been in contact with Guido before he left Rome and later to have formed his style on Domenichino. His art is conservative, parallel in style with that of Cozza and Sassoferrato. His best works are from his earlier period, up to the later 1640's, when he spent some time in Perugia (where there are good examples in S. Pietro) and at Florence: during his later years in Rome he did little painting.

Bibl.: Pascoli, I, 51 ff. (who says his Roman works were not his best).

Rome. GALLERIA NAZIONALE (Deposito). *Christ and the Samaritan woman at the well.* (GFN, E, 18762.)

GALLERIA COLONNA. (28) *S. Sebastian succoured by the Holy Women.* Photo Anderson 20734 as Cantarini. First correctly ascribed to Cerrini by H. Voss.

GALLERIA SPADA. (5) *David with the head of Goliath.*

S. CARLO ALLE QUATTRO FONTANE. Convent (passage leading from Church to Convent). *S. Ursula with a banner.* 1642. [Plate 17.] *Holy Family with SS. Agnes and Catherine.* 1643. Painted for the side altars of the Church: for dates, see Pollak, I, 105.

S. FRANCESCA ROMANA. Sacristy. *Tobias and Angel.* (GFN, E, 20156.) Unattributed, but probably by Cerrini.

S. ISIDORO. 2 to L: *Vision of S. Anthony of Padua.* (GFN, E, 20455.) Recorded by Fioravante Martinelli (p. 74) about 1663. He suggests that the frescoes on the side walls were once by Cerrini—but they seem wholly repainted.

S. MARIA IN TRANSPONTINA. R. transept altar: *Christ and the Virgin in the sky adored by S. Maria Maddalena dei Pazzi and two male Saints.* First in 1674 Titi.
Frescoes in pendentives of dome: *Elijah; Elisha; S. Andrea Corsini; B. Peter Thomas.* Not listed in 1674 Titi.

S. MARIA IN VALLICELLA. 5 to R: *Assumption.* Formerly in the sacristy (Titi); identified by R. Longhi, *L'Arte,* 1925, 225. On stylistic grounds it is probably from the 1640's.

S. MARIA DELLA VITTORIA. Fresco in dome: *S. Paul received into Heaven.* (GFN, E, 25181.) Completed by 1663 (G. B. Mola, p. 180).

PALLAVICINI COLLECTION. (135) *Ecce Homo.* (136) *S. Peter liberated from prison.*

CARLO CESI (1626–1686)

One of the first generation of pupils of Pietro da Cortona; he is better known as an engraver than as a painter. Principe of the Accademia di S. Luca 1675. His style is conservative and rather elusive. Two of his recorded commissions for churches which were demolished in the

present century (S. Dionigi alle Quattro Fontane and S. Maria della Visitazione) are probably still in the clausura of the modern successor convents.

Bibl.: Pascoli.

Rome. S. MARIA MAGGIORE (Cappella Cesi). 1 to L: L. wall: *Marriage of S. Catherine.* Perhaps from the later 1660's.

S. MARIA DELLA PACE. 2 to R: *Holy Family with S. Anne.* (GFN, E, 40264.) Listed in the MS. additions to the 1663 MS. of Mola's Guide in Viterbo.

PROPAGANDA FIDE (I RE MAGI). 2 to R: *SS. Charles Borromeo and Filippo Neri kneeling before the Virgin and Child.* (GFN, E, 20432.) [Plate 18.]

SS. SUDARIO. Altar to R: *Madonna and Child with S. Francis de Sales.* This is a late attribution and is open to doubt.

PALAZZO DEL QUIRINALE. Sala degli Ambasciatori: fresco: *Judgment of Solomon.* 1656–7. See N. Wibiral, *Bollettino d'Arte,* 1960.

FABRIZIO CHIARI (*c.* 1615 or earlier–1695)

A decidedly secondary painter, allegedly self-taught; he became an Accademico di S. Luca in 1635 and did some engravings after Poussin about the same date; in the 1650's he rates as a minor Cortonesque and was influenced in later life by Maratti.

Bibl.: Nicola Pio (*Archivio della R. Soc. Romana di Storia patria,* XXXI (1908), 48).

Rome. S. ANASTASIA. Chapel at end of N. aisle: second picture on N. wall: *S. Apollonia directs the burial of S. Anastasia.* Not recorded until after 1722, but the chapel was decorated about 1692 (GFN, E, 21407).

S. CARLO AL CORSO. First fresco on vault of ambulatory on L. side: *Allegory of Patience, Tolerance and Discretion.* 1678. For the date see G. Drago and L. Salerno, *SS. Ambrogio e Carlo al Corso,* 1967, 108 (repr. fig. 25).

S. MARCO. Fourth of the frescoes to L. on the side walls of the nave, above the columns: *Translation of the body of S. Mark.* Part of the 1653–7 redecoration of the church.

S. MARTINO AI MONTI. 3 to R: *S. Martin and the beggar.* 1645. For the date see Ann Sutherland (Harris), *Burl. Mag.,* CVI (1964), 62.

PALAZZO ALTIERI. Sala degli Specchi: fresco on ceiling: *The Chariot of Apollo.* 1675. For date, see Armando Schiavo, *Palazzo Altieri,* 1964, 110.

PALAZZO DEL QUIRINALE. Sala Gialla: fresco on L. wall: *Meeting of Jacob and Esau.* 1656–7. For documents see N. Wibiral, *Bollettino d'Arte,* 1960, pp. 131 and 162.

GIUSEPPE CHIARI (1654–1727)

He was already studying with Maratti at the age of twelve and became his closest and most faithful follower. In the middle 1680's he succeeded Niccolo Berrettoni as the leading Marattesque and became Accademico di S. Luca in 1697. A certain prettiness and a slight tendency towards the rococo distinguish him from his master.

Bibl.: Pascoli; there is a miniature monograph by Bernhard Kerber, *Art Bulletin*, L (March 1968), 75–86. P. Dreyer in *Zeitschrift für Kunstgeschichte*, XXXIV (1971), 184 ff.; Erich Schleier in *Berliner Museen*, 1973, 2, 58–67.

Ariccia. PALAZZO CHIGI. *A hermit praying*; *The sleeping Armida*. Two *sugo d'erbe* canvases (cf. G. Gimignani); they appear to have been designed by Chiari.

Rome. ACCADEMIA DI S. LUCA. *Pietà.* (GFN, C, 4632.)

Penitent Magdalen with Angels. (GFN, E, 36032.)

Allegory of the Church. (Kerber, fig. 14.)

MUSEO DI ROMA. *Allegory of the reign of Clement XI.* From the Casa Orsini. (GFN, E, 43757.)

Judith returning with the head of Holofernes. Signed: JOSEPH CHIARI FECIT ANNO MDCCXII. (GFN, E, 43794.) [Plate 20.]

SPADA. Four companions: *Latona changing the shepherds into frogs; Mercury bringing the infant Jupiter to the Melian Nymphs; Bacchus and Ariadne; Apollo and Daphne.* Painted about 1708 for Cardinal Spada.

S. ANDREA AL QUIRINALE. 2 to L: Fresco on ceiling of chapel: *Angels making music.* Soon after 1712.

SS. APOSTOLI. 3 to L: *S. Francis swooning in ecstasy.* 1726.

S. CLEMENTE. Canvas on ceiling: *S. Clement in Glory.* Shortly before 1715; cf. Forcella, IV, no. 1259.

S. FRANCESCO DE PAOLA. 2 to R: Frescoes: L. wall: *S. Francis de Paola restoring some stonemasons to life*; R. wall: *the Saint gives features to a child born without them*; Ceiling: *S. Francis de Paola in glory.* About 1726. The *modelli* for the frescoes on the side walls are in the Pallavicini and Colonna collections respectively.

S. FRANCESCO A RIPA. 4 to R: *SS. Pietro d'Alcantara and Pasquale Baylon below a vision of the Trinity.* The chapel was first opened for worship in Jan. 1725 (Valesio).

S. GIOVANNI IN LATERANO. The 2nd to L. of the oval Prophets over the arches of the nave arcade: *Obadiah.* Commissioned 1718 (Kerber, fig. 17).

S. IGNAZIO. 2 to R: Painting over the arch on the L. side: *Ecstasy of the B. Lucia of Narni. c.* 1712. For the date see Forcella, X, no. 188.

S. MARIA DELLE FORNACI. 3 to L: *Holy Family with Baptist.* About 1726–7. Chiari's last work (Pascoli).

S. MARIA DI MONTESANTO. 3 to L: fresco on ceiling: *Virgin in Glory. c.* 1686–7 (Forcella, IX, no. 394).

Sacristy attached to 3 to L: *Pietà*. Probably *c.* 1692 (Forcella, IX, no. 397). It is a copy of the Farnese Carracci now at Naples.

S. MARIA DEL SUFFRAGIO. 3 to R: Pictures on side walls: L. wall: *Birth of Virgin*; R. wall: *Adoration of Kings*. Chiari's first public commission, soon after the death of Berrettoni in 1682. They are in the 1686 Titi.

S. SILVESTRO IN CAPITE. I to R: Altar: *Virgin and Child with S. Anthony of Padua and Pope S. Stephen*; L. wall: *Idols destroyed by a thunderbolt at S. Stephen's prayer* [Plate 19]; R. wall: *S. Anthony resuscitates a dead man*; Frescoed lunettes: to L: *Martyrdom of Pope S. Stephen*; to R: *S. Anthony prophesying*. Fresco on ceiling: *Glory of Angels*. 1695–6. For the date see I. Lavin, *Bolletino d'Arte*, 1957, 49.

PALAZZO BARBERINI. Ceiling fresco: *Apollo with his chariot, Aurora, the Seasons, Time etc.* After 1693. (GFN, E, 42039.) [Plate 21.] Ceiling fresco of a smaller room: *Birth of Pindar*. (GFN, E, 42040.) For the elucidation of the subjects see Kerber, 77.

PALAZZO COLONNA. Fresco on ceiling of the first Sala in the Galleria Colonna: *Hercules introduces Marcantonio Colonna to Olympus*. Dated 1700.
(Private rooms.) Modello for fresco on R. wall of 2 to R. in S. Francesco de Paola (*q.v.*).

PALAZZO PALLAVICINI. Modello for fresco on L. wall of 2 to R. in S. Francesco de Paola (*q.v.*).

Zagarolo. S. PIETRO. High altar: *S. Peter receiving the keys*. The church was finished in 1722.

BACCIO CIARPI (1578–1654)

A native of Barga (province of Lucca), pupil of Santi di Tito. In Rome before 1613, where he became the first serious teacher of Pietro da Cortona; Accademico di S. Luca by 1635. He has a certain originality in a late mannerist style.

Bibl.: Passeri; F. Noack in Thieme-Becker; his *post mortem* inventory published by A. Pescatori, *Rivista d'Arte*, 1958, 65 ff.; Ilaria Toesca, *Bolletino d'Arte*, 1961, 177 ff.

Rome. S. CARLO AI CATINARI. Inner choir: *Death of S. Benedict*. From demolished church of S. Benedetto in Clausura, where it was already recorded by Mancini in 1623 (see Ilaria Toesca, *op. cit.*, 177). (GFN, E, 47756.)

S. GIOVANNI DEI FIORENTINI. N. transept altar: *Assumption of S. Mary Magdalen*. The chapel was begun 1622 (Mgr. Emilio Rufini, *S. Giovanni dei Fiorentini*, 1957, 72).

S. GIOVANNI IN LATERANO. 3 to L: frescoes in stucco frames on arch over the altar: *Kiss of Judas*; *Resurrection*; *Pietà*.

S. LUCIA IN SELCI. Nuns' choir. *Adoration of the Shepherds*. (GFN, E, 15833); *S. Ambrose*. (GFN, E, 15884); *Communion of S. Lucy*. (E, 15881). On the other side,

S. *Carlo Borromeo* (E, 15882) between two other subjects. 1614–15. For the date see Howard Hibbard, *Carlo Maderno*, 1971, 137.

S. MARIA DELLA CONCEZIONE. 4 to R: *Agony in the Grarden*. 1632. For the date see O. Pollak, *Urban VIII*, I, 172.

S. MARIA IN MONTICELLI. E. end of S. aisle: *Virgin and Child with SS. Ninfa, Mamiliano, Eustozio, Proculo and Galbodio*. Datable 1613 according to Noack (Thieme-Becker).

S. SILVESTRO IN CAPITE. Altar in S. transept: *Madonna and Child with SS. Louis, John Baptist, Pope S. Dionisio and Filippo Neri*. Probably c. 1622. The attribution is due to F. Zeri (*Pittura e Controriforma*, 1957, 111). (GFN, E, 52114.)

GIOVANNI COLI (1636–1681) and
FILIPPO GHERARDI (1643–1700)

Natives of Lucca and known in Rome as 'I Lucchesini', they always worked together until Coli's death. Pupils of Paolini at Lucca, they later worked in Cortona's orbit and finished their training at Venice, where they received their first commission. In Rome 1669 to 1678, when they returned to Lucca. Accademici di S. Luca 1675: after Coli's death Gherardi did one major work in Rome.

Bibl.: H. Voss in Thieme-Becker (with full bibliography up to 1920); Anna Maria Cerrato, *Commentari*, X (1959), 159–69.

Rome. S. CROCE DEI LUCCHESI. Paintings inserted into the nave ceiling: *Heraclius brings the Cross back from Persia*; *The Volto Santo supported by Angels*; *The Sudario supported by Angels*; eight corner panels with *Putti with Instruments of the Passion*. 1673–7. See Umberto Vichi, *S. Croce dei Lucchesi*, 1964, 44.

S. NICOLA DA TOLENTINO. Fresco in cupola: *S. Nicholas in glory*. 1670–1. (GFN, E, 21345.) See J. Garms, *op. cit.*, nos. 93 and 353.

S. PANTALEO. Fresco on ceiling of nave: *The Triumph of the Name of Mary*. 1687–92. By Gherardi alone, assisted by Cristoforo Tondini; see Gianfranco Spagnesi, *S. Pantaleo*, 1967, 88.

PALAZZO COLONNA. Frescoes on the ceiling of the Galleria (Sala II of the present Galleria Colonna): *Scenes from the Life of Marcantonio Colonna*. 1675–8.
The quadratura of the Galleria had already been painted by Giovanni Paolo Schor and assistants in 1665–70 (Guido Corti, *Catalogo della Galleria Colonna*, 1937 (1970), XIII).

BARTOLOMEO COLOMBO (working 1648 to 1667)

A Cortonesque artist of about the same secondary quality as Gismondi. He has been confused and conflated by the sources with a painter (or musician) called Domenico (?) Palombo (for

*a statement of the confusion see N. Wibiral, Bollettino d'Arte, 1960, 131–3); and even
with a painter named Matteo Piccione (Ann Sutherland, Burl. Mag., CVI (1964), 63, n. 57).*

Rome. S. GIUSEPPE DEI FALEGNAMI. I to R: *Death of S. Joseph.* Datable 1648 (G.
Zandri, *S. Giuseppe dei Falegnami*, 1971, 50).

PALAZZO DEL QUIRINALE. Sala degli Ambasciatori. Fresco: *Adam and Eve chased
from Paradise.* 1657. See N. Wibiral, *op. cit.*

Tivoli. DUOMO. I to L: *Martyrdom of S. Martha in front of her husband, S. Marius.*
Also frescoes on dome and side walls: in the dome: *SS. Marius and companions
are received into heaven*; the spandrels and lunettes are inscrutable. The main
scenes on the side walls are: to L: *SS. Marius and Martha driven into the wilder-
ness*; to R: *SS. Marius and Martha kneel before an altar.* An inscription in the
chapel states that it was built and provided with the relics of SS. Marius and his
companions by Mario Carlo Mancini in 1667.

SEBASTIANO CONCA (1680–1764)

*A native of Gaeta and at first a pupil of Solimena at Naples. He came to Rome in 1707 and
fell a little under the spell of Maratti, but quickly developed into the leading exponent of the
rococo on a grand (and also on a miniature) scale. Accademico di S. Luca, 1719: and Principe
of the Academy 1729–32 and 1739–40. His first public commission in Rome was the*
Madonna del Rosario *for S. Clemente in 1714; his major work the nave ceiling in S.
Cecilia, 1721–4; the paradigm of his later style the altar of 1740 in the N. transept of SS.
Luca e Martina. He retired to his native Gaeta in 1752 and latterly worked there and for
Naples.*

Bibl.: Anthony M. Clark in *Apollo*, vol. 85 (May 1967), 328–35 (the early sources
are given in note 1 on p. 335); Giancarlo Sestieri, *Commentari*, XX (1969), 317–
41 and XXI (1970), 122–38 (with catalogue of pictures).

GUGLIELMO CORTESE (1628–1679)

*Born Guillaume Courtois at S. Hippolyte (Franche-Comté) and younger brother of the
Jesuit battle-painter, Giacomo: both are often known by the name 'Borgognone'. The
family arrived in Rome c. 1640 and Guglielmo became a pupil of Pietro da Cortona.
Accademico di S. Luca 1657; he was much employed under Alexander VII. He scraped a
few engravings.*

Bibl.: Pascoli; F. A. Salvagnini, *I pittori Borgognoni*, Rome, 1937 (with full biblio-
graphy); Erich Schleier in *Antichità Viva*, Jan./Feb. 1970, and *Pantheon*, 1973,
46 ff.; Dieter Graf in *Burl. Mag.*, CXV (Jan. 1973), 24 ff. and *Master Drawings*

. . . from Kunstmuseum Düsseldorf, 1973, 15–35; Ann Sutherland Harris, *Master Drawings*, x (1972), 360 ff.; D. Graf and E. Schleier, *Burl. Mag.*, cxv (Dec. 1973), 794 ff.

Ariccia. COLLEGIATA. Fresco in tribune: *Assumption*. 1664–6. See G. Incisa, *Rivista del R. Ist. d'archeologia e Storia dell' Arte*, i (1929), 371–3 (GFN, E, 18546).

 S. MARIA DI GALLORO. I to R: *S. Francis of Sales preaching to the Swiss*. 1663. See V. Golzio, *Documenti artistici sul Seicento nell' archivio Chigi*, 1939, 417.

Castel Gandolfo. S. TOMMASO DE VILLANOVA. Altar to L: *Assumption*. 1660. See V. Golzio, *op. cit.*, 403; for drawings see Dieter Graf, *Burl. Mag.* (Jan.) 1973, 24 ff.

Monteporzio Catone. S. GREGORIO. Altar to L: *Madonna del Rosario*. (GFN, E, 48628.) [Plate 24.] Documented by a payment of 1666 (E. Schleier, *Antichità Viva*, Jan./Feb. 1970, note 45).

Rome. ACCADEMIA DI S. LUCA. *Pietà*. Perhaps his reception piece of 1657.

 GALLERIA NAZIONALE. 2494. *Adoration of Shepherds* (GFN, E, 61953); 2495. *Adoration of Kings* (GFN, E, 61956). Bought in 1964: correctly identified by Schleier, *loc. cit.*, 1970.

 S. ANDREA AL QUIRINALE. High altar: *Martyrdom of S. Andrew* [Plate 23]; oval fresco in cupola above it: *God the Father and Angels*. Commissioned 1668 (F. Haskell, *op. cit.*, p. 87): a *modello* belongs to B. D. L. Thomas, London.

 GESÙ, ORATORIO DELLA CONGREGAZIONE PRIMA PRIMARIA. Frescoes in collaboration with his brother Giacomo. 1658. See Salvagnini, *op. cit.*, 124 ff. and figs. XXXVI to XLIX, where the whole series is described and illustrated. There are revisions to the allocation of some of the frescoes to Guglielmo in E. Schleier, *loc. cit.*, 1970.

 S. GIOVANNI IN LATERANO. 5 to L: *S. Hilary in meditation on the Trinity*. c. 1660–5.

 S. MARCO. Paintings on the sides of the tribune, behind high altar: to L: *S. Mark's body dragged along the ground*; to R: *S. Mark martyred at the altar*.

 Chapel to R. of the high altar. Frescoes on the side walls: L. wall: *Sacrifice of Abraham*; R. wall: *Sacrifice of Aaron*.

 Frescoes on the side walls of the nave, above the columns: I to L: *S. Mark crowned as Pope*; I to R: *SS. Abdon and Sennen burying the bodies of martyrs*.

 These are Cortese's earliest commission. All are parts of the redecoration of the church 1653–7 under Niccolo Sagredo (Salvagnini, *Boll. d'Arte*, 1935, 167 ff.).

 S. PRASSEDE. 2 to R. Pictures on the side walls: to L: *Adoration of the Kings*; to R: *SS. Joachim and Anne see a vision of the Virgin Immaculately conceived* [Plate 22]. Frescoes on the ceiling: *Almighty with Angels* in centre; in corners, *SS. Pasquale I, Filippo Neri, Francesca Romana and Firmina*. On stylistic grounds of the same date as: Sacristy: *S. Giovanni Gualberto treading down the heresies of Simony and Nicolaism*. 1661–3. Once over 4 to L; see Davanzati, *Notizie al pellegrino della Basilica di Sta Prassede*, 1724, 240.

 SS. QUATTRO CORONATI. Convent. *Christ in house of Martha and Mary*. c. 1675. Originally over the high altar of S. Marta. Rediscovered by Salvagnini (pl. LXIII). For related drawings see Dieter Graf, *Master Drawings*, x (1972), 356.

SS. TRINITA DEI PELLEGRINI. I to L: *Virgin and Child with SS. Charles Borromeo, Filippo Neri, Dominic and the B. Felice. c. 1677.* For the date, see Forcella, VII, no. 447.

COLLEGIO ROMANO. Oratorio della Congregazione Prima Primaria. (Now accessible only from the Gesù: *q.v.*)

PALAZZO DEL QUIRINALE. Sala del Trono: fresco: *Joshua's Battle.* 1656–7. See N. Wibiral, *Bollettino d'Arte*, 1960, 133 ff., where it is plausibly suggested the design may be due to Giacomo.

Valmontone. PALAZZO DORIA-PAMPHILY. Ceiling fresco in the third of the great rooms: *Allegory of the Element of Water (Neptune riding the waves; Polyphemus watches Acis and Galatea; Triumph of Amphitrite; Proteus and Naiads?).* 1658–9. L. Mortari, *Commentari*, VI (1955), 267 ff., documents Cortese as working at Valmontone, but she wrongly supposes he painted the 'Element of Earth', which is by G. B. Tassi. Though badly damaged by fire during the war, parts of the frescoes are still visible (GFN, D, 592 and 595).

PIETRO DA CORTONA (1596–1669)

Pietro Berrettini, a native of Cortona, was equally distinguished as painter, decorator and architect. He came to Rome about 1612 and studied with the Tuscans, Commodi and Ciarpi, but formed his own style largely by studying what resources Rome could offer. Through the patronage, from about 1620, of Marcello Sacchetti, he was introduced to the Barberini family and became one of the central figures in the art-projects of Urban VIII. Principe of the Academy of S. Luke 1634–6, he was absent from Rome, mainly in Florence, from 1639 to 1647, where he did much work in the Palazzo Pitti. Later he worked almost wholly in Rome. In the 1660's he was much hampered by gout.

Flor: Sansoni, 1982

Bibl.: Giuliano Briganti, *Pietro da Cortona*, 1962, has a full bibliography and catalogue raisonné, as well as splendid illustrations. I have therefore cut down to a minimum the comments and references in the list below.

Castelfusano. VILLA CHIGI (formerly Sacchetti). Fresco decoration of the Galleria on the second floor: done by many hands under general direction of Pietro, 1627–9. Much repainted: some scenes are by Sacchi.
Frescoes in the chapel, mostly by Pietro himself: 1626–9.
Two fresco ceilings on the first floor: *Cain and Abel sacrificing* (figure of God repainted by Pietro Bianchi); *Adam and Eve and their children.* 1628–9.

Castel Gandolfo. S. TOMMASO DE VILLANOVA. High altar: *Crucifixion with the Virgin, S. John and the Magdalen. c.* 1661.

Castel S. Pietro. S. PIETRO. *Christ's charge to Peter.* 1636.

Frascati. VILLA MUTI. Two fresco ceilings: *Daniel visited by Habbakuk in the lion's den; Fall of Manna. c.* 1620.

Rome. ACCADEMIA DI S. LUCA. Copy of Raphael's *Galatea. c.* 1620.

BORGHESE. (162) *Marcello Sacchetti* (d. 1639). Before 1630.

CAMPIDOGLIO. (A) PALAZZO DEI CONSERVATORI. Sala di Mario. *Battle of Issus. c.* 1635.

(B) CAPITOLINE GALLERY. *Triumph of Bacchus.* Before 1625.

Sacrifice of Polyxena. Before 1625.

Rape of the Sabines. c. 1630.

Madonna adoring Child, with Angels. Before 1630.

View of Allumiere in the Tolfa. Before 1630.

(Depositi). *Two oval landscapes.*

(C) PALAZZO SENATORIO. *Aurora. c.* 1620.

Copy of Titian's *Madonna with S. Catherine. c.* 1620.

GALLERIA NAZIONALE (CORSINI). *Guardian Angel.* 1655–6. Oval *View of Villa Sacchetti at Castelfusano. c.* 1629. Bought 1971. Briganti, fig. 97.

DORIA. 91 (1) *God appearing to Noah. c.* 1654.

QUIRINALE. *David departs to slay Goliath.* (GFN, E, 35244); *David returns victorious.* (GFN, 35245.)

MUSEO DI ROMA. *Urban VIII.* Before 1630. [Plate 25.]

S. BIBIANA. Frescoes above L. nave arcade: *Three scenes from the life and martyrdom of S. Bibiana*; *S. Demetria*; *S. Flavianus.* 1624–6.

Altar at end of R. aisle: *S. Dafrosa.* 1626–7.

S. CARLO AI CATINARI. High altar: *S. Charles Borromeo carrying the Holy Nail in procession.* 1667.

S. IVONE ALLA SAPIENZA. High altar: *S. Ivo besought by the poor to advocate their cause.* Left unfinished; the lower half completed by Giovanni Ventura Borghesi (*q.v.*).

S. LORENZO IN MIRANDA. High altar: *Martyrdom of S. Lawrence.* 1646.

S. MARIA DELLA CONCEZIONE. 1 to L: *S. Paul healed of blindness by Ananias. c.* 1631–2.

S. MARIA IN VALLICELLA. Fresco on ceiling of nave: *S. Filippo Neri's vision during the building of the Chiesa Nuova.* 1664–5.

Fresco in dome: *The Trinity in glory.* 1647–51; frescoes in the pendentives: *Isaiah, Jeremiah, Daniel and Ezechiel.* 1655–60; fresco in the tribune: *Assumption.* 1655–60.

Sacristy. Fresco on the ceiling: *Angels bearing the Instruments of the Passion.* 1633–4.

Chapel upstairs in former Convent: fresco on ceiling: *S. Filippo Neri in ecstasy before an altar. c.* 1633–4.

S. MARIA IN VIA LATA. Winter choir: *Crucifixion.* Studio copy of the Castel Gandolfo picture with squared corners (GFN, E, 49820).

S. NICOLA DA TOLENTINO. 2 to L: Frescoes in cupola: *Angel musicians* (finished by Ciro Ferri).

S. SALVATORE IN LAURO. 3 to R: *Adoration of Shepherds. c.* 1628–30.

PALAZZO BARBERINI. Fresco ceiling of the Salone: *Triumph of Divine Providence etc.* 1633–9. [Plate 27.]

Frescoes in the private Chapel. 1631–2.

Frescoes in corridor on first floor: *The story of Caeculus and Palestrina*; *Sacrifice to Juno.*

PALAZZO MATTEI DI GIOVE. Frescoes in the Galleria: *Stories of Solomon* in a setting by Pietro Paolo Bonzi. Before 1625; *Adoration of the Shepherds.* Early.

PALAZZO PALLAVICINI ROSPIGLIOSI. (I) Pallavicini Collection. (43) *Rest on the Flight into Egypt.*

(46) *Xenophon sacrificing to Diana.* A studio variant of the picture of 1653, formerly in the Barberini collection, and at present lost.

(II) Consorzio Agrario. *S. Ivone besought by the poor to advocate their cause.* (GFN, E, 38413.) A *modello* for the picture in S. Ivone.

PALAZZO PAMPHILY (Piazza Navona). Frescoes in the *Galleria*: *Stories from the Aeneid.* 1651–5. [Plate 26.]

PALAZZO SACCHETTI. Two frescoes: *Virgin and Child* and *Adam and Eve. Burl. Mag.*, LXXIV (Mar. 1939), rep. p. 136.)

Cardinal Giulio Sacchetti. c. 1626.

COLL. GIULIANO BRIGANTI. *Death of Hector.* Unfinished. *c.* 1625.

Vatican. EX-CHAPEL OF URBAN VIII. Fresco over altar: *Pietà.* 1635.

S. PIETRO. CHAPEL OF SS. SACRAMENTO. Altar: *Trinity in glory.* 1628–32.

There are also the following mosaics executed from Pietro's cartoons: those in the cupolas, spandrels and lunettes of the 2nd and 3rd bays in the R. aisle; and the cupola of the 1st bay.

PINACOTECA. (405) *Virgin and Child appearing to S. Francis.* (Version of picture of 1641 in SS. Annunziata, Arezzo.)

(410) *David killing the Lion.* Before 1630.

(414) *David killing Goliath.* Before 1630.

(2063) *S. Teresa crowned by Christ.* Late work, presented to Pius XII by Dr Giorgio Papasogli Pizzotti.

FRANCESCO COZZA (1605–1682)

A Calabrian from Silo. Pupil of Domenichino before 1630, and Accademico di S. Luca by 1634. He is a classicizing figure, with a vein of poetic fancy, and has affinities with Sasso-errato and Cerrini. Like them he has a tendency to repeat successful compositions with slight variations. He also scraped five etchings of some distinction.

Bibl.: Pascoli; L. Lopresti, *Pinacoteca*, 1928–9, 321–4; L. Cunsolo, *Arch. Stor. per la Calabria e la Lucania*, IX (1939), 169–99, and *Francesco Cozza*, Cosenza, 1966; L. Mortari, *Paragone*, no. 73 (1956), 17–21; Lina Montalto, *Commentari*, VII (1956), 41–52; Erich Schleier, *Arte Illustrata*, 1971.

Genzano. S. MARIA DELLA CIMA. High altar: *Madonna in glory with SS. Peter and Paul.* Signed. L. Mortari, *Paragone* (*op. cit.*), figs. 9–11. Perhaps done soon after the church was completed in 1650 (cf. G. Spagnesi, *Giovanni Antonio de' Rossi*, 1964, 18).

Rome. GALLERIA NAZIONALE (Mag.), see *infra* (S. MARTA).

GALLERIA NAZIONALE (Deposito dei Lincei). *Pietà.* Signed. (GFN, E, 61344.)

Pietà. Signed. (Small version of last.)

For both, see Erich Schleier, *op. cit.*, figs. 22–3.

S. AMBROGIO DELLA MASSIMA. Frescoes in the pendentives of the cupola: *Justice, Prudence, Fortitude* and *Moderation.* (GFN, E, 55133–55136.) In iconography, though not in pattern, they recall Domenichino's pendentives in S. Carlo ai Catinari, which Cozza completed.

S. ANDREA DELLE FRATTE. 4 to L: *S. Joseph holding the Christ Child, with Angels.* Signed and dated 1632. See L. Mortari in *Attività della Soprintendenza alle Gallerie del Lazio*, 1967, 18.

2 to R: Frescoes on side walls: to L: *S. Charles Borromeo succouring the plague-stricken*; to R: *The Madonna appears to S. Francesca Romana.* (GFN, E, 35502–3.) The battered remains of the original altarpiece of 2 to R. survive in the room to R. of the tribune: *S. Charles Borromeo interceding for the plague-stricken.* (GFN, E, 36256.) Painted at the time of the plague of 1656–7. Signed.

S. CARLO AI CATINARI. Cozza completed *Moderation* in a spandrel of the dome left unfinished by Domenichino in 1630.

S. FRANCESCO DE PAOLA. Chapter House: fresco behind the altar: *Crucifixion with S. Francesco de Paola.* Probably mid-1640's.

S. MARIA IN S. MARCO. Wall to R. of altar: *Flight into Egypt.* Original repetition of picture of *c.* 1645 in S. Bernardino, Molfetta (*Mostra d'Arte in Puglia*, 1964, 166). A three-quarter-length variant is said to be in the Convent of S. Angelo in Pescheria (GFN, F, 19775).

S. MARIA DELLA PACE. Fresco in lantern of dome: *God and Angels.* All that survives of the original decoration of the dome, which was destroyed in 1656–7 soon after completion.

S. MARTA. Oval altarpiece: *S. John preaching.* Signed: F. cozza F./1675. (GFN, E, 59120.) [Plate 30.] At present in Galleria Nazionale. The church was secularized for many years but the picture was bought back by the State in 1966.

PANTHEON. 2 to L. (first niche): Frescoes at the sides of the altar: to L: *Adoration of Shepherds*; to R: *Adoration of Kings.* 1659–60.

S. ROCCO. Fresco on ceiling of Sacristy: *Madonna and Child appearing to S. Roch.* Ascribed to Cozza by Erich Schleier, *Arte Illustrata*, 1971, fig. 13, and dated *c.* 1650–1.

PII STABILIMENTI DI S. MARIA IN AQUIRO. *Finding of Moses.* Rediscovered by Erich Schleier and published in *Arte Illustrata*, 1971, fig. 14, as probably from the 1660's.

PALAZZO ALTIERI. Salone verde. Two frescoes in stucco frames on the ceiling:

Autumn and *Winter*. 1674–5. For the dates see Armando Schiavo, *Palazzo Altieri*, 1964, 103. The frescoes are surrounded by a frieze which goes all round the room, illustrating *The Seasons* and *Signs of the Zodiac*, by Andrea Carlone 1674–7 (see also Ezia Gavazza, *Arte Lombarda*, VIII (ii), 1963, 264 ff.).

CASSA DEPOSITI E PRESTITI. (56) *The Element of Water. Modello* for a corner figure in the Collegio Innocenziano.

COLLEGIO INNOCENZIANO. Saletta d'Ingresso. Fresco in centre of ceiling: *Peace, Strength and Justice.*

Libreria Pamphily. Ceiling fresco: *The Triumph of (Pamphily) Wisdom, surrounded by Virtues, Elements etc.* The payments are 1667 to 1672 (L. Mortari, *Commentari, op. cit.*). The theme is a sort of Pamphily answer to the Barberini ceiling, and there are many emblems of the Pamphily and Aldobrandini families. A *modello* for *Water* is in the Cassa Depositi e Prestiti; and a small autograph repetition, on copper, of *Music* is in the Glasgow Gallery (144).

COLLEGIO NEPOMUCENO. Refectory. *Madonna del Riscatto.* Signed: Fran^cus Cozza Pin^at/MDCLX. (GFN, E, 14785.) [Plate 29.] From the high altar of the demolished church of S. Francesca Romana in the Via Sistina. First published by L. Lopresti, *op. cit.*, where the date is wrongly given as 1650.

PALAZZO DELL' OSPEDALE DI S. SPIRITO. Sala intermedia: *La Madonna cucitrice.* (GFN, E, 38062.) Good studio replica, with slight variations, of a design etched by Cozza himself (Bartsch I). An original version of it was incorporated in 1645 into a composite altar structure in S. Bernardino, Molfetta (GFN, E, 56580); another was formerly in the von Zedlitz collection, Berlin (Voss, p. 212).

Segni. CATTEDRALE. Altar to L. of high altar: *Incredulity of S. Thomas.* (GFN, E, 46973). Much restored.

Valmontone. PALAZZO DORIA-PAMPHILY (già). Frescoes on the ceiling of the first of the large rooms on the first floor: *The Element of Fire.* [Plate 28.] Now almost invisible, owing to fire damage. The payments are 1658 to 1661 (L. Montalto, *Commentari, op. cit.*, 289 ff.). One of the scenes was etched by Cozza himself (Bartsch, no. 5).

Fresco on ceiling of small room: *Asia. c.* 1658. Companion to the *Africa* of Mola (*q.v.*). I am not sure if this still survives. It is reproduced in *Commentari, op. cit.*, pl. LXXVI, fig. 3, and seems to be by Cozza.

GASPARD DUGHET (1615–1675)

Born in Rome of a French father and an Italian mother, his sister married Nicolas Poussin in 1630, and Gaspard studied with his brother-in-law 1630 to 1635, and was often called by his name. He was elected an Accademico di S. Luca in 1657 as 'Gasparo Duchè alias Pusino'. He specialized in landscapes, serene or wild, based largely on the Roman Campagna, but he also travelled a good deal in central Italy. He was a rapid worker and very prolific, and his naturalistic, but carefully composed, landscapes had a profound effect on the feeling for the

picturesque in Northern Europe. He had a considerable following and his own works and those of his followers in easel painting have not been fully disentangled. He sometimes collaborated with other painters (Maratti, Mola, Miel, Lauri, etc.) and executed landscapes with their figures. It seems fairly certain that a painter at one time isolated as 'The Silver-birch Master', is an early phase of Gaspard. His frescoes are only to be found in the Roman area and these alone, except for certain series, are all that I have listed below.

Bibl.: Pascoli; Baldinucci; Dézallier d'Argenville. A convenient summary of information, with numerous illustrations, by Denys Sutton, *Gazette des Beaux Arts*, 1962, 269–312. Best account, with full bibliography, by Francesco Arcangeli in pp. 256 ff. of the catalogue of the 1962 Bologna Exhibition *L'ideale classico del Seicento in Italia e la pittura di Paesaggio*; Malcolm R. Waddingham in *Paragone*, no. 161 (1963), 37–54.

Rome. S. MARTINO AI MONTI. Frescoes on the side walls of the Church: *Landscapes with scenes from the lives of Elijah, Elisha and S. Simon Stock.* 1647–51. The figures in one at least were designed by Testa. The whole series (including the two frescoes by G. F. Grimaldi (*q.v.*) which are wrongly ascribed to Dughet) was engraved by P. Parboni, 1810, with captions which identify the, often esoteric, subjects; see also T. S. R. Boase, *Journal of the Warburg and Courtauld Institutes*, III (1939–40), 107–18. For the payments and dates, see Ann B. Sutherland, *Burl. Mag.*, CVI (Feb. 1964), 63 ff.

PALAZZO BORGHESE. Frescoes on the ceilings of two small rooms on the mezzanine floor: (i) *Scenes of the Loves of the Gods* (Birth of Myrrha, Diana and Actaeon, Mars and Venus, Latona and the frogs, and four *tondi* with the loves of Jupiter) round a central fresco by Filippo Lauri. (2) *Four landscape scenes with figures* round a fresco by Lauri. Payments to Lauri, 1671; to Gaspard, 1672. First illustrated in Bianca Riccio, *Commentari*, X (1959), 3 ff. For documents see Howard Hibbard, *The Architecture of the Palazzo Borghese*, 1962, 78, *n.* 23.

PALAZZO COLONNA. Rooms on the ground floor: (1) Frescoes on the end walls of the room with Pintoricchio ceiling: *Two big and two small landscapes* (much redone). (2) Frescoes on the side walls of the second room beyond the last: *Six large landscapes, seven partial landscapes,* and one oval, arranged among columns and trellises by another hand (a good deal repainted).

Gallery. *Twelve landscapes* (gouaches). The late Sr Corti reported that these were all bought together in 1673, but not from the painter.

PALAZZO COSTAGUTI. Fresco friezes, with figures by Allegrini (?) in two small rooms: *Landscapes with scenes from Roman history.*

PALAZZO DORIA-PAMPHILY (Piazza Navona). Fresco frieze in the room between the Camassei room and the one with Roman scenes by Gimignani: *Three landscapes and one coast scene.* [Plate 31.] About 1648 to 1650.

PALAZZO DORIA (al Corso). Some of the easel pictures in the Gallery and some of the very numerous Gaspardesque *Landscapes* in the State Rooms (constructed

1659–61) are certainly by Gaspard, but certainty of attribution can only be
achieved by publication of the documents, which are said to exist: see Malcolm
Waddingham, *op. cit.*

PALAZZO MUTI-BUSI. Frieze with fourteen scenes in ovals and rectangles (*Land-
scapes* and *Coastscenes*) in a setting by another hand. Published by Ilaria Toesca,
Paragone, no. 125 (1960), figs. 33–5.

PALAZZO PATRIZI. *Two landscapes* and one *Harbour scene*. Very large gouaches.

PALAZZO PECCI-BLUNT (formerly Malatesta). *Frescoes on ceiling of small loggia.*
(In centre *Creation of Eve*, very damaged; and six scenes in fancy shapes: *Lot
leaving Sodom, Lot and his daughters, Balaam and the Angel, Abraham repudiates
Hagar, Tobias and the fish, Hagar and Ishmael in the desert.*)

PALAZZO DEL QUIRINALE. Sala degli Ambasciatori: oval fresco: *Creation of Adam
and Eve* (figures by Lazzaro Baldi); oval fresco: *Sacrifices of Abel and Cain*
(figures by Filippo Lauri). 1657. For the documentation see N. Wibiral, *Bollettino
d'Arte*, 1960, 134 ff.

Valmontone. PALAZZO DORIA. Frescoes in room on first floor at the back: *Balconies
with trees behind and Gallants and Ladies* (figures presumably by Mola). 1658 ff.
For the documentation see L. Mortari, *Commentari*, VI (1955), 267 ff. Sabine
Jacob, *Revue de l'Art*, 1971, 54, for unknown reasons ascribes them to Grimaldi.

CIRO FERRI (1628 (*or* 1634)–1689)

*The closest, and one of the ablest, but least original, pupils of Pietro da Cortona. Accademico
di S. Luca 1657: from 1659 to 1665 he was in Florence completing Pietro's decorations for
the Pitti Palace, and he did not return to Rome until 1667. He completed some of Pietro's
unfinished works after his death in 1669 and remained in Rome for the rest of his life. (The
Masucci drawing made for N. Pio gives the date of his death as 1692.) Much of his work
consists of designs for church furnishings (often sculpture), frontispieces and religious or com-
memorative engravings (cf. Karl Lankheit,* Florentinische Barockplastik, *1962, 39–47;
Jennifer Montagu in* Art Bulletin, *LII (1970), 288 ff.).*

Bibl.: Pascoli; good article in Thieme-Becker (with bibliography).

Frascati. VILLA FALCONIERI. Frescoes on three ceilings: *Rape of Oreithyia; A wine
Feast; Flora* (later enlarged into a bower). Probably from the 1670's: heavily
restored in 1910. See under Grimaldi.

Monteporzio Catone. S. GREGORIO. Altar to R: *Vision of S. Anthony of Padua.*
Engraved by A. Bloemaert 1678. The church was built and decorated 1666 ff.

Rome. ACCADEMIA DI S. LUCA. *Martyrdom of S. Lazarus.* Formerly in SS. Luca e
Martina. [Plate 32.]

DORIA. 87 (183). *Erminia and the Shepherds.* Latterly given to Pietro da Cortona:

but in the 1682 inventory as Ciro Ferri (see Lina Montalto, *Un mecenate in Roma barocca*, 1955, 583).

GALLERIA NAZIONALE (Corsini). *Cyrus liberating the Israelites from prison in Babylon.* 1656. (GFN, E, 51761.) *Modello* for fresco in Quirinal. Bought in London 1962. (Deposito Lincei). 934. *Jacob and Rachel.* (GFN, E, 49159.)

1341. *Moses liberating the daughters of Jethro.* (GFN, E, 49158.) Companion to last.

SPADA. 279. *Vestal Virgins tending the Sacred Flame.* (GFN, E, 27948.) Engraved by Pietro Aquila as Ferri.

PALAZZO VENEZIA. 882. *Marriage of S. Catherine.* Signed and dated 1686 on the back.

S. AGNESE A PIAZZA NAVONA. Frescoes in dome: *S. Agnes introduced to the Virgin by the Heavenly host.* Commission in 1670 and the *modello* was ready quite soon. It is not clear how much had been executed at the time of Ciro's death. It was completed by a feeble painter whose name may have been Corbellini (B. Canestro Chiovenda in *Commentari*, X, 1959, 16 ff.).

S. MARCO. 3 to L: L. wall: fresco *S. Nicholas of Bari.*
Sala Capitolare: *Virgin and Child with S. Martina.* Formerly on the altar of 3 to L: parts of the decoration of the 1650's, completed by 1657.

S. MARIA DELLA MORTE. High altar: *Crucifixion.*

S. NICOLA DA TOLENTINO. 2 to L: frescoes in cupola: *Angel musicians.* (GFN, E, 39779.) Begun by Pietro da Cortona; finished after 1669.

S. PRASSEDE. 2 to R: fresco lunettes on side walls: to L: *The attack on Gelasius II when saying Mass in S. Prassede*; to R: *S. Helena supervising the setting up of a statue of the Madonna* (?). Probably painted just before Ciro left Rome in 1659.

PALAZZO DEL QUIRINALE. Galleria di Alessandro VII: *Cyrus liberating the Israelites from prison in Babylon.* 1656–7. See N. Wibiral, *Bollettino d'Arte*, 1960, 136 ff. The *modello* is in the Galleria Nazionale.

Vatican. S. PIETRO. First bay of R. aisle. Designs for *mosaics in spandrels and lunettes.* 1669–73. Cortona had finished most of the cartoons for the cupola of this bay at the time of his death in 1669. Ferri did the rest and also the cartoon for *S. Peter.* 1675, over the Holy Door (O. Pollak, *Italienische Künstlerbriefe*, 1913, 14–15).
Third bay in L. aisle: *Mosaics in cupola* on the text 'Procidebant et adorabant viventem'. Ferri began some cartoons for this bay, but none of the spandrels or lunettes are his: and the cupola looks as if the cartoons had been at least modified by M. A. Franceschini, who completed the work in 1710–12.

Valmontone. S. MARIA ASSUNTA. 3 to L: *Annunciation.* Probably a very late work as the church was not finished until 1689.

Viterbo. PALAZZO ARCIVESCOVILE. *Madonna with SS. Thomas of Villanova and William of Aquitaine.* Executed in collaboration with Anton Angelo Bonifazi (*q.v.*). This joint authorship is also visible in the *modello* which was in Lord Methuen's sale, Sotheby's, 26 May 1965 (36), and last in Anon. sale, Sotheby's, 6 Dec. 1972 (82).

Note: It seems probable that certain of the cartoons for tapestries taken over by the State from the Barberini Collection may be by Ciro Ferri from *c.* 1683 (see Blunt and Cooke's *Roman Drawings of the XVII and XVIII Centuries at Windsor Castle*, 1960, 36).

LUIGI GARZI (1638–1721)

A native of Pistoja, he was trained under Sacchi. Accademico di S. Luca 1670, and Principe of the Academy 1682. He worked in Naples about 1696 to 1698. He was much employed and had a good reputation, but a good deal of his work appears slovenly and is of studio quality. In later years he fell under the spell of the Marattesque.

Bibl.: Pascoli; F. Tolomei, *Guida di Pistoja*, 1821, 166–8; Giancarlo Sestieri, *Commentari*, XXIII (1972), 89–111 (with list of works).

Rome. ACCADEMIA DI S. LUCA. Modello: *Glory of Angels.* For the ambulatory ceiling of S. Carlo al Corso (*q.v.*).

GALLERIA NAZIONALE (Corsini). *Finding of Moses.* (GFN, E, 68876.) Wrongly listed in my first edition as by Baciccia and in the Palazzo Chigi (where it then hung). *S. Sylvester showing the portraits of SS. Peter and Paul to Constantine.* (GFN, E, 68885.) Bought 1969; a *modello* (with considerable variations) for the picture in S. Croce in Gerusalemme.

The Prophet Joel. (GFN, E, 69052.) Bought 1970; a *modello* for the picture in S. Giovanni in Laterano.

S. BARBARA DEI LIBRAI. Former high altar: *S. Barbara adoring the Trinity.* Ruined. Fresco on nave ceiling: *S. Barbara in glory*: and hopelessly repainted frescoes on the walls of the transepts.

All part of a general restoration in the 1680's. This long neglected church has now been deconsecrated and these battered wrecks need not be considered in an estimate of Garzi.

S. CARLO AL CORSO. Fresco on ceiling of 3rd bay of L. aisle: *Allegory of Faith*, with *Virtues* in the angles. *c.* 1677–8.

Fresco on ceiling of ambulatory, behind the High altar: *Glory of Angels.* 1681. A *modello* in Accademia di S. Luca (Sestieri, *op. cit.*, 94). For dates see G. Drago and L. Salerno, *SS. Ambrogio e Carlo al Corso*, 1967, 108 ff.

S. CATERINA A MAGNANAPOLI. Fresco on ceiling of nave: *The Virgin introducing S. Catherine of Siena to Christ in glory.* (GFN, E, 21200.) Noticed as lately completed in the 1713 Pinaroli Guide. A *modello* is in Copenhagen. It is closely related to the nave ceiling fresco of *c.* 1696 in S. Caterina a Formiello, Naples. Probably executed with studio help from Nelli (T. Poensgen, *Die Deckenmalerei in Italienischen Kirchen*, 1969, 91). 2 to R: *Triumph of S. Catherine and All Saints.*

(GFN, E, 20126); Frescoes on the ceiling: *Marriage of S. Catherine*; *Christ in glory*; *Martyrdom of S. Catherine*. Probably after 1713.

S. CROCE IN GERUSALEMME. 3 to L: *S. Sylvester showing the portraits of SS. Peter and Paul to Constantine*. (GFN, E, 56442.) [Plate 33.] Probably soon after 1675 and certainly before 1686. A *modello* in Galleria Nazionale.

S. GIOVANNI IN LATERANO. 3rd to L. of the series of ovals above the nave arcades: *The Prophet Joel*. 1718. A *modello* is in the Galleria Nazionale.

S. GIOVANNI DELLA PIGNA. Fresco in the attic above the High altar: *Pietà*. Before 1686.

ORATORIO DEL GONFALONE. In a room attached to the Oratory. *Madonna with SS. Charles Borromeo and Filippo Neri*. (GFN, E, 25124.) Probably *c*. 1715. A wreck: from the church of SS. Venanzio e Ansuino.

S. IGNAZIO. 2 to R: Fresco in dome: *S. Joseph received into Heaven*. Frescoes in angles of cupola: *The Marriage of the Virgin*; *Christ among the Doctors*; *Adoration of the Shepherds*; *Angel warns S. Joseph to fly to Egypt*. Late work; begun soon after 1712 (Forcella, x, no. 188).

S. MARCELLO. 4 to R: Screen which covers the Crucifix: *Angels supporting the Cross*. Before 1686.

S. MARIA IN CAMPO MARZIO. 3 to R: *S. Gregory Nazianzen*. (GFN, E, 20406.) Mentioned as lately commissioned in the 1686 Titi.

S. MARIA DEL CAMPOSANTO (Collegio Teutonico). Museo: *Immaculate Conception*. Before 1686. This ruined object seems to be the picture which was once over the altar in the Oratory.

S. MARIA DI MONTESANTO. 3 to L: R. wall: *Vision of S. Francis*. About 1686.

S. MARIA DEL POPOLO. 2 to R: Fresco in cupola: *God and Angels. c.* 1685-6.
Left wall of choir, behind high altar: *Martyrdom of S. Lucy.* (ruined.)

S. MARIA IN TRANSPONTINA. Oratory: altar: *Christ preaching*. The oratory was built in 1715 (Forcella, VI, 1148).

S. PAOLO ALLA REGOLA. Frescoes in apse: *S. Paul preaching*; *Conversion of S. Paul*; *Decapitation of S. Paul*. Probably soon after 1700. Repd. in Padre Giovanni Parisi, *S. Paolo alla Regola*, 1931, figs. 4-6.

S. SILVESTRO IN CAPITE. 2 (3) to L: *S. Marcello in prison receiving a vision of the Holy Family*. 1705. For the date, see J. S. Gaynor and I. Toesca, *S. Silvestro in Capite*, 1963, 110. (GFN, E, 52101.)2 (3) to R. L. wall: *S. Francis preaching*. (GFN, E, 49505) [Plate 34]; R. wall: *S. Francis renouncing his worldly possessions*. (GFN, E, 49506); Fresco on ceiling: *S. Francis in glory*. An inscription says all the chapels were finished in 1696 and these appear in the 1697 guides: but as Garzi was in Naples 1695-7, they may have been finished later; however, the payments are 1695-6 (Sestieri, p. 96).

STIMMATE DI S. FRANCESCO. Fresco on ceiling of nave: *S. Francis ascending to glory. c.* 1720.

ANTONIO GHERARDI (1644–1702)

*A native of Rieti, pupil of Mola, after whose death in 1666 he transferred for a short time to
Pietro da Cortona. Extensive travels in North Italy before he settled again in Rome in 1670
gave him what was called a 'maniera lombarda' and was certainly something new in Roman
baroque painting. Accademico di S. Luca 1674. He practised also as an engraver, and, with
considerable ingenuity, as the architect for chapels with illusionist arrangements.*

Bibl.: Pascoli, II, 287; Amalia Mezzetti, *Bollettino d'Arte*, 1948, 157 ff.; Urbano
 Barberini, *ib.*, 1968, 92 ff.

Rieti. MUSEO CIVICO. *S. Leonardo visiting a prisoner.* 1698. From S. Maria del Suffragio.
 The date, with the name of the donor, is on the picture (GFN, E, 39086).
 S. ANTONIO DEL MONTE. *Assumption.* For the Rieti pictures see Luisa Mortari,
 Opere d'arte in Sabina, 1957, figs. 49–50.

Rome. GALLERIA NAZIONALE. Cartoon for tapestry: *Urban VIII visits Perugia to
 repair the damage caused by the flooding of Lake Trasimene.* 1665. See Urbano
 Barberini, *loc. cit.* Gherardi's other two cartoons (*Urban VIII receiving his doctor-
 ate at Pisa.* 1663, and *Urban VIII made cardinal.* 1666–7) now belong to Prince
 Corsini in Florence.
 S. CARLO AI CATINARI. 3 to R: *S. Cecilia and Angels.* [Plate 35.] Engraved by F.
 Aquila, 1692. The whole chapel, which is on Gherardi's design, was completed
 rather later. (GFN, E, 24832.)
 CRISTO RE. 1 to R: L. wall: *Family of the Virgin.* From the demolished church of
 S. Venanzio dei Camerinesi.
 S. MARIA IN ARACELI. Chapel to R. of high altar: L. wall: *Death of S. Francesco
 Solano.* (GFN, E, 7702.) The chapel, which was originally on Gherardi's design but
 has been remodelled, was begun very soon after the Saint's beatification in 1675.
 S. MARIA IN TRANSPONTINA. 4 to L: *S. Teresa in ecstasy.* Illustrated (as Calandrucci)
 in E. Mâle, *L'art religieux après le concile de Trente*, p. 166). For the confusion
 between this and the Calandrucci in 2 to L. see Mezzetti, *op. cit.*, 173. Probably
 c. 1700.
 S. MARIA IN TRASTEVERE. 5 to L. (Avila chapel): *S. Jerome.* Gherardi also designed
 the whole chapel, about 1680 (Forcella, II, no. 1106).
 S. MARIA IN TRIVIO. Ceiling of nave: in central compartments: *Marriage, Assumption*
 and *Presentation of the Virgin.* In the triangles at the sides of these: *Visitation,
 Nativity, Flight into Egypt, Christ among the doctors, Adoration of the Shepherds,
 Birth of the Virgin, S. John's Vision on Patmos.* Dated 1670.
 Room to L. of sacristy. Oval canvas on ceiling: *S. Camillo de Lellis healing a sick
 member of the Crescenzi family.* Probably soon after the paintings in the church.
 SS. SUDARIO. High altar: *SS. Maximus and Maurice and the BB. Amadeo, Margherita
 and Ludovica of Savoy in adoration of the dead Christ lying on the SS. Sudario.*
 Documented as 1682 (Mezzetti, *op. cit.*, 178).

PALAZZO NARI (Via di Monterone 2). Frescoes in room on first floor: *Stories of Esther and Ahasuerus. c.* 1670. Discovered and published by A. Mezzetti, *op. cit.*, 159 ff.

FILIPPO GHERARDI see GIOVANNI COLI

GIUSEPPE GHEZZI (1634–1721)

Son of a painter and engineer from the Marche, he was at first trained locally but finally decided to become a painter after moving to Rome in the 1660's. Accademico di S. Luca, 1674; and Secretary of the Academy from 1678 to 1719. He became a central figure in the Roman art world, latterly much in demand as an advisor to collectors and restorer of old masters for, among others, Queen Cristina of Sweden. He and his son, Pierleone Ghezzi (who was an excellent portrait painter), were protégés of Clement XI and of the rest of the Albani family. He does not seem to have done much independent painting after 1700.

Bibl.: Pascoli; a letter from Ghezzi to Padre Orlandi in Amico Ricci, *Memorie storiche delle arti e degli artisti della Marca di Ancona,* Macerata, 1834, II, 316–17.

Rome. ACCADEMIA DI S. LUCA. The surviving portraits of *Federico Zuccaro* and *Muziano* (and perhaps others) were redone after the battered originals by either Giuseppe or Pierleone Ghezzi.

GALLERIA NAZIONALE. *SS. Paula and Eustochium embarking from Ostia for the Holy Land.* Signed and dated 1676. (GFN, E, 73309.) [Plate 36.] From S. Maria Annunziata delle Turchine (where there were also Ghezzi altarpieces of the *Annunciation* and *S. Gertrude*). Bought 1971 (*Acquisti della Galleria Nazionale . . . 1970–1972,* p. 44).

S. CECILIA IN TRASTEVERE. I to L: *SS. Stephen and Lawrence.* Signed and dated 1676. 3 to R: *S. Benedict.* Also of 1676. This has changed places with Baglione's *S. Andrew* on the opposite altar.

S. GIUSEPPE DEI FALEGNAMI. 2 to R: *Holy Family with S. Anne.* 1692. For the date see Giuliana Zandri, *S. Giuseppe dei Falegnami,* 1971, 50.

S. MARIA IN ARACELI. Chapel to R. of high altar: five small paintings on the ceiling: *Virgo Immaculata; SS. Joseph and Francis;* and *Two Prophets.* Painted between 1675 and 1686.

S. MARIA MADDALENA. Attic of altar of 2 to R: *Angels and Dove of the Holy Spirit.* 1718. See *Attività della Soprintendenza alle Gallerie del Lazio,* 1970, Scheda 33.

S. MARIA DEL SUFFRAGIO. High altar: *The Madonna del Suffragio, with Souls in Purgatory below.* Ghezzi's first public commission and already listed in the 1674 Titi. Thought to be dated 1672 (L. Salerno, etc., *Via Giulia,* 1973, p. 341).

S. MARIA IN VALLICELLA. Two of the ovals above the nave arcades. Second oval to

L: *S. Mary Magdalen in penitence*; second oval to R: *Rebecca and Eliezer at the well*. Pictures over the transept arches. To L: *The Resurrection of the Dead*; to R: *Adam and Eve before God*. All four are part of the series of paintings planned for the Anno Santo of 1700. They were already being allocated in 1695 (Bottari-Ticozzi, *Raccolta di Lettere*, 1822, III, 490 ff.).

S. MARIA IN VIA LATA. 2 to R: *S. Joseph, holding the Child Christ, is adored by SS. Nicholas of Bari and Blaise*. 1686. The 1686 Titi says Ghezzi was then painting it.

S. SALVATORE IN LAURO. I to R: *Madonna weeping over the dead Christ*. Canvases on side walls: to L: *S. Giacomo della Marca*; to R: *S. Nicolas of Tolentino*. The date of the chapel is about 1694 (Forcella, VII, no. 194).

S. SILVESTRO IN CAPITE. 3 (4) to R: altar: *Pentecost*. (GFN, E, 52104). R. wall: *S. John baptizing*. (E, 52105) [Plate 37]; in lunette: *S. Gregory the Great*. (E, 52109). L. wall: *Baptism of Christ*. (E, 52108); in lunette: *Paul I inspired by an Angel to build S. Silvestro*. (E, 52101). Frescoes on ceiling: *God the Father and Angels*. About 1696–7.

Ronciglione. DUOMO. L. transept altar: *Madonna del Rosario*. The date of the altar is 1698 (G. B. Bedini, *Ronciglione nella Storia e nell' Arte*, 1960, 81).

GIACINTO GIMIGNANI (1611–1681)

A native of Pistoja, and son of an unknown painter, Alessio Gimignani, he had settled in Rome by 1630, where he became more attached to the classicizing style of Sacchi and Poussin than to the Baroque. He followed the tradition of Domenichino and Poussin and always retained an interest in tone and texture. He became Accademico di S. Luca in 1634 and married the daughter of Alessandro Turchi in 1640.

Bibl.: Pascoli; Gemma di Domenico Cortese, *Commentari*, XVIII (1967), 186 ff.; Bartsch, XX, 193 ff. (for his engravings): F. Tolomei, *Guida di Pistoja*, 1821, 170–3.

Ariccia. COLLEGIATA. I to L: *Death of S. Anthony Abbott*. Signed: HYACINTHVS / GIMIGNANVS / PISTORIES. PINGEBAT / A°.1665. See G. Incisa della Rocchetta, *Rivista del R. Inst. d'Archeologia e Storia dell'Arte*, I (1929), 373–4.

PALAZZO CHIGI. Eight sughi d'erbe canvases with *Putti playing, harvesting, mocking Silenus, etc*. Unattributed, but they are sufficiently close to Bartsch engravings nos. 8 to 19 to be pretty certainly by Gimignani.

S. MARIA DI GALLORO (near Ariccia). I to L: *S. Thomas of Villanova distributing alms*. 1662–3. Signed: HYACINTHVS GIMIGNANVS PISTORIENSIS Ping. 1662. See Vincenzo Golzio, *Documenti artistici sul Seicento nell' Archivio Chigi*, 1939, 410 and 416.

Castel Gandolfo. S. TOMMASO DE VILLANOVA. Altar to R: *S. Thomas of Villanova distributing alms*. 1661. For the date, see V. Golzio, *op. cit.*, 388 and 403.

Rome. ACCADEMIA DI S. LUCA. *Bacchanal*. (GFN, E, 36060.)

S. CARLO AI CATINARI. 3 to L: Fresco lunettes on side walls; to L: *Martyrdom of*

SS. *Marius, Martha, Audifax and Ambachum* [Plate 38]; to R: SS. *Marius, Martha, etc., relieving prisoners*. Signed HYACINTH / GIMIGNA^VS / PISTORIE^S P. / A.S. 1641. Former Refectory. Fresco: *Christ at Emmaus*. Signed and dated 1678 (Restauri della Soprintendenza, 1970–1, 1972).

S. CRISOGONO. Chapel to R. of high altar: ceiling fresco: *The Trinity and Virgin surrounded by Angels*. After 1641 (Cortese). Almost wholly repainted.

S. GIOVANNI IN FONTE. First large fresco to R: *Constantine's Vision of the Cross*. Part of the redecoration of 1640 to 1649 under Sacchi's general direction.

S. LORENZO IN LUCINA. 4 to R: R. wall: *Elisha pouring salt into the waters of Jericho*. Signed HYACINTHVS / GIMIGNANVS / PISTORIE^S / PING. A.S. / 1664.

S. MARIA DELL'ANIMA. 2 to R: *S. Anne receiving the Child from the Virgin*. Signed and dated 1640.

S. MARIA AI MONTI. Frescoes in lower part of tribune: *Crucifixion* (signed and dated 16(7?)6); *S. Peter baptizing in prison*; *Christ appearing to the Virgin*. The frescoes at either side of these are damaged studio work: to L: *S. Michael* above a bust of *S. George* (?) in a circle; to R: *Baptism of Christ* above *S. Peter* (?) in a circle. First noticed by G. di Domenico Cortese (*op. cit.*).

S. MARIA IN MONTICELLI. I to L: wall to L: *Martyrdom of S. Erasmus*. My attribution; perhaps the missing picture from S. Maria del Camposanto.

PROPAGANDA FIDE (I RE MAGI). High altar: *Adoration of the Kings*. Signed: ... Gemignani 1634. [Plate 40.]

S. SILVESTRO AL QUIRINALE. 2 to R: Canvas surrounding niche containing a Dugento 'Madonna delle Catene': *S. Pius V and Cardinal Alessandrino supporting the Image, with Angels*. Probably early work (Pascoli).

PALAZZO CAVALLERINI. Via dei Barbieri. Two ceiling frescoes: *Venus in her car, with Time clipping Cupid's wings*; *Flora scattering flowers*. Discovered and plausibly ascribed to Giacinto by L. Salerno, *Palatino*, VIII (1964), 13–14.

PALAZZO DORIA-PAMPHILY (Piazza Navona). Fresco frieze in room between Dughet and Camassei rooms: *Coriolanus with his wife and mother*; *Romulus and Remus* [Plate 39]; *Rape of the Sabines*; *Romulus dedicating the spolia opima*. Photos GFN, E, 45898–45906. Gimignani himself etched the design of the *Rape of the Sabines* in 1649 and dedicated it to Prince Pamphily. The final payment was in 1653 (D. Redig de Campos in *Piazza Navona*, 1970, 170).

Frescoes on the frieze of the Camera delle Donne illustri at the back of the Palace: *Judith showing the head of Holofernes* (signed and dated 1648); *Finding of Moses*; *Solomon and the Queen of Sheba*; *Esther and Ahasuerus*. The final payment of 1653 also applies to these. First published by G. di Domenico Cortese in *Commentari*, 1967, 194–7.

PALLAVICINI COLLECTION. (220) *Rest on Flight*.

(221) *Assumption of Pope S. Clement*.

(223) *Allegory*. Signed and dated 166(5 or 6). See *Commentari*, XIV, 1963, 255. Zeri ascribes it to the young Ludovico.

LUDOVICO GIMIGNANI (1643–1697)

Son of Giacinto Gimignani (q.v.) and no doubt his pupil; he completed his father's unfinished works. But he was also at first much influenced by Bernini, and, after 1665, by the experience of Venetian and 'Lombard' painting. Accademico di S. Luca 1672, and Principe 1688–9. At the end of his life he became influenced by the style of Maratti.

Bibl.: Pascoli; Gemma di Domenico Cortese, *Commentari,* XIV (1963), 254–65.

Ariccia. COLLEGIATA. 2 to L: *Rest on the Flight.* Signed and dated 1665. (GFN, E, 38639.) [Plate 41.]

Rome. ACCADEMIA DI S. LUCA. *Rinaldo and Armida.* (GFN, E, 35976.)

 S. ANDREA DELLE FRATTE. 1 to R: *Baptism.* Signed and dated 1683. 2 to R: *S. Michael overcoming Satan.*

 Sacristy altar: *Crucifixion.* Probably datable 1691–3 (*Commentari,* 1963, 262 n.).

 S. CARLO AL CORSO. Fresco on vault of ambulatory to L. of Garzi's fresco: *Allegory of Tolerance etc.* Probably soon after 1676.

 S. LORENZO IN LUCINA. 4 to R: *Annunciation.* An imitation in oval shape of Guido's picture in the Quirinal chapel. Ludovico's first public commission and already noted by G. B. Mola in 1663 (without attribution). Fioravante Martinelli about 1664 indicates his authorship.

 S. LUIGI DEI FRANCESI. 3 to L: *S. Louis hands the Crown of Thorns to the Archbishop of Paris.* Signed: LODOVICVS GIMIGNANVS MDCLXXX. Finished *modello* in the Düsseldorf Gallery (rep. in *Commentari,* 1963, pl. CI, with companion *modello* of lost Gesù altarpiece).

 S. MARIA IN CAMPITELLI. 3 to L: *Conversion of S. Paul.* The patronage of the chapel was acquired by Cardinal Capizucchi in 1685 and the picture is in the 1686 Titi.

 S. MARIA DI MONTESANTO. 2 to L: *Virgin covers S. Maria Maddalena dei Pazzi with a veil;* L. wall: *Appearance of S. Augustine to the Saint;* R. wall: *Christ communicating the Saint;* fresco on ceiling: *Christ in glory.* Datable 1680 ff; cf. Forcella, IX, no. 393. The chapel was completed before 1686.

 S. MARIA DELLE VERGINI (S. RITA DA CASCIA). Fresco on ceiling of tribune: *Glory of the Trinity. c.* 1682–3.

 Frescoes in dome: *Glory of Heaven, etc.,* 1690's.

 For the dates see *Commentari,* 1963, 261, *n.* 28 and 264, *n.* 39.

 PROPAGANDA FIDE (I RE MAGI). 2 to L: *A Saint preaching about the Crucifixion.*

 S. PUDENZIANA. *Assumption.* (GFN, E, 202361.) Formerly the high altar of S. Maria delle Vergini and datable 1682–3 (*Commentari,* 1963, 261). It is no longer hung in S. Pudenziana.

 S. SILVESTRO IN CAPITE. 3 (4) to L: Altar: *Immaculate Conception.* (GFN, E, 52102); fresco lunettes on side walls, to L: *Annunciation.* (GFN, E, 52131); to R: *Nativity.*

(GFN, E, 52130); frescoes on ceiling: *God in glory* and *Putti* in the angles. Payment 1697.

2 (3) to L: Canvases on side walls: to L: *Death of S. Joseph.* (GFN, E, 52110); to R: *Holy Family.* (GFN, E, 52107); fresco on ceiling: *S. Joseph in glory.* Documented 1695.

Semidome of apse. Fresco: *S. Sylvester baptizing Constantine.* Commissioned 1688.

Frescoes on ceiling of N. transept: *Pope S. Stephen preaching against idols*; *Glory of Angels*; *The Baptist preaching.* 1688–90.

For the dates see I. Lavin, *Bollettino d'Arte*, XLII (1957), 44–9; and J. S. Gaynor and Ilaria Toesca, *S. Silvestro in Capite* (Le Chiese di Roma illustrate, no. 73), 1963.

PALAZZO CAVALLERINI (Via dei Barbieri). Fresco on ceiling of a small room: *Justice, Fame and Truth.* Published, with plausible attribution, by Luigi Salerno, *Palatino*, VIII (1964), 14.

PALAZZO PALLAVICINI-ROSPIGLIOSI. Pallavicini collection: (224) *S. Pietro Alcantara in ecstasy.* 1669. (225) *S. Maria Maddalena dei Pazzi healing a possessed woman.* 1669.

Federconsorzio (ex Rospigliosi collection). *S. Maria Maddalena dei Pazzi receiving the veil.* 1669. (Signed and dated.) (GFN, E, 32305.) *Death of S. Joachim of the Franciscan Order.* 1669. (GFN, E, 38462.)

The last four pictures are companions and were all painted to celebrate the canonization by the Rospigliosi Pope (Clement IX) of the three Saints involved in 1669.

Esther and Ahasuerus. (GFN, E, 38506.)

Young man with a dog. (Anderson 41300 as Baciccia.) See F. Zeri, *Paragone*, no. 61 (1955), 56–7. The dog is by Ludovico David.

Tivoli. DUOMO. 3 to R: Lunettes on the side walls: to L: *S. Lawrence distributes the goods of the Church as alms*; to R: *S. Lawrence baptizes his gaoler, S. Hippolytus.* (GFN, E, 67030; E, 67027.)

PAOLO GISMONDI (c. 1612–c. 1685)

A native of Perugia and generally known as 'Paolo Perugino', he became a pupil of Pietro da Cortona and was Accademico di S. Luca in 1641: he has little individual style and his most ambitious work, the decoration of S. Giovanni a Porta Latina (1668), has been destroyed in the present century.

Bibl.: Pascoli, *Pittori etc. Perugini*, 202–4.

Rome. S. AGATA DEI GOTI. Six large paintings on the clerestory level of the nave: *Scenes from the Life and Martyrdom of S. Agatha.* Fresco in apse: *S. Agatha received*

into Glory. Four *Female Allegorical figures* (two in the spandrels of the triumphal arch and two at the sides of the organ). Though listed by Pascoli, four of the large paintings are reproduced in *S. Agata dei Goti,* by C. Huelsen and others, 1924, as by Cerrini.

S. AGNESE A PIAZZA NAVONA. Sacristy. Frescoes on the ceiling: in centre *S. Agnes in glory with worshippers below* [Plate 42]; in triangular compartments at the sides *Religion* and *Purity.* On the arch over the altar: *The Virgin in glory amid Angels* (damaged), *c.* 1664. For the date see V. Golzio, *Archivi d'Italia,* I (1933–4), 302; J. Garms, *op. cit.,* no. 717.

GIOVANNI FRANCESCO GRIMALDI (1605/6–1680)

Known as 'il Bolognese', he formed his rather old-fashioned landscape style in the Carracci tradition at Bologna, probably under Albano. He settled in Rome about 1626 and produced a great many engravings. Accademico di S. Luca 1634; Principe 1665. He was Court Painter at Paris 1649–51, but spent the rest of his life in Rome, where he had a large foreign clientèle for his cabinet pictures.

Bibl.: Pascoli; Noack in Thieme-Becker; for MS. lives see note 2 in Danuta Batorska, *Master Drawings,* X (1972), 145–50; N. Wibiral, *Boll. d'Arte,* 1960, 155 and notes 134–5 (with bibl.).

Frascati. VILLA FALCONIERI. Frescoes in the last room at left (Sala di Primavera) converting it into a bower (the *Flora* in the centre of the ceiling is by Ciro Ferri, *q.v.*). See Danuta Batorska, *op. cit.* Perhaps 1672.

Rome. BORGHESE. 75–8. *Four landscapes.* Bought 1678.

GALLERIA NAZIONALE. 154. *Landscape with Pyramus and Thisbe.*

DORIA. 372 (234). *Landscape with satyr family.*

S. MARIA DELL' ANIMA. 2 to R: Frescoes on vault and upper side walls: to L: *Meeting of Joachim and Anne;* to R: *Angel appears to Joachim in the desert;* in vault: *Virgin and S. Anne in glory.* Altarpiece dated 1640.

S. MARIA IN PUBLICOLIS. Altar to L: *S. Francis in prayer* (after Carracci). Dated 1655. See *Mostra dei Restauri,* 1969, 25.

S. MARIA IN TRIVIO. I to R: Canvases on sides and vault of entrance arch: *The Seven Sorrows of the Virgin.* See L. Mortari in *Mostra dei Restauri,* 1969, 26.

S. MARIA DELLA VITTORIA. 3 to L: Frescoes on ceiling: *Nativity, Baptism,* and *Transfiguration;* on vault of entrance arch: *S. Ambrose; S. Augustine.* Mostly ruined. Soon after 1641 (G. Matthiae, *S. Maria della Vittoria,* 1965, 79).

S. MARTINO AI MONTI. Frescoes to L. and R. of 2 to R: that to L. is practically destroyed; to R: *Elijah foretelling rain* (Anderson 17992). 1648. The first is recorded in an engraving by Parboni: see for this and date, Ann Sutherland, *Burl. Mag.,* CVI (Feb. 1964), 58 ff.

VILLA DORIA-PAMPHILY. Casino. Frescoes in room on ground floor: *Perseus and Andromeda* and *Six scenes from the Life of Hercules*. [Plate 43.] (One has disappeared and all are damaged.) See Olga Raggio, *Paragone*, no. 251 (1971), 6 ff. For the iconographic programme see Danuta Batorska, *Abstracts of CAA Meeting at Detroit*, Jan. 1974, p. 91.

Frescoes in central room on first floor: *Four landscapes* (overdoors).

Payments to Grimaldi (who shared the architectural responsibility for the Casino with Algardi) are 1644–6 (O. Pollak, in *Zeitschrift für Geschichte der Architectur*, v, 1910–11, 49 ff.

PALAZZO DEL QUIRINALE. Sala Gialla. Two oval frescoes: *Moses and the burning Bush*; *Explorers returning from the promised Land*. Also general grisaille decoration. 1656–7. See N. Wibiral, *Boll. d'Arte*, 1960, 137 ff. and 162.

PALAZZO SANTACROCE. Frescoes on ceiling of small gallery. On vault: *Angel at Christ's empty tomb* and two landscapes with *Jacob wrestling with the Angel* and *Hagar and Ishmael*; also *Landscape lunettes*. (The figures on a larger scale may be Ruggieri.) Silvana Sinisi, *Palatino*, VII, 1963, 14 ff., identifies the frescoes in another room as those by Grimaldi (who made a valuation of the Santacroce collection as late as 1670). See *Storia dell'Arte*, 18 (1973), 173–9.

Tivoli. DUOMO. 2 to R. frescoes: L. wall: *Adoration of Shepherds*; R. wall: *Flight into Egypt*; dome: *Glory of Paradise*; spandrels: *SS. Lawrence, Alexander (Pope), Romuald and Hyacinth*. An inscription records that the chapel was begun in 1656; Grimaldi is documented as painting at Tivoli in 1658, and they are recorded by G. B. Mola in 1663.

Sacristy: fresco above the altar: *Pietà*; fresco on ceiling: *S. Lawrence in glory*. The sacristy was built in 1657 at the expense of Cardinal Santacroce, Bishop of Tivoli.

GIOVANNI LANFRANCO (1582–1647)

The one direct Carracci scholar whose works were listed in the first edition of this book. So much research has been done on Lanfranco since 1937 that my old list must be considered obsolete. A very full catalogue, with an exhaustive bibliography, will be found in Erich Schleier's forthcoming monograph.

FILIPPO LAURI (1623–1694)

Born in Rome, son of Balthasar Lauwers, a landscape painter of Flemish origin. He was a pupil of an elder brother, Francesco, and of his brother-in-law, Angelo Caroselli. Accademico di S. Luca 1654, and Principe 1685–6. His main speciality was in small canvases or coppers with paintings of religious or mythological scenes, of which he painted a prodigious number

(many of them repetitions); he also worked much in collaboration with other painters. Only his few major works are here listed.

Bibl.: Pascoli; Francesco Saverio Baldinucci (*Commentari*, x (1959), 3–15); Didier Bodart, *Les peintres des Pays-Bas méridionaux ... à Rome au XVIIme siècle*, Bruxelles/Roma, 1970, i, 169 ff.

Ariccia. PALAZZO CHIGI. *Spring* (with Mario de' Fiori). 1659. One of a set of four pictures of the Seasons done by Lauri, Brandi, Maratti and Mei all jointly with Mario de' Fiori (V. Golzio, *Documenti artistici sul Seicento nel Archivio Chigi*, 1939, 267 and 280) (GFN, E, 47807).

Rome. MUSEO DI ROMA. *Nocturnal fête held in 1656 at the Palazzo Barberini in honour of Cristina of Sweden* (with Filippo Gagliardi).

S. MARIA DELLA PACE. 2 to L. in nave: Frescoes above the altar. To L: *Adam and Eve chased from Paradise*; to R. *Adam and Eve with their children. c.* 1668–70.

PALAZZO BORGHESE. Frescoes, jointly with Gaspard Dughet, on the ceilings of two small rooms on the mezzanine floor, 1671 f. (see under Dughet).

PALAZZO DEL QUIRINALE. Sala degli Ambasciatori: oval fresco: *Sacrifices of Cain and Abel*. 1657; Sala del Trono: fresco: *Gideon with the fleece*. 1656–7. The landscape in the former is by Dughet (see N. Wibiral, *Bollettino d'Arte*, 1960, 140 ff. and 163).

GIOVANNI BATTISTA LENARDI (1656–1704)

A pupil of Lazzaro Baldi. Accademico di S. Luca 1690. Engravings after several of his works are known.

Bibl.: Thieme-Becker (1929).

Rome. S. ANDREA DELLE FRATTE. Painting to R. on wall behind the high altar: *Burial of S. Andrew*. Probably a very late work (Pascoli gives it to Antonio Crecolini, another pupil of Lazzaro Baldi). In much of the literature (*e.g.* my first edition and Mario d'Onofrio, *S. Andrea delle Fratte*, 1971, where it is reproduced fig. 19) it is confused with the Trevisani to L. of the high altar.

S. GIOVANNI CALABITA. 2 to R: *Death of S. Giovanni Calabita*.

BENEDETTO LUTI (1666–1724)

A Florentine, pupil of Gabbiani (who had been a pupil of Cortona). He came to Rome in 1690 and lived under the protection of the Grand Duke of Tuscany, in whose palace an Academy was held. Accademico di S. Luca 1694, and Principe of the Academy in 1720. He

was also associated with the French Academy in Rome and is one of the pioneers of Italian rococo. He had rather few public commissions in Rome, but was an able portraitist, especially in crayons. He was also well known as an 'expert', notably in drawings.

Bibl.: Pascoli; V. Moschini in Thieme-Becker (with bibliography); P. H. Dowley, *Art Bulletin*, XLIV (1962), 219–36; A. M. Clark, *ib.*, XLV (1963), 59; Giancarlo Sestieri, *Arte illustrata*, VI (1973), 232–55 with bibl.

Rome. ACCADEMIA DI S. LUCA. 26. *S. Benedict in the thornbush.* Reception piece, 1695.
 292. *Magdalen at Christ's feet.* Dated 1707 at back. Reduced version on copper of a large picture of the 1690's at Kedleston (Dowley, *op. cit.*).
 294. *Supper at Emmaus.* Companion to last.
 319. *Self-portrait.*
 427. *Cupid and Psyche.*
 COLONNA. Canvas let into ceiling of Sala di Martino V: *Pope Martin V received into heaven.*
 GALLERIA NAZIONALE. Inv. 2523. *David playing the harp to Saul.* Very large, unfinished, work. Bought 1969.
 SPADA. 311. *Portrait of Angela Mignanelli.*
 SS. APOSTOLI. 3 to R: *Vision of S. Anthony of Padua.* 1722. (GFN, E, 20350.)
 S. CATERINA A MAGNANAPOLI. 1 to R: *Last communion of the Magdalen.* Frescoes in vault: *Putti in adoration.* [Plate 44.] First recorded in 1721 Titi. Luti sent a drawing of the fresco to Ratti to be engraved in 1721 (Bottari-Ticozzi, VI, 168).
 S. GIOVANNI IN LATERANO. 6 to L. of the series of ovals over the nave arcades: *Isaiah.* 1718. (GFN, E, 21135.) [Plate 75.]
 PALAZZO DE CAROLIS. Ceiling painting in one of the rooms: *Luna and the Hours,* about 1722 ff. Recently recovered from the Theodoli collection (repr. *Arte Illustrata, loc. cit.*).
 PALAZZO PALLAVICINI-ROSPIGLIOSI. Pallavicini (289). *Portrait of the Duchessa Maria Camilla Pallavicini-Rospigliosi* (1645–1710). After 1700.
Valletta. S. CATHERINE OF ITALY. Altar to R: *Mater Dolorosa.* Signed: EQVES / BENEDICTVS LVTI / ROMAE PINGEBAT / MDCCXXI.

CARLO MARATTI (1625–1713)

The leading master of High Baroque Classicism, his manner being a fusion of the style of his master, Sacchi, with the movement and complex organization of Pietro da Cortona. He was doing some independent work as early as 1646 (i.e. for John Evelyn), but emerged as an independent master shortly before 1650. Accademico di S. Luca 1662; Principe 1664–5 and 1699–1713. By the end of the 1680's his classical vein had defeated the baroque of Baciccio in public favour, and he had become something like the art-dictator of the age. He is equally correctly called Maratta.

Bibl.: The most important contemporary source is G. P. Bellori's life, of which the only reliable text is in *Le vite inedite del Bellori*, ed. Michelangelo Piacentini, I, Roma, 1942. The fullest modern account is Amalia Mezzetti, in *Rivista dell' Istituto nazionale d'archeologia e Storia dell'Arte*, N. S. IV (1955), 253–354 with catalogue and bibliography under each picture, so that the lists below note only additions. See also Eckhard Schaar in Ann Sutherland Harris and Eckhard Schaar, *Die Handzeichnungen von Andrea Sacchi und Carlo Maratta*, Düsseldorf Museum, Düsseldorf, 1967 (with further bibliography).

Anagni. S. ANTONIO ABATE. High altar: *Annunciation.* 1659. Dated by a document published by C. Lorenzetti, *Rassegna marchigiana* I (1924–5), 337; but on the back is the date 1663. (GFN, D, 892.) Closely related small versions on copper are at Windsor Castle and in Leningrad.

Ariccia. PALAZZO CHIGI. *Summer* (with Mario dei Fiori). 1659. One of a set of the four seasons, with fruit and flowers painted by Mario dei Fiori, of which the others are by Brandi, Mei and Morandi (V. Golzio, *Documenti artistici . . . nell' archivio Chigi*, 1939, 280). (GFN, E, 27492.)

Monterotondo. COLLEGIATA. 3 to L: *SS. Peter, Philip, Michael, Paul and James* (in adoration of a 'holy picture' of the Madonna). *c.* 1645. (GFN, E, 9137.)

Rome. ACCADEMIA DI S. LUCA. (14) *Jael and Sisera*. (GFN, E, 36041.) Related to the cartoon for mosaics in S. Peter's.

CAPITOLINE. (52) *Holy Family.*

COLONNA. (77, 85, 93, 101). Mirrors with *Putti* painted by Maratti and flowers by other hands. 1670's.

GALLERIA NAZIONALE. *Cardinal Antonio Barberini*. (GFN, C, 5162.) [Plate 45.] Probably early 1660's. A three-quarter-length original is at Alnwick (Duke of Northumberland).

S. Bartholomew; *S. Matthew*; *S. Simon*; *S. John Evangelist* [Plate 46]; *S. Thaddeus* (dated 1696); *S. Paul*. Cardinal Antonio Barberini commissioned nine Apostles from Sacchi, who had only completed the *S. Peter* at the time of his death (1661). Maratti took over and *S. Paul* and five others are in the 1671 Barberini inventory; *SS. John* and *Thaddeus* were completed later (cf. Colnaghi's Exh., London, April/May, 1971). The first three above were acquired in 1934, the last three in 1972. *S. James the Greater* was acquired by the City Art Gallery, Leeds, in 1972. *S. James the Less* belongs to Esmé Almagià Simpson (R. E. Spear, *Renaissance and Baroque Paintings from the Sciarra and Fiano Collections*, Rome, 1972, no. 33).

GALLERIA NAZIONALE (Palazzo Corsini). (336) *Portrait of a man.*

(228) *The painter's daughter, Faustina (Allegory of Painting).*

(2344) *Maria Maddalena Rospigliosi* (1645–95). About 1665. Bought by the State at the Rospigliosi sale in 1932 and for some years exhibited in the Galleria Borghese.

(198) *S. Andrew adoring his cross*. Reduced version on copper of the central part of the big picture now at Bob Jones University, Greenville, S.C.

(223) *Madonna and Child with child Baptist and Angels.*

(402) *Rebecca and Eliezer.* Engraved by R. van Audenarde as belonging to Michelangelo Maffei.

(Mag.) *Reclining Venus with three Cupids.* Restoration of a classical painting in the Palazzo Barberini. (GFN, E, 28915.)

(Director's Office). *Flight into Egypt.* [Plate 50.] The altarpiece commissioned for Siena Cathedral and paid for in 1664. It was replaced by a mosaic. Bought in 1959 from the Chigi collection at Castelfusano. (GFN, E, 66685.)

MUSEO DI PALAZZO VENEZIA. *Cleopatra.* Ruffo bequest. Probably *c.* 1695 and a portrait of his daughter. (GFN, E, 26560.) A half-length version is at Providence, R.I.

S. ANDREA AL QUIRINALE. 3 to L: *Appearance of the Virgin and Child to S. Stanislas Kostka.* Commissioned in 1679 and completed in 1687.

S. CARLO AL CORSO. High altar: *S. Carlo Borromeo received into glory with SS. Ambrose and Sebastian below.* Begun 1685; finished 1690.

S. CROCE IN GERUSALEMME. 2 to R: *S. Bernard induces the Antipope Victor IV to submit to Innocent II.* Painted for D. Alberico Melzi, Superior 1656–9. (GFN, E, 15736.)

GESÙ. R. transept altar: *Death of S. Francis Xavier.* Commissioned 1674; completed 1679.

S. GIOVANNI IN FONTE. Fresco over the door leading to the Chapel of S. John Evangelist: *Constantine orders the Cross to be set up after the destruction of the idols. c.* 1648. Painted on Sacchi's cartoon.

Green grisaille figures (? *Peace and Abundance*) as supporters to the arms of Innocent X. 1648.

S. GIUSEPPE DEI FALEGNAMI. 2 to L: *Adoration of the Shepherds.* 1651.

S. ISIDORO. 1 to R. (Alaleona chapel). Frescoed lunettes on side walls: to L: *S. Joseph's dream*; to R: *Adoration of Shepherds.* Damaged fresco in cupola: *S. Joseph in glory.* About 1653–4.

This chapel originally included a *Sposalizio* on the altar: the *Flight into Egypt* (L. wall) and the *Death of S. Joseph* (R. wall), all of which have been replaced by copies.

1 to L. (Ludovisi chapel). Frescoed lunettes on side walls: to L: *Agony in the garden*; to R: *Christ crowned with thorns.* Fresco on ceiling: *Angels bearing the Cross and the Crown of Thorns. c.* 1655–7.

Chapel to R. of high altar (Sylva chapel). Oval: *Madonna Immaculata and Child. c.* 1663.

S. LUIGI DEI FRANCESI. Sacristy: *Holy Family with S. Joseph embracing the child Christ.* 1695. Very damaged. From S. Ivo dei Brettoni. A variant is in the Czernin Gallery, Salzburg.

S. MARCO. 3 to R: *Adoration of the Kings. c.* 1656.

1 to L: Battered remains of frescoes, especially *Prudence* (L.) and *Innocence* (R.) on side walls.

S. MARIA DEGLI ANGELI. Wall to L. of high altar: *Baptism.* 1696–8. Painted for the

Baptistery chapel in S. Peter's, where it was replaced by a mosaic copy in
1730–4. (F. R. Di Federico, *Art Bulletin*, L, 1968, 194 ff.).

S. MARIA SOPRA MINERVA. Second chapel to R. of high altar: *S. Peter presenting to
the Madonna SS. Luis Beltran, Rose of Lima, Philip Benizzi, Francisco Borgia and
Gaetano Thiene.* 1671–2. All five saints were canonized in 1671. (GFN, E, 21361.)
An excerpt of the figure of *S. Rose of Lima* in the Galleria Nazionale (Corsini),
which hung for a time in the Galleria Spada, is hardly an original.

S. MARIA DI MONTESANTO. 3 to L: *Virgin and Child with SS. Francis and James.* 1686
to 1689. [Plate 51.]

S. MARIA DELLA PACE. Large painting above first chapel to R. in the octagon:
Visitation. c. 1656–7.

S. MARIA DEL POPOLO. 2 to R: *Virgin Immaculata with SS. Gregory, John Chrysostom,
John Evangelist and Augustine.* Finished 1686.

S. MARIA DEI SETTE DOLORI. Altar to L: *S. Augustine and the child. c.* 1655.

CONVENTO DI S. MARIA DEI SETTE DOLORI. Waiting room: *Portrait of Donna Camilla
Farnese, Duchessa di Latera.* Foundress of the Convent, to which she moved in
1655. It is either by Maratti or by Sacchi.

CONVENTO DI S. MARIA IN TRANSPONTINA. *SS. Michael and Carlo Borromeo* (after
G. C. Procaccini in Dublin). 1673. See *Attività della Soprintendenza alle Gallerie
del Lazio*, XII Settimana dei Musei, Apr. 1970, Scheda 31.

S. MARIA IN VALLICELLA. Chapel to R. of high altar: *Virgin and Child with SS. Carlo
Borromeo, Ignatius and Angels.* Begun in 1674.

VILLA ALBANI. 71. *Death of the Virgin. c.* 1686.

PALAZZO ALTIERI. Fresco on ceiling of the Salone: *The Triumph of Clemency.*
[Plate 49.] Payments are 1674–5 and 1677 (Armando Schiavo, *Palazzo Altieri*,
1964, 92). There are also in the Palace two *modelli* for the fresco. The *Miracle of
S. Filippo Benizzi* (GFN, E, 32186) was sold about 1971.

PRINCIPE BARBERINI. *Don Maffeo Barberini.* Signed. (GFN, C, 8824.)

CONTE ANDREA BUSIRI-VICI. *Israelites rejoicing at crossing the Red Sea (Miriam).*
(GFN, E, 38011.) *Modello* for cartoon in the Vatican (*q.v*).

PALAZZO MASSIMO ALLE COLONNE. *Cardinal Camillo Massimo. c.* 1670. (GFN, E,
13961.)

PALAZZO PALLAVICINI-ROSPIGLIOSI. Pallavicini coll. 295. *Cardinal Jacopo Rospigliosi.*
Replica of the original, now in the Fitzwilliam Museum, Cambridge. Engraved
by P. Simon 1669.

PALAZZO DEL QUIRINALE. Sala degli Ambasciatori: *Adoration of the Shepherds.*
1657; retouched 1689–91. (GFN, C, 10847.) [Plate 52.] See N. Wibiral, *Bollettino
d'Arte*, 1960, 163.
 Cappellina della Manica Lunga: *Annunciation.* A variant of the Anagni design:
repr. G. Briganti, *Palazzo del Quirinale*, 1962, pl. 95.

Vatican. S. PIETRO. Mosaics executed from Maratti's cartoons:
 Second bay of L. aisle: *Cupola, spandrels and lunettes.* 'Dispersit superbos, respexit
humilitatem'. For full description see Chattard, I, 119 ff. Commissioned as

early as 1677, but some of the cartoons were finally completed by Giuseppe Chiari in 1708.

Third bay of L. aisle: Spandrels (*Jonah, Daniel, Habbakuk* and *David*). After 1689; not finished by 1699.

PINACOTECA. 397. Colossal *Virgin and Child.* The painting made for the mosaic in the cortile of the Quirinal. Begun before 1695 and finished *c.* 1697. (*Roma,* 1943, 262.)

453. *Portrait of Clement IX.* Signed and dated 1669. The prime original, from the Rospigliosi collection. Given to the Vatican 1930.

LOGGIA DELLA BENEDIZIONE. Cartoons: *Judith with the head of Holofernes* (Arch. Fot. Vat., XXXI, 75, 20) [Plate 48]; *Jael and Sisera; Elijah* (XXXI, 75, 19); *Moses and the burning bush* (XXXI, 75, 17); *Miriam* (XXXI, 75, 16); *Joshua* (XXXI, 75, 18). Cartoons for the mosaics in the second bay of the L. aisle of S. Peter's.

STANZA DI ELIODORO. Grisaille scenes below Raphael's frescoes: *Nine scenes relating to Agriculture, Commerce and Industry.* 1702–3.

PASQUALE MARINI (active 1682 to 1712)

A native of Recanati in the Marche. He won a prize at the Roman Accademia di S. Luca in 1682 and he appears also as a member of the Virtuosi al Pantheon in 1704, but he worked mainly in the Marche, producing rather undistinguished altarpieces. His one fresco in Rome is unexpectedly lively and suggests a study of Lanfranco as well as of Maratti.

Bibl.: Amico Ricci, *Memorie storiche . . . degli artisti della Marca di Ancona,* II (1854), 364; Thieme-Becker (Noack).

Rome. S. ANDREA DELLE FRATTE. Frescoes in the catina of the apse: *Multiplication of the loaves and fishes;* and in the dome over the crossing: *The Redemption;* in the spandrels: *The Fathers of the Greek and Latin Churches.* Apparently soon after 1700 (Mario d'Onofrio, *S. Andrea delle Fratte,* 1971, 44—who oddly ascribes the spandrels to Cozza); they are already in the 1708 Titi.

S. MARIA DI CAMPO MARZIO. R. Transept: altar: *Baptism;* L. wall: *Birth of the Baptist;* R. wall: *Decollation of the Baptist.* Reproduced in Mario Bosi, *S. Maria in Campo Marzio,* 1961, figs. 7 (*Baptism*), 11 (*Birth of Baptist*—with wrong caption), and 9 (*Decollation*).

AGOSTINO MASUCCI (1692–1758)

Also spelt 'Massucci'. A Roman and one of the last of Maratti's favourite pupils. Accademico di S. Luca, 1724, and Principe of the Academy 1736–8. On Chiari's death in 1727 he became

the head of the Maratteschi in Rome and showed some leanings towards the rococo. His heyday was before the accession of Benedict XIV in 1740. He had a large practice as a portrait painter.

Bibl.: Nicola Pio (up to 1723); Anthony M. Clark in *Essays in the History of Art presented to Rudolf Wittkower*, 1967, 259.

Cantalupo. PALAZZO CAMUCCINI. (Collection dispersed). *Portrait of Clement XII.* Signed and dated 1730. (Clark, fig. 18)
Portrait of Maddalena Stella. Signed and dated 174–.

Rome. ACCADEMIA DI S. LUCA. *Martyrdom of S. Barbara.* Possibly his reception piece of 1724.
Portrait of Benedict XIV. (Clark, fig. 19.)
Self-portrait.

S. FRANCESCO DE PAOLA. Sacristy: five of the lunettes round the walls with *Stories from the Life of S. Francis de Paul.*

S. MARCELLO. 1 to L: *Madonna with the Seven Founders of the Servite Order. c.* 1728. [Plate 53.] A copy, dated 1729, by a certain Bigatti is on 3 to L. in S. Maria in Via. For the large *modello* see Colnaghi's Exh. London, April/May 1971 (24).

S. MARIA MAGGIORE. 1st nave altar to R: *Holy Family and S. Anne* (oval). Signed and dated 1723. The payment, however, is 1743, as for the companion altars.

S. MARIA DEL POPOLO. 3 to L: *S. Nicholas of Tolentino introduced to the Virgin by S. Nicholas of Bari.* Between 1745 and 1750.

S. MARIA IN VIA LATA. Circular painting on south side of entrance wall: *Baptism.* Four of the ovals on the side walls of the nave: 1 to R: *Annunciation*; 4 to R: *Adoration of the Kings*; 1 to L: *SS. Joachim and Anne see a vision of the Virgin immaculately conceived*; 4 to L: *Marriage of the Virgin.* All about 1716–17.

SS. NOME DI MARIA. 2 to R: *Education of the Virgin by S. Anne.* Signed and dated 1757. From 1749 Masucci (with Mauro Fontana) was in charge of the decoration of the church; and several altarpieces are by his pupils.

PALAZZO PALLAVICINI-ROSPIGLIOSI. Pallavicini collection. (21) *Miracle of the loaves and fishes.* This is a modification of the Quirinal painting (*q.v.*) and appears to be the cartoon for a tapestry made in 1746. It is presumably by Masucci, although ascribed (like its companion) to Batoni.
(305) *Portrait of Cardinal Antonio Banchieri.* A studio replica. The original, signed and dated 1728 (Photo Brogi 19168), was lot 981 in the Rospigliosi sale, December 1932.
(307) *Child Christ with child S. John.* Signed and dated 1728 on back.

PALAZZO DEL QUIRINALE. COFFEE HOUSE. Paintings on the ceiling of the Pannini room: in the centre: *Pasce oves meas*; on cove of the ceiling: *Four prophets* in ovals. All are 1743; see G. Briganti, *Il Palazzo del Quirinale*, 1967, 82 (note 160).

ALESSANDRO MATTIA (1631–after 1679)

A retardataire artist of some charm, with considerable affinities to Cozza and Sassoferrato. He was also a portrait painter of ability and worked chiefly for the Chigi family. All that is known about him is to be found in: Giovanni Incisa della Rocchetta, 'Notizie sulla fabbrica della Chiesa Collegiata di Ariccia' in Rivista del R. Istituto d'Archeologia e Storia dell'Arte, I, *1929, 349 ff.*

BERNARDINO MEI (c. 1615–1676)

A Sienese painter, possibly a pupil of Rutilio Manetti, who worked in Rome, almost wholly for the Chigi family, from about 1655 to 1665. He has considerable talent and charm and his style is related to that of Cerrini.

Bibl.: C. Brandi in Thieme-Becker; V. Golzio, *Documenti artistici sul Seicento nell' Archivio Chigi*, 1939; Carlo del Bravo in *Pantheon*, N.S. v, 1966, 294–302 (with list of recorded works).

Ariccia. COLLEGIATA. 2 to R: *S. Augustine meditating on the Trinity.* 1665. See G. Incisa della Rocchetta, *Rivista del R. Inst. d'Archeologia e Storia dell'Arte*, I (1929), 374.

PALAZZO CHIGI. *Winter* (with Mario de' Fiori). 1659. One of the four pictures of the Seasons done by Lauri, Maratti, Brandi and Mei jointly with Mario de' Fiori: cf. Golzio, *op. cit.*, 267 and 280. (GFN, E, 27495.)

Rome. S. MARIA DELLA PACE. Third chapel to R. in octagon: L. wall: *The Baptist led off to martyrdom.* (GFN, E, 40238); R. wall: *The Baptist prophesying before Herod.* (GFN, E, 40239.) Part of Alexander VII's redecoration of the Church, 1655–60.

S. MARIA DEL POPOLO. L. transept altar: *Holy Family with Child treading on skull and snake, and Angels holding the Instruments of the Passion.* 1659. (GFN, E, 56397.) [Plate 54.] For the date see G. Cugnoni, *Archivio della R. Soc. romana di Storia patria*, VI (1883), 539.

PIERFRANCESCO MOLA (1612–1666)

Born at Coldrerio (Ticino), son of the architect G. B. Mola, who was already established at Rome in 1616, he is said to have first studied under Cesari d'Arpino. He formed his style in North Italy between 1633 and 1646, especially at Venice and, for two years (1644–6), under Albani at Bologna. Briefly in Rome 1640–1, he only finally settled there in 1647. Accademico di S. Luca 1655, he was Principe 1662–3. He was first patronized by the Marchese Costaguti and later by Prince Camillo Pamphily, until a bitter quarrel in 1659. His execution is more dashing and Venetian than was usual in Rome. His public commissions in Rome are authenticated by his father's Roma l'anno 1663 di Giov. Battista Mola *(ed. K. Noehles, Berlin, 1966). He also specialized in smallish pictures with small-scale figures in romantic landscapes.*

Bibl.: Passeri; Pascoli; W. (E.) Arslan, *Bollettino d'Arte*, VIII (Aug. 1928), 55–80;

Lina Montalto, *Commentari*, VI (1955), 267 ff.; Ann Sutherland (Harris), *Burl. Mag.*, CVI (Aug. 1964), 363 ff.; Richard Cocke, *Pier Francesco Mola*, Oxford 1972 (with full bibliography); Dieter Graf, *Master Drawings ... from Kunstmuseum, Düsseldorf*, 1973, 102 ff.; Valentino Martinelli, *Scritti ... in Onore di Eduardo Arslan*, 1966, 713–8.

Ariccia. PALAZZO CHIGI. *The Senses of Smell, Sight, Taste and Hearing.* Four male mythological figures as overdoors; not documented but they seem to me by Mola. Illustrated in Martinelli, *op. cit.*, figs. 462–463a.

Rome. ACCADEMIA DI S. LUCA. *Bust of old woman spinning.*
Portrait of Giovanni Battista Mola.
GALLERIA NAZIONALE. *Homer dictating.*
Inv. 2503. *Portrait of a woman.* (GFN, E, 60539.)
CAPITOLINA. *Diana and Endymion.* (GFN, E, 28746.)
Abraham repudiates Hagar. (Alinari 7278.)
COLONNA. (82) *Hagar and Ishmael.* (87) *Rebecca.*
DORIA. 147 (251) *Head of a woman* (study).
State Rooms (III) *Rest on the Flight.* (GFN, E, 28522.) Documented as already painted by 1657.
SPADA. *The young Bacchus.*
S. ANASTASIA. I to R: *Young Baptist in wilderness.* Placed in the Church by Cardinal Giovanni Battista Costaguti, who became Cardinal of S. Anastasia 1693; it may have been a Costaguti commission of the 1650's.
S. CARLO AL CORSO. I to L: *S. Barnabas preaching.* Commissioned by Cardinal Luigi Alessandro Omodei, who became Cardinal Protector of the Sodalizio dei Lombardi in 1652.
SS. DOMENICO E SISTO. 3 to R: *The appearance of the picture of S. Dominic at Soriano.* 1648. A Costaguti commission: for the date see *Chronique du Monastère de S. Sisto etc.*, 1919, II, 202.
GESÙ. I to L: frescoes on the side walls: L. wall: *S. Peter baptizing in prison.* (GFN, D, 5651); R. wall: *Conversion of S. Paul.* (GFN, D, 5650.) [Plate 55.] Passeri, by inference, dates them from the 1650's.
S. MARCO. Fourth fresco on right, above the nave arcade: *Martyrdom of SS. Abdon and Sennen.* Part of the 1653–7 redecoration.
4 to L: *S. Michael confounding Lucifer.* 1655.
Antesacristy: *Portrait of Niccolò Sagredo.*
PALAZZO COSTAGUTI. Fresco ceiling: *Bacchus and Ariadne.* Probably soon after 1648.
PALAZZO DEL QUIRINALE. Sala Gialla: fresco: *Joseph making himself known to his brothers.* 1657. See N. Wibiral, *Bollettino d'Arte*, 1960, 143.
CONTE ANDREA BUSIRI-VICI. *Death of Archimedes.*
INCISA DELLA ROCCHETTA COLLECTION. *S. Bruno in the wilderness.* c. 1663–6. (GFN, E, 38134.) This is the grand original of this design, of which numerous smaller variants, sometimes from the studio, exist.

Portrait of Alexander VII (unfinished). *c.* 1657. See V. Martinelli, *Commentari*, IX (1958), 102 ff.

Valmontone. PALAZZO DORIA-PAMPHILY. The Stanza dell'Aria, frescoed by Mola in 1658, was demolished and redone by Preti in 1661. This would have been Mola's major work in fresco; some idea of it can be had from drawings: see R. Cocke, *Burl. Mag.*, CX (Oct. 1968), 558 ff., and W. Vitzthum, *ib.*, CXI (Feb. 1969), 91.

Arslan's suggestion that Mola painted the figures in the frescoes in the Sala del Principe, for which Gaspard Dughet received payment in 1657, is convincing (GFN, E, 48154). Destroyed (?)

Africa. 1658. Fresco on ceiling of a small room. The companion fresco of *Asia* in another room is probably, as R. Cocke suggests, by Cozza. In 1934 I saw in another room what may have been the *America*, for which there is a payment of 1658. This part of the Palace seems largely to have been destroyed.

Vatican. PINACOTECA. 403. *S. Jerome.* The attribution is probable, though hardly certain.

1931. *S. Bruno* (good studio version).

GIOVANNI MARIA MORANDI (1622–1717)

A Florentine, pupil of Biliverti before he came to Rome in the service of the Duca Salviati, who sent him for training to North Italy, where he formed his somewhat eclectic style. Elected an Accademico di S. Luca 1657, he was President in 1671 and 1680. Apart from a visit to Vienna c. 1666–7 to paint the Emperor, he worked in Rome for the rest of his life and had a high reputation as a courtly person and as a painter—especially of portraits for the Curia.

Bibl.: Pascoli; E. K. Waterhouse, *Studies in Renaissance and Baroque Art presented to Anthony Blunt*, 1967, 117–21 (with list of portraits engraved after Morandi).

Albano. DUOMO. I to L: *S. Thomas of Villanova distributing alms.* It bears no attribution but seems to me to be by Morandi. The Saint was canonized by Alexander VII (Chigi) in 1658. The altarpiece may have been installed when Cardinal Flavio Chigi was Archbishop of Albano 1686–9.

Ariccia. PALAZZO CHIGI. *Portrait of Mario dei Fiori* (the flowers by Mario dei Fiori). 1659. (GFN, E, 27491). The payment is published in facsimile by V. Golzio, *L'Urbe*, XXVIII (Jan.–Feb. 1965); and first in V. Golzio, *Documenti artistici . . . nell'archivio Chigi*, 1939, 280.

Portrait of Niccolo Simonelli. Probably about 1660; reproduced *Catalogo della Mostra di Roma secentesca*, April–May 1930, fig. XII.

Alexander VII; Cardinal Flavio Chigi. There seems to be an original, and one

or more copies of Morandi's portraits of each of these in the Palace. The best
original of the *Alexander VII* known to me is at Broughton Hall, Yorkshire.

Oriolo Romano. PALAZZO ALTIERI. *Clement X (Altieri).* Full-length.

Rome. BORGHESE. (405) *Death of the Virgin.* [Plate 58.] *Modello* for picture in S. Maria
della Pace (*q.v.*).

GALLERIA NAZIONALE. (Corsini) *Christ on the Cross.* [Plate 57.]
(Magazzino). *Cardinal Rospigliosi.* (Anderson 40141.)

MUSEO DI ROMA. *Clement IX (Rospigliosi).* Full-length.

S. MARIA DELL' ANIMA. Sacristy: (1) *Annunciation*; (2) *Sposalizio.* Both 1682. See
J. Schmidlin, *Geschichte der deutschen Nationalkirchen in Rom,* 1906, 513.

S. MARIA DELLA PACE. Large painting above arch of 1 to L: *Death of the Virgin.*
Engraved by Pietro Aquila. Commissioned *c.* 1657, but the last payment (in the
Chigi archives) is 1671 (Golzio. 291). The *modello* is in the Borghese Gallery.

S. MARIA DEL POPOLO. R. transept altar: *Visitation.* 1659. See G. Cugnoni, *Archivio
della R. Soc. di Storia patria,* VI (1883), 539.

S. MARIA IN VALLICELLA. 4 to R: *Pentecost.* Probably a very late work.

S. SABINA. MUSEUM in Convent. *Madonna del Rosario.* 1686. [Plate 56.] Painted for
the d'Elce chapel, where it has been replaced by a Sassoferrato of the wrong
proportions.

S. STEFANO DEL CACCO. Sacristy. Large oval: *A female Saint dragged to martyrdom.*
Not recorded in the Guides, but a convincing attribution.

Viterbo. DUOMO. Altar of large chapel to R: *SS. Valentine and Hilary adoring the
Sacrament.* Commissioned in 1696; completed in 1698 (Mario Signorelli,
Il palazzo papale di Viterbo, 1962, 139).

DOMENICO MARIA MURATORI (1661–1744)

*A painter of Bolognese origin and training, pupil there of Pasinelli. In Rome from at least
1703 and Accademico di S. Luca in 1705. His most prosperous period in Rome was from the
1720's and he died in Rome.*

Rome. SPADA. 28. *Death of Mark Anthony.* Signed.
29. *Death of Cleopatra.* Companion picture to last.

SS. APOSTOLI. High altar: *Martyrdom of SS. Philip and James.* The largest altarpiece
in Rome; finished 1726. (See Emma Zocca, *La Basilica dei SS. Apostoli,* 1959, 112.)

BAMBINO GESÙ. Altar to R: *S. Augustine trampling on heresy.* The church was under
construction 1731–6.

S. CROCE DEI LUCCHESI. 2 to R: *S. Lorenzo Giustiniani healing a possessed woman*
After 1701.

S. FRANCESCO A RIPA. 2 to R. (altar of S. Giovanni Capistrano). Over the altar:
The Saint directing the battle of Belgrade; L. wall: *The consequences of the Saint's
preaching at Perugia*; R. wall: *The Saint at the Siege of Vienna. The Birth* and

Death of the Saint in the lunettes on the side walls are barely visible and the fresco on the ceiling has disappeared. Probably not far from 1725.

S. GIOVANNI IN LATERANO. 1st to R. of the oval canvases over the arches of the nave arcade: *Nahum.* 1718.

S. PRASSEDE. High altar: *SS. Prassede and Pudenziana gathering up the bones of martyrs.* Signed: Dominicus Mᵃ Muratori F. A. 1735. (GFN, E, 55665.) [Plate 59.]

SPIRITO SANTO DEI NAPOLETANI. 1 to L: *S. Thomas Aquinas healing a child.* Not earlier than 1727. Repr. in L. Salerno etc., *Via Giulia,* 1973, fig. 318.

STIMMATE DI S. FRANCESCO. 1 to R: L. wall. *Crowning with Thorns.* Painted in competition with the opposite Benefial of 1731.

PALAZZO DE CAROLIS. Ceiling of small room between the Procaccini and the Odazzi rooms: oval canvas with *A group of Five Allegorical Females.* This plausible attribution is due to F. Zeri (see Alessandro Bocca, *Il Palazzo del Banco di Roma,* 1961, 54 and plate in colour). Probably from the 1720's.

PALAZZO COLONNA. Overdoors in room on piano nobile: *Eliezer and Rebecca; The death of a Queen; Judgment of Solomon.* Still in the positions in which they appear in the 1783 catalogue (no. 114).

Vetralla. DUOMO. High altar: *Martyrdom of S. Andrew.* (GFN, E, 39870.) 1720.

3 to L: *Assumption with SS. Clement and Eustace below.* (GFN, E, 32052.) Over door in W. wall: *Immaculate Conception and S. Hippolytus.*

The church was rebuilt in the 1720's and most of the altarpieces date from that decade. See A. Scriattoli, *Vetralla,* 1971, p. 271.

FRANCESCO MURGIA (working 1650 to 1673)

A Sardinian pupil of Pietro da Cortona. Accademico di S. Luca 1657; Regent of the Virtuosi al Pantheon 1660. His name appears in Roman records up to 1673. His one known work is of some merit and was long ascribed to Baldi.

Bibl.: Norbert Wibiral, *Bollettino d'Arte,* 1960, p. 159, notes 211–13.

Rome. PALAZZO DEL QUIRINALE. Galleria di Alessandro VII: fresco: *David killing Goliath.* 1657. For documents and repr. see N. Wibiral, *op. cit.,* 152.

GIUSEPPE NASINI (1657 (or 1664)–1736)

From a family of Sienese painters and a pupil of Ciro Ferri. He won prizes in Accademia di S. Luca 1679–83; left Rome for Florence 1685. He worked mainly in his native Siena and in Tuscany, but was in Rome for some years before and after 1720.

Bibl.: G. Nasini, *Della Vita e delle Opere del Cav. Giuseppe Nasini*; good article in Thieme-Becker (with bibliography).

Rome. SS. APOSTOLI. 3rd bay of R. aisle: frescoes in cupola: *S. Paul shipwrecked at Malta*; *S. Anthony of Padua received into heaven by the Madonna and Child.* In the spandrels *Four Virtues.* The chapel was completed in 1722.

S. GIOVANNI IN LATERANO. 3rd to R. of the oval prophets above the marble Apostles in the nave arcade: *Amos.* 1718.

S. LORENZO IN LUCINA. 1 to L. (Baptistery), end wall: *Baptism.* (GFN, E, 20417.) Lately completed in 1721.

PALAZZO DELLA CANCELLERIA. Sala Riaria. Frescoes in near monochrome of *Buildings restored by Clement IX.* The room was decorated in 1718 (Armando Schiavo, *Il Palazzo della Cancelleria,* 1963, 148).

GIOVANNI ODAZZI (1663–1731)

His name is also spelled Odasi: a pupil of Ciro Ferri, at whose death (1689) he became pupil and assistant to Baciccio. Accademico di S. Luca 1706. He was a prolific artist of uneven gifts, whose works are rather fully listed by his friend Pascoli.

Palestrina. DUOMO. Altar to L. of chancel steps: *S. Ildefonso invested by the Madonna with the chasuble*; altar to R. of chancel steps: *Ecstasy of S. Teresa.* Commissioned by Cardinal Portocarrero, Archbishop of Palestrina 1698–1709. See Ilaria Toesca, *Mostra dei Restauri 1969*, Palazzo Venezia, 1970, Scheda 57.

Rome. S. ANDREA DELLE FRATTE. Chapel beyond ante-sacristy: *S. Francis de Paul adoring a crucifix.* c. 1723.

S. ANDREA AL QUIRINALE. 3 (2) to L: ceiling fresco. *S. Stanislas Kostka in glory.*

SS. APOSTOLI. Fresco on ceiling of apse: *Fall of the rebel Angels.* Executed soon after the death of Baciccio in 1709.

S. BERNARDO ALLE TERME. Altar to L: *Madonna and Child with S. Robert de Molesmes in the sky, and S. Benedict below.* c. 1710 but enlarged by Odazzi to its present shape c. 1730 (GFN, E, 55140).

Altar to R: *S. Bernard's vision of the Crucified Christ.* c. 1710 but altered by Odazzi to its present form c. 1718. (GFN, E, 55139.) [Plate 60.]

S. CLEMENTE. 4 to L. of paintings above the nave arcade: *The body of S. Clement brought to the Basilica.* 1716. See John Gilmartin, *Burl. Mag.,* CXVI (June 1974), 306 ff.

STIMMATE DI S. FRANCESCO. 1 to R: fresco on vault: *Putti with Symbols of the Passion.* After 1726.

S. GIOVANNI BATTISTA DEI GENOVESI. 2 to L: *The apparition of the Madonna di Savona.* Early.

S. GIOVANNI IN LATERANO. 4 to R. of the ovals above the Apostle statues on the nave piers: *Hosea*. 1718.

S. MARIA DEGLI ANGELI. Chapel at end of L. transept, in a painted altar frame: *S. Bruno's Vision of the Madonna*. On Maratti's design; soon after 1700.

S. MARIA IN ARACELI. First three frescoes above the nave arcade to L: *King David*; *Adoration of the Kings*; *Flight into Egypt*. His first independent works noted by Pascoli.

S. MARIA DELLA SCALA. 3 to R: R. wall: *Dream of S. Joseph*. Fresco in vault: *S. Joseph received into Heaven*.

S. MARIA IN VIA LATA. Altar to L. of high altar: *Madonna and Child with SS. Catherine and Cyriac*. See L. Cavazzi, *La Diaconia di S. Maria in Via Lata*, 1908, 143.

S. PRISCA. Sacristy. Detached frescoes, framed: *Madonna Immacolata with Child slaying the serpent*. Two ovals of *putti*, one with a lily, one with a rose.

S. SABINA. D'Elci Chapel on L. aisle: frescoes. In cupola: *Triumph of S. Catherine of Siena*; in spandrels: *S. Catherine receiving the stigmata*; *a crown of thorns*; *Communion from Christ*; *the Sacred Heart*.

S. STEFANO DEL CACCO. Sacristy. *S. Nicholas of Bari adoring Christ and the Virgin*.

PALAZZO DE CAROLIS. Fresco ceiling in one of the rooms: Probably the *Flora scattering flowers* in the last room but one to R.

PALAZZO DEL DRAGO (Albani). Frescoes in the centre of the ceilings of three rooms: *Justice and Peace*; *Faith and Hope*; *Charity and Prudence*. 1721–22.

GIOVANNI BATTISTA PACE (fl. 1665)

Son of Michele Pace (1610–70), better known as Michelangelo del Campidoglio, the well-known flower and animal painter, he received payment for copies through his father in 1664, but was paid directly for original works in 1665 (V. Golzio, Documenti artistici sul Seicento nell' Archivio Chigi, *1939, 285 and 288). He was reputedly a pupil of G. F. Mola and is known for a single etching. His two certain and documented works, painted for Cardinal Flavio Chigi in 1665, are a* Joseph's dream *and* Rest on the Flight, *both now in the same Roman private collection (Italo Faldi,* Arte antica e moderna, *1966, 147). They show considerable individuality of style and a distinct relationship with Mola.*

GIUSEPPE PASSERI (1654–1714)

Nephew of the biographer, he became a favourite pupil of Maratti, but his style is less severely classical and has a softness of handling which marks him out from the other Marat-teschi. Accademico di S. Luca 1693. He painted a number of portraits and had a large practice in easel pictures.

Bibl.: Pascoli; Dieter Graf, *Master Drawings . . . from the Kunstmuseum, Düsseldorf,* 1973, 113 ff.

Rome. ACCADEMIA DI S. LUCA. *Madonna.* Dated (on the back) 1707.

S. Sylvester baptizing Constantine [Plate 62]; *S. Peter baptizing SS. Processus and Martinianus.* Companion *modelli*, presumably about 1711, for the pictures commissioned by Clement XI for S. Sebastiano fuori le mura (*q.v.*) and S. Peter's (*q.v.*).

GALLERIA NAZIONALE. Two frescoes, removed from a precarious ceiling and to be replaced there: *Victory of Bellerophon on Pegasus over the Chimaera*; *The Argonauts.* (GFN, E, 68881, 68880.) The former is documented: see Galleria Nazionale, *Acquisti, Doni etc;* 1962–70, nos. 33 and 34. Painted 1675–8 for Cardinal Francesco Barberini, see Jennifer Montagu, *Journal of the Courtauld and Warburg Institutes*, XXXIV (1971), 366 ff.
Nativity. (GFN, E, 61710.)

S. CATERINA A MAGNANAPOLI. 3 to L: *Madonna del Rosario.* A *modello* is reproduced in Voss, p. 359.

Frescoes over the sacristy doors at either side of the tribune: to L: *S. Catherine receives the double crown from Christ*; to R: *S. Catherine's father discovers her in prayer.*

All three are not yet recorded in the 1708 Titi.

S. CROCE IN GERUSALEMME. 1 to L: *Incredulity of S. Thomas.* (GFN, E, 56443.) Between 1675 and 1686. [Plate 61.]

S. FRANCESCO A RIPA. 3 to R: frescoes: L. wall: *The Angel warns S. Joseph to fly into Egypt*; R. wall: *Flight into Egypt.* Frescoes on ceiling and in spandrels: *S. Joseph in glory.* The chapel was built 1686. These are not yet recorded in the 1708 Titi.

S. GIACOMO DEGLI INCURABILI. 2 to R: L. wall: *S. Francis de Paola restores some stonemasons to life*; R. wall: *S. Francis de Paola raises water miraculously.* Very late works, about 1714 (see Forcella, IX, no. 281).

S. MARIA IN ARACELI. Frescoes above the nave arcades: fourth and fifth on L. wall: *Death of the Virgin*; *Assumption.*

Frescoes in the spandrels of the presbytery arch: *Augustus and the Sibyl.* Probably later 1680's.

S. MARIA IN CAMPITELLI. 1 to L: Fresco above the sculptured altarpiece: *Putti.* Fresco on ceiling: *Assumption.* First noticed in the Addenda to the 1708 Titi.

S. MARIA IN VALLICELLA. Two of the pictures above the nave arcades: 3 to L: *Christ giving the keys to S. Peter*; 3 to R: *Moses breaking the tables of the Law.* Part of the series of paintings done for the Anno Santo of 1700, which were already being allocated in 1695.

S. SEBASTIANO FUORI LE MURA. 4 to R. (Albani chapel): R. wall: *S. Sylvester baptizing Constantine.* The chapel was consecrated in 1712. The *modello* is in the Accademia di S. Luca (Forcella, XII, no. 200).

SPIRITO SANTO DEI NAPOLETANI. Damaged frescoes in dome: *The Trinity in a glory of Saints and Angels.* 1707–8 (L. Salerno etc., *Via Giulia*, 1973, p. 401).

S. TOMASO IN PARIONE. 1 to L: *Immaculate Conception.* Before 1686.

Vatican. S. PIETRO. Chapel of the Baptistery (1 to L.): Mosaic on Passeri's design: *S. Peter baptizing SS. Processus and Martinianus.* The original painting is in S. Francesco, Urbino. The picture was commissioned from Maratti *c.* 1698, but was eventually painted by Passeri 1709–11 and replaced by a mosaic copy 1730 (Frank R. Di Federico, *Art Bulletin*, L (1968), 195). The *modello* is in the Accademia di S. Luca.

Vignanello. COLLEGIATA. 3 to R: *Death of Giacinta Marescotti.* Engraved by Frey as after Passeri. It was probably painted at the time her life was published, in 1695. She died in 1640 and was beatified in 1726 and canonized in 1807. The picture of the same theme formerly in S. Bernardino at Viterbo and ascribed to Passeri was by another hand.

Viterbo. DUOMO (formerly). The frescoes on the ceiling of the Presbytery with *S. Lawrence in glory, the Cardinal Virtues etc.* were destroyed by bombing in 1944. For drawings see Dieter Graf, *loc. cit.*, 119 ff.

CARLO PELLEGRINI (1605–1649)

A native of Carrara; in Rome at least by 1628, where he was influenced by Sacchi. His Roman activity is only known from a few paintings executed between 1635 and 1640 on Bernini's suggestions or designs. He returned to Carrara, where he died.

Rome. PROPAGANDA FIDE (I RE MAGI). 1 to R: *Conversion of S. Paul.* 1635. For the payment, see O. Pollak, *Urban VIII*, I, 217.

GALLERIA NAZIONALE (Barberini). Cartoon for the *S. Bernard* in S. Peter's (*q.v.*) 1636. Bought from the Barberini collection 1951.

Vatican. S. PIETRO. Chapel of S. Michael: mosaic of *S. Bernard* from Pellegrini's design (*cf. supra*). For payment of cartoon, see O. Pollak, *Urban VIII*, II, 579.

MUSEO PETRIANO (former). *Martyrdom of S. Maurice and his companions.* 1636–40. Originally in S. Peter's, over the altar to R. in the chapel of the Sacrament. For payment, see O. Pollak, *op. cit.*, II, 279.

GIOVANNI DOMENICO PIASTRINI (1678–1740)

Born at Pistoja either in 1678 or 1680, the son of a painter. Brought to Rome 1704 and became a pupil of Luti. His art derives from the Marattesque but has a rococo tincture.

Bibl.: Pio (*Master Drawings*, V (1967), 21); Erich Schleier, *Burl. Mag.*, CXII (Dec. 1970), 833.

Magliano Sabina. S. LIBERATORE. Apse fresco. Signed and dated 1737. Reported by E. Schleier, *op. cit.*

Monterotondo. DUOMO. Ceiling fresco: *Assumption of the Virgin*. E. Schleier, *op. cit.* as *c.* 1730. A probable attribution.

Rome. S. CLEMENTE. 2 to R. of the paintings above the nave arcades: *S. Ignatius of Antioch before the Emperor Trajan*. 1716. See J. Gilmartin, *Burl. Mag.*, CXVI (June 1974), 306 ff.

　　SS. GIOVANNI E PAOLO. Fresco in apse. To L: *SS. John and Paul giving alms. c.* 1726.

　　S. MARIA IN VIA. Fresco ceiling of nave: *The first Mass of S. Filippo Benizzi.*1723-4. Restored 1773 (T. Poensgen, *Die Deckenmalerei in Italienischen Kirchen*, 1969, 99).

　　S. MARIA IN VIA LATA. Large oval on R. wall (between 3rd and 4th ovals of the small series): *Madonna del Rosario.*
　　Circular painting on N. side of entrance wall: *Ascension.*
　　Both probably *c.* 1716-17.

　　S. PRASSEDE. 1 to R: R. wall: *Martyrdom of B. Tesauro Beccaria*. Signed: *c.* 1717.

PIETRO DE' PIETRI (1663 (or 1665)–1716)

A Lombard who came young to Rome and was at first a pupil of Giuseppe Ghezzi, but soon developed into a close follower of Maratti, whom he helped in the restoration of the Stanze of the Vatican (1702-3). Accademico di S. Luca 1711. There is an important group of drawings at Windsor.

Bibl.: Pascoli; Pio; Peter Dreyer in *Zeitschrift für Kunstgeschichte*, XXXIV (1971), 184 ff.

Rome. GALLERIA NAZIONALE. (1143) *Martyrdom of S. Lawrence*. See P. Dreyer, *op. cit.*

　　ACCADEMIA DI S. LUCA. *S. Peter and the Pharisee*. Reception piece of 1711.

　　S. CLEMENTE. First to L. of the paintings over the nave arcades: *S. Clement giving the veil to S. Flavia Domitilla*. 1716. See J. Gilmartin, *Burl. Mag.*, CXVI (June 1974), 306 ff.

　　S. MARIA DELLE FORNACI. 3 to L: fresco in dome: *Assumption of the Virgin*. The chapel was begun 1712 and this fresco was completed before Pietro's death in 1716.

　　S. MARIA IN VIA LATA. 1 to L: *Madonna enthroned with SS. Lawrence, Antony of Padua, Prassede and Venanzio*. The altar was renewed about 1705; cf. L. Cavazzi, *La Diaconia di S. Maria in Via Lata*, 1908, 138.
　　Four of the ovals on the side walls of the nave: 2 to R: *Nativity*; 3 to R: *Presentation of Christ*; 2 to L: *Birth of the Virgin*; 3 to L: *Presentation of the Virgin*. Very late work.

FRATEL' ANDREA POZZO (1642–1709)

A native of Trento, Fratel' Pozzo (often called, even in his lifetime, 'Padre Pozzo') entered the Jesuit Order as a lay brother in 1665 and became the most remarkable perspective virtuoso

of the century. His earlier training was Milanese and his first major works are at Mondovì and Turin. He was in Rome from c. 1681 to 1702, and spent his last years in Vienna, where he died, and where his influence on Austrian rococo style was very great. His fame was spread by his Perspectiva pictorum . . ., *published in the 1690's, which was translated into many languages.*

Bibl.: Baldinucci; Pascoli; Remigio Marini, *Andrea Pozzo*, Trento, 1959; Anna Maria Cerrato, in *Commentari*, x, 1959, 24–32; Bernhard Kerber, *Andrea Pozzo*, Berlin, 1971 (with full bibliography).

Frascati. GESÙ. Three altars in which painting and architectural members are all done in feigned perspective on canvas. High altar: *Presentation in the Temple*; L. transept: *S. Ignatius receiving S. Francisco Borgia into the Jesuit Order*; R. transept: *Martyrdom of S. Sebastian.* The two other altars, the damaged *cupola finta*, and some of the nine overdoor-shaped paintings, were painted in collaboration with his pupil, Antonio Colli. Painted in the summer months of 1681 and 1684 (Kerber, p. 47); see Alberto de Angelis, in *Studi Romani*, VI, 1958, 163 ff.

Rome. GALLERIA NAZIONALE (Corsini). 1382, 1387. Two *modelli*, one for the ceiling fresco, the other for the cupola, in S. Ignazio.

 S. ANDREA AL QUIRINALE. Ante-room to the Camera di S. Stanislao. Twelve water-colour sketches (perhaps designed for tapestries): *Scenes from the Life of S. Stanislaus Kostka.* See Kerber, p. 25, who gives the subjects and dates them from the beginning of Pozzo's Roman period. Large versions of two, certainly not by Pozzo himself, are in the atrium of S. Stefano Rotondo (*Roma*, I, 1923, 38).

 GESÙ. I to L: *S. Francisco Borgia and the Japanese Martyres.* The *Japanese martyrs* were added by Pietro Gagliardi (after their canonization) in 1862 (P. Pecchiai, *Il Gesù*, 1952, 252). The Pozzo of *S. Francisco Borgia in prayer* dates from before 1686.

 Altar in L. transept: the statue of S. Ignatius is at times covered by a painting of *Christ receiving S. Ignatius into Heaven, with representatives of the Four Corners of the World below.* The whole altar, of 1695, was designed by Pozzo: for payments, see P. Pecchiai, *Il Gesù*, 1952, 355 ff.

 S. IGNAZIO. *Cupola finta.* 1685. Gravely damaged in 1891; the restoration was finally completed in 1963.

 Frescoes in the apse: *S. Ignatius, supported by Angels, promises succour to the infirm; S. Ignatius wounded at the siege of Pamplona;* on the wall of the tribune behind the high altar: *S. Ignatius sends S. Francis Xavier to the Indies; The Vision at La Storta; S. Ignatius receives S. Francisco Borgia into the Jesuit Order.* Between 1685 and 1691. Frescoes on the ceiling of the nave: *Allegory of the Missionary Work of the Jesuits.* 1691–4. [Plate 63.] See Lina Montalto, *Studi Romani*, 1958.

 Frescoes in R. transept: above the sculptured altarpiece: to L: *Appearance of the Virgin and Child to S. Luigi Gonzaga;* to R: *S. Luigi Gonzaga receives his first communion from S. Carlo Borromeo;* on ceiling: *S. Luigi Gonzaga adored by S. Maria*

Maddalena dei Pazzi; on upper parts of the side walls: *Musician Angels*. Finished 1698.

There is an unpublished thesis, for the University of Kiel, on Pozzo in S. Ignazio, by Peter Wilberg-Vignau, 1966.

Sacristy: a number of *bozzetti* (see *Mostra di Opere d'Arte restaurate nel 1967*).

CASA PROFESSA (attached to the Gesù). Frescoes on the ceiling and walls of the corridor in front of the rooms of S. Ignatius: *Life and Miracles of S. Ignatius* in an elaborate quadratura setting. The paintings were begun by Jacques Courtois (d. 1676) and completed by Pozzo, probably between 1681 and 1686 (B. Kerber, *op. cit.*, 50 ff.). See P. Tacchi Venturi, S.J., *La Casa di S. Ignazio di Loiola a Roma*, 1924.

COLLEGIO INTERNAZIONALE DEI FRATI MINORI (Via Barcelli 56–70). Battered frescoes in the chapel. The building was originally a Vigna of the Collegio Romano (see B. Kerber, p. 54 and figs. 35–6).

CONVENT OF SS. TRINITA DEI MONTI. Former Refectory: frescoes in an elaborate quadratura setting, 1694. Executed in three days, with a good deal of help; see Anna Maria Cerrato, *Commentari*, X, 1959, 26, and Kerber, *op. cit.*, 75.

Valmontone. S. MARIA ASSUNTA. 2 to R: *S. Francis in adoration of the Crucifix.* (Photo GFN. 38780.) The church was built 1685–9. A *bozzetto* is in the Sacristy of S. Ignazio, Rome (Kerber, fig. 15).

MATTIA PRETI (1613–1699)

Preti is normally regarded as belonging to the Neapolitan school, although his style was largely formed in North Italy. In 1661 he settled in Malta for the rest of his life: but he was in Rome for a number of years after 1642, when he professed as a Knight of Malta, and he returned for a short time to paint the remarkable frescoes at Valmontone. I list only his few public commissions.

Bibl.: Pascoli; De Dominici; B. Chimirri and A. Frangipane, *Mattia Preti*, Milano, 1914; Valerio Mariani, *Mattia Preti a Malta*, Roma, 1929; Claudia Refice Taschetta, *Mattia Preti*, Brindisi, 1962 (with bibliography); Catalogue of Exhibition of Order of S. John in Malta, Valletta, 1970.

Rome. S. ANDREA DELLA VALLE. Three frescoes in the apse of the tribune: *S. Andrew tied to the Cross*; *S. Andrew crucified*; *Burial of S. Andrew*. 1650–1.

S. CARLO AI CATINARI. Fresco on west wall, over south entrance door: *S. Charles Borromeo giving alms during the plague in Milan.* (GFN, E, 33220.) The companion fresco over the north door: *S. Charles authorizing Domenico Boerio to go and combat heresy in the Grisons* (GFN, E, 33219) is ascribed to Mattia's brother Gregorio Preti. The reasons given for dating these about 1642 are very dubious. Preti was in Rome 1649–51 and Gregorio in 1652.

s. GIOVANNI CALABITA. (Ospedale dei Fatebenefratelli.) On the wall of the staircase: *Flagellation of Christ*. Probably part of the restoration of the church in the early 1640's (originally on an altar).

Valmontone. PALAZZO DORIA. Frescoes on the ceiling of the second large room on the first floor: *The Element of Air*. (GFN, D, 592-3.) 1661. For the date see *Commentari*, VI, 1955, 297.

ANDREA PROCACCINI (1671–1734)

A native of Rome and a star pupil of Maratti, whom he assisted in the restoration of the Vatican Stanze in 1702–3. In 1710 he was put in charge of the tapestry works of S. Michele a Ripa. He had a considerable vogue in Rome until 1720, when he was summoned to Spain (where he died) as Court artist. He was also an engraver.

Bibl.: Pascoli.

Rome. s. GIOVANNI IN LATERANO. Fourth to L. of the series of ovals above the nave arcade: *The Prophet Daniel*. 1718.

s. MARIA DEGLI ANGELI. Frescoes in vault above the altar in the L. transept: *The Four Evangelists* around a Sacred Monogram adored by putti. Soon after 1700.

s. MARIA SOPRA MINERVA. 6 to L: *S. Pio V seated in glory and raising the Cross against the Turks*.

s. MARIA DELL'ORTO. Oval frescoes over doors at the sides of the high altar: to L: *SS. Joachim and Anne's vision of the Virgin*; to R: *Pentecost*. (Anderson 20812.) Probably soon after 1707.

s. MARIA IN TRASTEVERE. 2 to L: *SS. Marius and Callistus I*.

PALAZZO DE CAROLIS (Banco di Roma). Canvas let into ceiling of central room on main floor: *Aurora*. 1720. The last painting done by Procaccini before leaving for Spain in 1720 (A. Bocca, *Il Palazzo del Banco di Roma*, 1961, colour plate at p. 52).

Vatican. s. PIETRO. Chapel of Baptistery (1 to L.): Mosaic on the design of Procaccini's paintings: *S. Peter baptizing the centurion Cornelius*. The original painting is in S. Francesco, Urbino. Originally commissioned from Maratti, 1698; it was finally executed by Procaccini 1710–11 (Frank R. Di Federico, *Art Bulletin*, L (1968), 195).

BIAGIO PUCCINI (1675–1721)

A native of Lucca (but also called a Roman), he was in good practice in Rome from about 1700, but was not an Accademico di S. Luca. Virtuoso del Pantheon in 1713. At his best he has a style of considerable dramatic power, which is outside the Marattesque canon.

Rome. S. AGATA IN TRASTEVERE. High altar: *Martyrdom of S. Agatha*; 3 to L: *Cruci-fixion with Magdalen, Virgin and S. John*; 3 to R: *Madonna del Rosario with SS. Dominic, Catherine and Souls in Purgatory.* The church was completed about 1711.

S. BRIGIDA. Frescoes on ceiling: *S. Bridget in glory* [Plate 64]; in the spandrels: *The Evangelists.* At either side are the arms of Clement XI when Cardinal Albani (i.e. before 1700). Four canvases in the choir: *S. Bridget, by praying for her son's death, prevents his bigamous marriage with Joanna of Naples*; *S. Bridget receives the Host from Christ*; *Ecstasy of S. Bridget*; *S. Bridget crowned by the Virgin.* These also seem to be by Puccini and part of the restoration undertaken shortly before 1700 by Cardinal Albani.

S. CATERINA A MAGNANAPOLI. 3 to R: *S. Dominic resuscitates a child.* Probably about 1720.

S. CROCE DEI LUCCHESI. 2 to R: *Virgin Immaculate with the Trinity.* After 1701.

S. EUSTACHIO. 1 to L: *S. Julian and his wife receive a pilgrim.* c. 1707.

S. MARIA MADDALENA. 1 to R: *S. Francis de Paola resuscitates a child.* Signed and dated 1720.

S. MARIA DI MONTESANTO. Sacristy altar: *Deposition.*

S. MARIA IN TRANSPONTINA. N. transept: strip of fresco on ceiling above the altar: *Intervention of S. Andrea Corsini at the battle of Anghiari.*

S. PAOLO ALLA REGOLA. Three large oval canvases: (1) on R. wall of 1 to R: *Martyr-dom of S. Erasmus*; (2) over door on R. wall of 3 to L: *Madonna and Child with S. Chiara*; (3) over door on L. wall of 3 to R: *S. Bonaventura in ecstasy at the sight of S. Thomas Aquinas.* The first and third are signed and the latter dated 1708; see *Mostra dei Restauri*, 1969 (XIII Settimana dei Musei 1970), Scheda 58.

GIOVANNI FRANCESCO ROMANELLI (1610?–1662)

A native of Viterbo: his style was formed by Pietro da Cortona, but a leaning towards the Raphaelesque gave him the nickname of 'Raffaelino': Principe of the Accademia di S. Luca, 1638. He was a protégé of the Barberini family, notably of Cardinal Francesco, and made a number of designs for Barberini tapestries. He is an important link with France and painted a good deal in Paris on two visits, in 1646–7 and 1655–7.

Bibl.: Baldinucci; Passeri; Pascoli; Thieme-Becker (up to 1934); L. Salerno, *Palatino*, VII (1963), 5–11; Italo Faldi, *Pittori Viterbesi*, 1960, 66 ff. and 300 ff.; B. Kerber in *Giessener Beitrgäe zur Kunstgeschichte*, 2 (1973), 133–70 (on engravings after Romanelli).

Bagnaia. VILLA LANTE. (Coll. Cantoni, 1963) *Bacchanal* and ten or more further tapestry cartoons of *Putti* in single figures or groups (Salerno, *loc. cit.*). 1637–42.

Rieti. DUOMO. Cappella del Sacramento: *Sacrifice of Noah*. 1653. (GFN, E, 45677); *Last Supper*. 1653. (GFN, E, 45688.)

Rome. BORGHESE. 183 (inv. 51) *Bust of a Sibyl*.

CAPITOL. Sala di Mario: *S. Francesca Romana*. 1638.

CAPITOLINA. *David with head of Goliath*. (GFN, E, 36600); *Innocence*; *Music* (oval half-lengths).

DORIA. 108 (223) *Autumn*; 68 (224) *Spring*.

96 (472) *Erminia and the Shepherds*.

Two busts, without numbers, of *The Angel Gabriel* and *The Virgin Annunciate*, which used to hang at either side of the door leading from the Gallery to the Salone dei Marmi, seem to have been destroyed during the war.

GALLERIA NAZIONALE (BARBERINI). Romanelli assisted Pietro da Cortona in the frescoes in the private chapel, 1631–2; and the *Adoration of the Shepherds* seems to be entirely his (G. Briganti, *Pietro da Cortona*, p. 196).

Nine cartoons for tapestries: *Annunciation*; *Adoration of the King*; *Adoration of the Shepherds*; *Rest on the Flight*; *Baptism*; *Last Supper*; *Agony in the Garden*; *Ressurection*; *Mission of the Apostles*. 1637–43. See Italo Faldi, *X Settimana dei Musei, Roma*, 1967. Examples of the finished tapestries are in the Cathedral of S. John the Divine, New York.

Bacchus and Ariadne. 1660–2. For the date see O. Pollak, *Künstlerbriefe*, 48. A large *modello* for this picture was also acquired by the Galleria Nazionale in 1971. A studio copy was presented by Cardinal Barberini to the British Royal Collection and remained at Holyrood until 1950: but it was so damaged that all but a small fragment had to be destroyed. The companion *Marriage of Peleus and Thetis* is a later studio copy of the original now in the Palazzo della Previdenza Sociale in EUR.

(Magazine). *The Presentation in the Temple* and *The Ecstasy of S. Theresa* from the destroyed Church of S. Maria di Regina Celi, which were for a time in the Convent of S. Teresa del Bambino Gesù, are now stored by the Galleria Nazionale.

GALLERIA NAZIONALE (CORSINI). *Annunciation*. *Modello* for the picture at Viterbo.

Adoration of the Shepherds; *Adoration of the Kings*.

SPADA. (8) *Boreas and Oreithyia*.

S. AGOSTINO. Altar in sacristy: *S. Thomas of Villanova distributing alms*. According to Dr Hess this is only an excellent copy and the battered original remains in the Convent.

S. CARLO AI CATINARI. 3 to L: R. wall: *SS. Marius, Martha, Audifax and Ambachum*. Originally over the altar in the same chapel, and probably 1641, the date of the Gimignani frescoes.

S. CARLO ALLE QUATTRO FONTANE. Altar in chapel to L. of high altar: *Holy Family and Angels*. 1642. (GFN, E, 38121.)

SS. DOMENICO E SISTO. I to L: *Madonna del Rosario*. 1652.

S. ELIGIO DEGLI OREFICI. Altar to R: fresco: *Adoration of the Kings*. Fresco: *Sibyls* in

spandrels. 1639. Fresco *Sibyls* in spandrels of altar to left. For the date see
Commentari, 1967, 204, *n.* 4.

S. GIACOMO ALLA LUNGARA. High altar: fresco: *S. James*. Cardinal Francesco
Barberini started to rebuild this church in 1635. (GFN, E, 42161.)

S. MARCO. Painting in apse: *S. Mark and lion among Angels etc.* Hopelessly ruined:
part of the redecoration of the church in 1653–7.

S. MARIA DEGLI ANGELI. R. wall before the high altar: *Presentation in the Temple.*
1638–42. (From S. Peter's.)

S. MARIA DELL' ANIMA. Sacristy: fresco on ceiling: *Assumption.* Contract 1634; last
payment 1638 (L. Salerno in *Palatino*, 1963, 9).

S. PIETRO IN MONTORIO. 2 to L: repainted fresco on ceiling: *S. Francis in glory.*
c. 1640–4.

PALAZZO ALTEMPS (Spanish College). Fresco frieze in room on first floor: *Europa*;
Aurora; *Galatea*; *Amphitrite.* (Now prudishly covered.)

PALAZZO COSTAGUTI. Ceiling fresco: *Arion.* Probably soon after 1647.

COLL. INCISA DELLA ROCCHETTA. *Assumption. Modello* for sacristy ceiling of S. Maria
dell'Anima. (L. Salerno, *Palatino*, 1963, p. 8.)

PALAZZO LANTE. Frescoes on ceiling of Galleria. Centre: *Mars, Venus and Mercury*,
with *Peace* and *War* in triangular compartments at the sides. Four corner strips:
Time and Fortune; *Painting, Sculpture and Architecture*; and two *Pairs of Allegorical
Females.* Six lunettes: *Fight of the Horatii and Curiatii*; *Cincinnatus called from the
plough* [Plate 65]; *The Rape of the Sabines* (ruined); *The discovery of Romulus and
Remus*; *Venus showing Aeneas his armour*; and *Numa and Egeria* (?). Above the
last, in quatrefoil medallions supported by putti, are green grisaille figures of
Jupiter, Juno, Venus, Hercules, Ceres and *Minerva.* 1653.

PALAZZO PATRIZI. *Death of Cleopatra.*

EUR: PALAZZO DELLA PREVIDENZA SOCIALE. *Marriage of Peleus and Thetis.* Probably
c. 1638. Transferred from Palazzo Sciarra (see L. Salerno, *Palatino*, 1963, 5 ff.).

BIBLIOTECA VALLICELLIANA. Grisaille frescoes on ceiling: *Two allegorical figures* and
Three groups of Putti. Damaged and largely assisted. Probably *c.* 1640, the date
of the vanished fresco for the attached Oratory.

Valletta (Malta). MUSEUM OF THE CO-CATHEDRAL OF S. JOHN. *The Baptist pointing
out Christ.*

GESÙ. S. transept altar: *Christ carrying the Cross appears to S. Ignatius Loyola.* The
arms on the frame are Testaferrata.

Vatican. GALLERIA DELLE CARTE GEOGRAFICHE. Fresco in centre of ceiling: *Pasce oves
meas.* 1637.

SALA DELLA CONTESSA MATILDA. Frescoes: five large scenes from the *Life of the
Contessa Matilda* [Plate 66] (of which one was probably executed by Abbatini,
q.v.); four full-length figures of *Peace, Authority, Temperance and Justice*; twelve
seated *Allegorical figures*; and six smaller scenes from the *Life of Contessa Matilda.*
1637–42. The decorative setting of the whole room is due to Abbatini; see
Jacob Hess, *Kunstgeschichtliche Studien*, 1967, I, 105–9.

PRIVATE APARTMENTS. Chapel: *Nativity*. 1637. This is reported as still existing. There is also in the Private Apartments (Arch. phot. Vaticano xi, 19, 17) an old copy of a lost Romanelli of *Henry IV at Canossa*.

MUSEO PETRIANO (? formerly). Ruined fresco: *The sick healed by S. Peter's shadow.* 1636–7. Originally in S. Peter's where the tomb of Alexander VII now is.

S. PIETRO. Mosaics from Romanelli's cartoons:

CHAPEL OF S. LEO. *Madonna and sleeping Child*; *S. Joseph warned by an Angel*; *David*; *Solomon*. 1643–4.

CHAPEL OF S. MICHAEL. In one of the angles of the cupola: *S. Gregory the Armenian.* 1636–7.

Viterbo. MUSEO. 19. *Rest on the Flight.* (GFN, E, 34467.)

20. *Assumption of the Virgin.* (GFN, E, 36144.) Much restored. Datable 1648–9 (Baldinucci).

21. *Annunciation.* (GFN, E, 15634.)

22. *Madonna and Child appear to S. Rosa.* 1657–8. (GFN, E, 15629.) For these see Italo Faldi, *Museo Civico di Viterbo*, 1955.
Hercules and Omphale.

DUOMO. End of N. side wall: *S. Lawrence.* (GFN, E, 42927.) Formerly on high altar. 1648.

CHIESA DEL GONFALONE. High altar: Banner, painted on both sides: *Madonna of Mercy*; reverse, *Baptism*. (GFN, E, 15721 and 15589.)

FRANCESCO ROSA (1638–1687)

A Roman, son of a Giovanni Rosa. Pupil of Canini, and, in 1656–7, of Poussin, whose work he is said to have imitated with great skill. Accademico di S. Luca 1673; secretary of the Virtuosi al Pantheon from 1675. He seems to have been confused (e.g. by Soprani-Ratti, II, 27) with a Genoese artist who was active at Venice.

Bibl.: Unpublished life among Pascoli MSS. at Perugia (Bibl. Augusta MS. 1383) partly excerpted in *Commentari*, IV (1953), 41–2.

Marino. DUOMO (S. BARNABA). W. end of S. aisle: *S. Francis Xavier.*

Rome. S. AGOSTINO. 4 to L: fresco in vault: *S. Apollonia in glory. c.* 1661.

S. CARLO AL CORSO. 2 to L: *S. Filippo Neri in ecstasy*; 1 to R: R. wall: *Vision of S. Enrico.* Both are recorded in the 1674 Titi.

Fresco on vault of 2nd bay of N. aisle: *Charity overcoming hatred.* 1677. See G. Drago and L. Salerno, *SS. Ambrogio e Carlo al Corso*, 1967, 112 and fig. 27.

S. CATERINA A MAGNANAPOLI. Lantern above chancel: *God the Father.* From the 1660's.

S. ROCCO. 3rd bay of L. aisle: frescoes in lunettes and cupola. Lunette to E: *Death*

of S. Anthony of Padua; to W: *S. Anthony leaves the canons regular and is invested as a Franciscan*; dome: *S. Anthony received into heaven*. Four *Virtues* in the spandrels. 1663. For the date see L. Salerno and G. Spagnesi, *La Chiesa di S. Rocco*, Roma, 1962, 72.

SS. VINCENZO E ANASTASIO. High altar: *S. Vincent before the judge and martyrdom of S. Anastasio.*

GALLERIA DORIA. 2 (305). *Blind Belisarius*. 1681. See Lina Montalto, *Un Mecenate in Roma Barocca*, 1955, 533, *n.* 42.

ANDREA SACCHI (1599–1661)

The great classical master of the Barberini group of artists and official painter to Cardinal Antonio Barberini senior. He stands in opposition to Bernini and Pietro da Cortona and his works are the most sensitive and considered to be produced by a native Roman painter in the century.

Bibl.: Bellori; Passeri; Hans Posse, *Andrea Sacchi*, Leipzig, 1925, and in Thieme-Becker (with bibliography); Ann B. Sutherland, unpublished dissertation, University of London, 1965 (being prepared for publication in revised form;) and, as Ann Sutherland Harris (with Eckhard Schaar), *Die Handzeichungen von Andrea Sacchi (und Carlo Maratta)*, Düsseldorf, 1967; and *Master Drawings*, IX (1971), 384 ff.

Note: The dates given below, when not otherwise explained, are those given by Mrs Harris.

Castelfusano. VILLA CHIGI (formerly Sacchetti). Parts of the fresco decoration in the Galleria on the second floor: *Rome and the Seasons*; *Sacrifice to Pan*; *Romulus and the Shepherds*. 1627–9. See G. Incisa, *L'Arte*, 1924, 60 ff. The whole gallery was painted under the direction of Pietro da Cortona, and there is a 1628 payment to Sacchi. The scenes listed are probably Sacchi's part (Incisa) but there is too much repainting for certain judgment.

Nettuno. S. FRANCESCO. High altar: *Madonna of Loreto with SS. Bartholomew, Joseph, Roch and Francis*. Probably from the middle 1620's; see Hess-Passeri, 291, *n.* 3.

Rome. GALLERIA NAZIONALE (Barberini). *S. Peter*. One of a set of full-length Apostles commissioned from Sacchi by Cardinal Antonio Barberini, and in his 1644 inventory. The others were done by Maratti after Sacchi's death. (*q.v.*)

GALLERIA NAZIONALE (Barberini). Cartoons: *S. Thomas Aquinas*. 1629–31; *S. Leo.* 1631. Cartoons for mosaics in S. Peter's (*q.v.*).

GALLERIA NAZIONALE (Corsini). SS. *Mary of Japan, Mary Magdalen and Maria Maddalena dei Pazzi*. 1633. A *modello* for the large picture of 1633 in the Uffizi depot. (GFN, E, 38866.)

BORGHESE. 184 (inv. 376). *Portrait of Mgr. Clemente Merlini. c.* 1632.

DORIA. 125 (132). *Daedalus and Icarus*. (GFN, E, 41748.) An original, of which an inferior replica is in the Palazzo Rosso, Genoa.

MUSEO DI ROMA. *Portrait of Cardinal Domenico Ginnasi.*

S. BERNARDO ALLE TERME. *Bust of Venerable Jean de la Barrière.* 1626. Inserted into the sitter's tomb: see S. Ortolani, *S. Bernardo alle Terme,* p. 43 (repr.).

S. CARLO AI CATINARI. 2 to L: *Death of S. Anne.* 1648–9.

GESÙ. Room off the sacristy: *Pope Urban VIII at the Gesù on October 2, 1639.* Painted 1641–2; see G. Incisa, *L'arte,* 1924, 66 ff.

S. GIOVANNI IN FONTE. The whole series of frescoes was executed under Sacchi's direction 1640–9, and he provided the cartoon for that painted by Maratti (*q.v.*).

The eight canvases for the cupola: *Zacharias and the Angel*; *The Visitation*; *Birth of the Baptist*; *Naming of the Baptist*; *Calling of the Baptist*; *Preaching of the Baptist*; *Baptism*; *Decollation of the Baptist.* 1639–45. Have all been replaced since 1960 by modern copies and transferred to the Palazzo del Vicariato.

S. ISIDORO. High altar: *The Madonna appears to S. Isidore.* 1622–3.

S. MARIA DELLA CONCEZIONE. 5 to L: *The Madonna appears to S. Bonaventura.* c. 1634–6.

5 to R: *S. Anthony of Padua revives a dead man.* c. 1631–3. The *modello* is in the D. Mahon collection, London.

S. MARIA SOPRA MINERVA. Sacristy. Painting above the altar: *Crucifixion with four male Dominican Saints and S. Catherine of Siena.* Fresco on ceiling of the altar niche: *Putti with Symbols of the Passion.* Between 1638 and 1642.

S. MARIA DEL PRIORATO. Museum of the Sovereign Order of Malta: *S. John Chrysostom(?) offering a dove to the Madonna and Child.* 1632–6. (GFN, E, 47324.)

PALAZZO BARBERINI. Fresco on ceiling of one of the rooms in the Galleria Nazionale: *La Divina Sapienza.* 1629–31. [Plate 67.] For an account of the Allegory see G. Incisa, *L'arte,* 1924, 65 ff.

COLLEGIO ROMANO. Farmacia dei Gesuiti: Fresco: *Madonna with SS. Ignatius, Francis Xavier, Cosmas and Damian.* 1629. (GFN, E, 9475.)

PALAZZO DEL VICARIATO. The originals of the eight canvases from S. Giovanni in Fonte (*q.v.*) have been transferred here. For payments see O. Pollak, *Urban VIII,* I, 141 ff.

COLL. INCISA DELLA ROCCHETTA. *Vision of S. Romuald.* 1658. (GFN, E, 56416); *La Divina Sapienza.* 1658. Repetitions by Sacchi himself, for Alexander VII (Chigi), of earlier designs: cf. G. Incisa, *L'arte,* 1924, 74, and Hess-Passeri, 301.

PALLAVICINI COLLECTION. 445. *Bust of an Apostle.*

Vatican. S. PIETRO. Mosaics on Sacchi's design:

CHAPEL OF S. LEO. Two of the angles of the cupola: *S. Thomas Aquinas.* 1629–31; *S. John Damascene.* c. 1632.

CHAPEL OF S. MICHAEL. Two of the angles of the cupola: *S. Leo I.* 1631; *S. Denys the Areopagite.* 1631.

For the dates see O. Pollak, *Urban VIII,* II, 553 ff. and 575 ff.

CANONICA DI S. PIETRO. Sala Capitolare: *S. Gregory and the Miracle of the corporal.* 1625–7. [Plate 68.]

MUSEO STORICO-ARTISTICO (TESORO).

S. Andrew adoring his Cross. 1633–4.

Martyrdom of S. Longinus. 1633–4.

Christ falling beneath the Cross, and S. Veronica. 1633–4.

S. Helena and the Miracle of the True Cross. c. 1646–50.

The last four were painted for the Grotte Vaticane; see O. Pollak, *Urban VIII,* II, 516.

PINACOTECA. 382. *Vision of S. Romuald.* c. 1631–2. Painted as the high altar of the demolished Church of S. Romualdo.

IL SASSOFERRATO (1609–1685)

Giovanni Battista Salvi, called il Sassoferrato from his birthplace in the Marche, is not mentioned by the early biographers. On stylistic grounds one would guess he was a pupil of Guido Reni and later refined his archaizing style by copying the works of Perugino and the young Raphael. The most numerous group of his works is in S. Pietro, Perugia. He had a certain patronage in Rome in the earlier 1640's. Most of his oeuvre consists in ten or a dozen designs for small devotional works, which were multiplied as if from a factory. Most of his known drawings are at Windsor.

Bibl.: G. Vitalletti, *Il Sassoferrato,* 1911; M. Goering in Thieme-Becker (with bibliography).

Casperia (formerly called **Aspra Sabina**). SS. ANNUNZIATA. High altar: *Annunciation.* (GFN, E, 34248.)

Genzano. S. MARIA DELLA CIMA. 3 to L: *Marriage of S. Catherine.* A battered replica, or studio version, of the important picture in the Wallace collection, London. The church was completed in 1650 (cf. under Cozza).

Rome. ACCADEMIA DI S. LUCA. *Madonna with Child holding an apple.*

COLONNA. (97) *Bust of the Virgin.*

GALLERIA NAZIONALE (Corsini). *Portrait of Mgr. Ottaviano Prati.* Signed.

DORIA. 122 (302) *Holy Family.* A repetition is in the Czernin collection.

53 (225) *Bust of the Virgin.*

PALAZZO VENEZIA. *S. Francis.* (GFN, E, 26539.)

S. FRANCESCO DE PAOLA. Sacristy. Canvas let in to ceiling: *S. Francis de Paul kneeling before the Madonna and Child.* 1641. (GFN, C, 6240.) [Plate 69.] For the date see O. Pollak, *Urban VIII,* I, 129.

S. GIOVANNI IN FONTE. Chapel of SS. Rufina e Seconda: fresco let into wall to L. of altar: *Virgin, Child and S. John.*

S. IVONE ALLA SAPIENZA. On small altar to R. of high altar: *Bust of the Virgin.*

s. SABINA. Altar in Chapel to L. *Madonna del Rosario*. 1643. Unsuitably transferred to its present place from the demolished altar del Rosario: see F. J. J. Berthier, *L'Eglise de S. Sabine*, 1910, 315. A half-length variant of the *S. Catherine receiving the Crown of Thorns and a rosary from a standing child Christ* is at Cleveland.

PALAZZO PALLAVICINI-ROSPICLIOSI. Pallavicini collection. (448) *Mater dolorosa*.

Vatican. PINACOTECA. (396) *Madonna and Child on crescent moon*.

(459) *Bust of a Cardinal*.

DANIELE SEITER (1647 or 1649–1705)

A native of Vienna, he became a pupil of Carlo Loth in Venice in the 1670's. Travelled in North Italy and was at Florence in 1680; in Rome by 1683 and Accademico di S. Luca 1686. He was summoned to Turin in 1688, where he remained until his death, except for visits to Rome in 1691, 1696 and 1698. He was made Court Painter at Turin in 1696.

Bibl.: Pascoli; Thieme-Becker (with bibl.); Cat. della Mostra Barocca Piemontese, 1965, II, 70 ff.

Rome. ACCADEMIA DI S. LUCA. *Lot and his daughters* (after C. Loth).
 Caritas Romana.

s. MARIA IN ARACELI. 8 to R: *Two posthumous miracles of S. Pasquale Baylon.* To L: *At a deathbed*; to R: *At a scene of birth.* (GFN, E, 34296–7.) [Plates 70–1.] The process for S. Pasquale's canonization was completed in 1679. These are noted in the 1686 Titi.

s. MARIA DI MONTESANTO. 3 to L: L. wall: *S. James succouring the sick. c.* 1686.

s. MARIA DEL POPOLO. 2 to R: L. wall: *Martyrdom of S. Lawrence.* (Alinari 28468 as Morandi); R. wall: *Martyrdom of S. Catherine.* (Alinari 28467.) 1685–6.

s. MARIA DEL SUFFRAGIO. 1 to L: *Madonna with SS. Catherine and Hyacinth. c.* 1685. For the date see Forcella, VIII, no. 1044.

s. MARIA IN TRANSPONTINA. 2 to R: *S. Canute. c.* 1686.

s. MARIA IN VALLICELLA. Painting over entrance door: *S. John preaching.* Four of the ovals above the nave arcades: 1 to L: *Communion of the Apostles*; 4 to L: *Virgo Immaculata*; 1 to R: *Fall of Manna*; 4 to R: *Judith with head of Holofernes.* About 1698.

PIETRO TESTA (1612–1650)

A native of Lucca and often known as 'il Lucchesino'. After a brief study with Domenichino before he left for Naples in 1630, he worked for a time with Pietro da Cortona. He was taken up by Cassiano dal Pozzo, for whom he made antiquarian drawings, and in whose circle he became much influenced by Nicolas Poussin. His mind was sensitive and original

*and he is one of the most interesting of Italian etchers (see Ann Sutherland Harris, Paragone,
no. 213, 1967, 35–60), but, though ambitious to become a major painter, his achievement in
the field of painting is rather slight.*

Bibl.: Passeri; L. Lopresti in *L'Arte*, XXIV (1921), 10–18 and 74–84; A. Marabottini
in *Commentari*, V (1954), 116–35 and 217–44; Erich Schleier in *Burl. Mag.*, CXII
(Oct. 1970), 665–8; Isa Belli Barsali, *Guida di Lucca*, 1970, 237; Elizabeth
Cropper, *Journal of the Courtauld and Warburg Institute*, XXXIV (1971), 262 ff.

Rome. CAPITOLINE. 139. *Joseph sold by his brethren.* A small version is in the Galleria
Spinola, Genoa. There are possible traces of a signature (illegible). Perhaps
painted for the Sacchetti *c.* 1631. It is fashionable at present to doubt the attribu-
tion, but no other early paintings are known.
SPADA. *The Sacrifice of Iphigeneia.* There is a closely related etching.
The Massacre of the Innocents.
S. MARTINO AI MONTI. I to L: *The Vision of S. Angelo Carmelitano.* 1645–6. For the
date see Ann B. Sutherland, *Burl. Mag.*, CVI (Feb. 1964), 62.
It is possible, from the existence at Naples (1696) of a picture by Testa of
Basilides prophesying to Titus (etched by Giovanni Cesare Testa), that the figures
in Gaspard Dughet's fresco of this subject in S. Martino (*q.v.*) are by Testa.

FRANCESCO TREVISANI (1656–1746)

*A native of Capodistria and trained in Venice under Zanchi. He came to Rome in 1678 and
was employed by Cardinal Flavio Chigi from 1681 onwards, but for major work only outside
Lazio. His first public commission for Rome was in 1695 (S. Silvestro in Capite) and he
became an Accademico di S. Luca in 1697. He softened his earlier style and, from about
1710, he succeeds Maratti as the most famous, prosperous and prolific painter in Rome, with
connections all over Europe. He was made a Cavaliere on 16 January 1730. He was equally
at home in altarpieces, mythologies, large or small devotional works (often repeated), and, as
a portraitist, he rather specialized in British travellers of Jacobite leanings.*

Bibl.: Pascoli (MS. biography in Bibl. Communale, Perugia; unpublished but used
by Bodmer in Thieme-Becker); V. Golzio, *Documenti artistici . . . nell'Archivio
Chigi*, 1939, 268 ff.; bibliography in Thieme-Becker up to 1939; Andreina
Griseri, in *Paragone*, no. 153 (1962), 28 ff.; Frank R. Di Federico, in *Art Bulletin*,
LIII (1971), 52 ff.; *do. Master Drawings*, 1972, 3 ff. (A book in preparation.)

Bolsena. S. CRISTINA. Chapel to L. of high altar: N. wall: *Birth of the Virgin.* (GFN,
E, 43492.) A small variant on copper in Galleria Doria.
Altar of the Miracle: *Miracle of Bolsena.* (GFN, E, 42250.) [Plate 77.] The altar
was reconstructed in 1693. A small version is in the Accademia di S. Luca.

Narni. DUOMO. R. transept (Chapel of B. Lucia of Narni): altarpiece: *Stigmatization of the Saint.* (GFN, E, 41258); attic of altar: *Madonna and Child with B. Lucy as a girl.* (GFN, E, 41256); R. wall: *Death of S. Joseph.* (GFN, E, 41257); L. wall: *Holy Family with SS. Catherine, Dominic and Anthony of Padua.* (Signed: F.T.) (GFN, E, 41259.) Commissioned by Cardinal Sacripanti 1714 and finished 1717. See F. R. Di Federico in *Storia dell'Arte*, 15–16 (1972), 307 ff.

Rome. ACCADEMIA DI S. LUCA. 160. *S. Francis.* (GFN, E, 28769.)

215. *Christ fallen beneath the Cross*; 374. *Flagellation.* Companion *bozzetti* for pictures in S. Silvestro in Capite.

GALLERIA NAZIONALE (CORSINI). 176. *Madonna.* (Anderson 1245.)

288. *Jacob and Esau.* (GFN, E, 37062.) 289. *Cain killing Abel.* (GFN, E, 37063.) Companions.

479. *Stoning of S. Stephen.* (Vasari 2185.)

512. *Madonna Addolorata.* (Alinari 3171 as 'Cignani'.)

978. *Penitent Magdalen.* (GFN, E, 61473.)

1285. *Martyrdom of S. Lucy.* (GFN, E, 60510.)

Four Corners of the World. Perhaps *c.* 1709. Bought 1972. Small *modelli* for mosaics in S. Peter's. See Frank R. Di Federico, *Arte Illustrata*, 1972, 321 ff.

COLONNA. 41. *Christ crowned with thorns.* Before 1700.

DORIA. 60 (319) *Madonna addolorata.*

389 (209) *The Baptist preaching.*

390 (210) *Birth of the Virgin.*

(471) *Landscape.*

SPADA. 164. *Feast of Anthony and Cleopatra.* After 1717. [Plate 73.]

S. ANASTASIA. R. transept: *S. Toribio, Bishop of Lima.* About 1726 (Forcella, X, no. 101). [Plate 76.]

S. ANDREA DELLE FRATTE. Behind high altar: to L: *S. Andrew affixed to his Cross.* Shortly before 1708 (the 1708 Titi says it was painted in twenty-four days).

S. GIOVANNI IN LATERANO. Fifth to L. of the ovals above the nave arcade: *Baruch.* 1718. (GFN, E, 21134.) [Plate 74.]

S. IGNAZIO. 2 to R: *Death of S. Joseph.* Over arch on R. wall: *Last Communion of S. Luigi Gonzaga.* About 1712 (Forcella, X, no. 188).

S. MARIA DEGLI ANGELI. Chapel at end of L. transept: huge canvases on side walls: *Two scenes from the Death of the Maccabees (Baptism by Blood).*

Chapel at end of R. transept: two huge canvases on side walls: *Baptism by Water*; *Baptism by Desire.*

Cartoons, to scale, for the mosaics in front of the Baptistery chapel in S. Peter's (1 to L.). 1738 to 1745 (see Vatican, S. Pietro).

Oval canvas above arch from entrance to crossing: *Expulsion from Paradise.*

S. MARIA IN ARACELI. 4 to L: *Holy Family with S. Anne in the clouds and the Beata Serafina Sforza below.* Stylistically about 1715; but the veneration of the Beata Serafina was not confirmed until 1755.

R. transept: *S. Francis in ecstasy. c.* 1729. See P. F. Casimiro, *Memorie storiche della Chiesa e Convento di S. Maria in Araceli,* 1736, 110.

ORATORY OF S. MARIA IN VIA. High altar: *Holy Family with S. Anne and Angels.* 1729. See Forcella, VIII, no. 887. A *modello* is in private hands in Rome (1972).

S. ONOFRIO. Sacristy. *B. Giovanni Gambacorta of Pisa.*

S. SEBASTIANO FUORI LE MURA. Sacristy. Miniature altarpiece: *The Holy Family.*

S. SILVESTRO IN CAPITE. 1 (2) to L. altar: *Crucifixion*; L. wall: *Flagellation* below *Christ crowned with thorns* (lunette); R. wall: *Christ falling beneath the Cross* below *Agony in the garden* (lunette) [Plate 72]. Frescoes on ceiling: *Angels with the Cross*; and *Putti with Instruments of the Passion* in the spandrels. 1695-6. The frescoes on the ceiling are Trevisani's only known frescoes. For documents and lists of the very numerous *bozzetti* and *modelli*, see J. S. Gaynor and Ilaria Toesca, *S. Silvestro in Capite,* 1963, 113; and F. R. Di Federico in *Art Bulletin,* LIII, 1971, 52 ff.

STIMMATE DI S. FRANCESCO. High altar: *S. Francis receiving the Stigmata.* The rebuilt church was consecrated in 1719 and this is in the 1721 Titi.
3 to L: *Vision of S. Anthony of Padua.* After 1721.

MINISTERO DELL'AERONAUTICA. *The Holy House of Loreto in Flight.* (GFN, E, 18272 as Maratti.)

PALAZZO DE CAROLIS (BANCO DI ROMA). Canvas let into the ceiling of large room on first floor: *Venus at the Forge of Vulcan.* (Signed F.T.) The Palace was decorated around 1725 (Alessandro Bocca, *Il Palazzo del Banco di Roma,* 1967, 23 and fig. VIII.)

PALAZZO COLONNA. Throne room: *Raising of Lazarus.*

PALLAVICINI COLLECTION. 503. *Dead Christ mourned by Angels.* One of Trevisani's most popular devotional designs; there is a large version at Bristol and small ones at Raveningham and Vienna.

PALAZZO SENATORIO. *Flight into Egypt* on the face of a clock. (*Bolletino dei Mus. Com. di Roma,* 1960.)

Ronciglione. DUOMO. R. transept altar: *Assumption.* The cathedral was completed in 1695.

Valletta. MUSEUM. *Holy Family with the Child Baptist.* The best version known to me of this popular devotional design; a smaller one was in the Duke of Beaufort sale 15 November 1967 (19).

Vatican. S. PIETRO. First bay of L. aisle (in front of Baptismal chapel): mosaics from Trevisani's cartoons in cupola, spandrels, and lunettes. For description see Chattard, I, 123. The commission was given in 1710. Cartoons for the spandrels were completed between 1713 and 1723; for the uprights 1732 to 1737; for the dome (those now in S. Maria degli Angeli), 1738 to 1745 (F. R. Di Federico in *Storia dell'Arte,* no. 6 (1970), 155-74). The cartoons for the spandrels perished with the dome of Urbino Cathedral in 1789, but small *modelli* are in the Galleria Nazionale (*q.v.*). See also below.

AULA DELLA BENEDIZIONE. Two of the cartoons for S. Pietro (*q.v.*): *Christ baptizing*

S. Peter (Arch. Vat. foto. XXXI, 75, 24); *S. Peter baptizing Cornelius* (do. XXXI, 75, 23).

FABBRICA STORE ROOM (formerly Museo Petriano). Cartoons for uprights for S. Pietro (*q.v.*): *Noah praying after the flood*; *Moses striking water from the rock*; *S. Peter baptizing Cornelius*; *S. Philip baptizing the Eunuch.* 1732–7.

GIROLAMO TROPPA (working 1661 to *c.* 1710?)

Born in Rocchette (Sabina), he was an independent painter in Rome from 1661 and had a row with Baciccio in 1665. By the 1690's he had fallen into the Marattesque orbit. He was certainly active in 1706 and probably as late as 1710.

Bibl.: Thieme-Becker; Cesare Verani, *L'Arte*, LX (1961), 300–1; Olsen, *Italian Paintings . . . in Denmark*, 1961, 97–8.

Rome. S. AGATA IN TRASTEVERE. Fresco on ceiling of nave: *S. Agatha in glory*; fresco above high altar: *God and cherubim.* It would seem that the vaults were not structurally ready for fresco until about 1710 (cf. F. Fasolo, *Le Chiese di Roma nel '700*, I, 1949, 133).

S. CARLO AL CORSO. Fresco on ceiling of 2nd bay of R. aisle: *Justice, Peace, Law and Truth* with *Putti* in the corners. 1678. See G. Drago and L. Salerno, *SS. Ambrogio e Carlo al Corso*, 1967, 104 and fig. 21.

3 to R: *Madonna and S. Francis.* 1680's.

S. CROCE ALLA LUNGARA (Buon Pastore). High altar: *Crucifixion.* This probably survives, but I have never got into the church.

S. MARIA DEL SUFFRAGIO. 2 to R: L. wall: *Sacrifice of Abraham.* Between 1675 and 1686.

S. MARTA AL COLLEGIO ROMANO. Frescoes on nave ceiling: the eight *Allegorical figures* in the corners beyond the first and third circular frescoes. *c.* 1672. (Four in photo Anderson 20753.) See also under Baciccio.

PALAZZO ODESCALCHI. Fresco on ceiling of small room: *Flora.* 1668. See V. Golzio, *Documenti artistici . . . nel Archivio Chigi*, 1939, 19.

PIETRO PAOLO UBALDINI (fl. 1630 to later 1660's)

He was executing cartoons for tapestries on Pietro da Cortona's design in 1630 (G. Briganti, P. da Cortona, 207) and in 1631–2 (as 'Pietro Paolo Modello') he did some painting in the Palazzo Barberini (O. Pollak, Urban VIII, I, 332). He seems later to have been profoundly influenced by Romanelli. His name appears in Titi as 'Baldini', and elsewhere as 'Naldini' (who has been supposed to be the same person as the sculptor, Bernini's pupil, Paolo Naldini, which I do not believe); the artist whose works are listed below is called Ubaldini in the

*Viterbo MS. of G. B. Mola (c. 1663) and 'Pietro Paolo . . . Romano chiamato del Modello'
by Fioravante Martinelli (c. 1665).*

Rome. SS. DOMENICO E SISTO. Fresco in stone frame on S. wall of chancel: *Miracle
of S. Dominic at the Battle of Muret.* 1639.

 S. ISIDORO. 2 to R: altar. *S. Anne with Madonna and Child.* (GFN, E, 20451.) [Plate
79.] Canvases on side walls, below frescoed lunettes: to L: *Birth of the Virgin*
below *Meeting of Joachim and Anne*; to R: *Presentation of the Virgin* below *Angel
appearing to Joachim and Anne.* Fresco in cupola: *SS. Anne and Joachim in glory.*
Recorded by G. B. Mola (ed. K. Noehles, 1966, 102) and by Fioravante Marti-
nelli in the early 1660's.

 S. MARIA IN PORTA PARADISI. Frescoes in the eight compartments of the dome:
Madonna assumed with Christ and Angels. The payments (to 'Pietro Paolo Naldini')
are 1645 (see *Quaderni dell' Istituto di Storia dell' Architettura,* 1962, 21), but they
seem to be by this hand.

 S. NICOLA DA TOLENTINO. Frescoes in the pendentives of the dome over the crossing:
Obedience; Discipline; Humility; Poverty. (Visible in GFN, E, 21345.) Probably
completed just before Coli's and Gherardi's frescoes of 1669–70 in the dome
(perhaps Ubaldini died *c.* 1669?).
Chapel to L. of high altar: *Madonna with SS. Matthew and Cecilia.* (GFN, E,
42426.) Canvases and frescoes on side walls and in dome from *Lives of SS.
Matthew and Cecilia.* Correctly ascribed to Ubaldini by Fioravante Martinelli
c. 1665, and in the 1686 Titi, but later always wrongly given to Romanelli (see
L. Salerno in *Altari barocchi in Roma,* 1959, 111).
3 to R: frescoes: L. wall: *Martyrdom of S. Gertrude* below a lunette of *S. Gertrude
professing her faith before a judge* [Plate 78]; R. wall: *Christ appears to S. Lucrezia
in a vision* below a lunette of *Christ embracing S. Lucrezia.* In cupola: *SS. Gertrude
and Lucrezia in glory at either side of the Virgin.* Also listed by Fioravante Martinelli
(p. 143) *c.* 1665.

RAFFAELLE VANNI (1587–1674)

*One of the two sons (the other was named Michelangelo) of the painter Francesco Vanni
(d. 1610), whose pupil he was at Siena before coming to Rome, where he studied under
Antonio Carracci. Most of his surviving work was for Siena, but he became an Accademico
di S. Luca in 1655 and Principe of the Academy 1658–60. As a Sienese he was chiefly
patronized by the Chigi Pope and it is probable that most of his Roman work was done
between 1655 and 1667: he was employed on restoring pictures in S. Peter's in 1662.*

Ariccia. COLLEGIATA. 3 to L: *Death of S. Thomas of Villanova.* 1665. [Plate 80.]
 For date see G. Incisa, *Rivista del R. Istituto d'archeologia e storia dell'arte,* I (1929),
374. (GFN, E, 42823.)

Rome. S. CROCE IN GERUSALEMME. 3 to R: *The mother of S. Robert has a vision of her son adopted by the Virgin as her spouse.* [Plate 81.] Probably a very late work. (GFN, E, 56446.)

ORATORIO DEI FILIPPINI. Altar: *Virgin and Child with SS. Cecilia and Filippo Neri.* Commissioned 1665. See Carlo Gasbarri, *L'Oratorio Romano*, 1962, 233.

S. MARIA DELLA PACE. Second to L. of the big pictures high up in the octagon: *Birth of the Virgin. c.* 1656–7. (GFN, E, 40217.)

S. MARIA DEL POPOLO: 2 to L: lunettes over pyramids on side walls: to L: *David playing before Saul*; to R: *Samuel and Eli.* 1653. For the date see G. Cugnoni, *Archivio della R. Soc. Romana di Storia Patria*, III (1880), 440.

Fresco in cupola over crossing: *The Virgin received into glory.* 1656–6 (Cugnoni, 529–36).

S. MARIA IN PUBLICOLIS. High altar: *Birth of the Virgin*; altar to R: *S. Helena with the True Cross.* The *terminus a quo* for both pictures is the rebuilding of the church in 1643 (Forcella, IV, nos. 1119–20). The date of 1655 on the companion altarpiece by Grimaldi is probably valid for this also; it was recorded in 1660 (*Mostra dei Restauri*, 1969, 25).

PALAZZO DI MONTECITORIO. 707. *Rape of Helen.*

PLATES

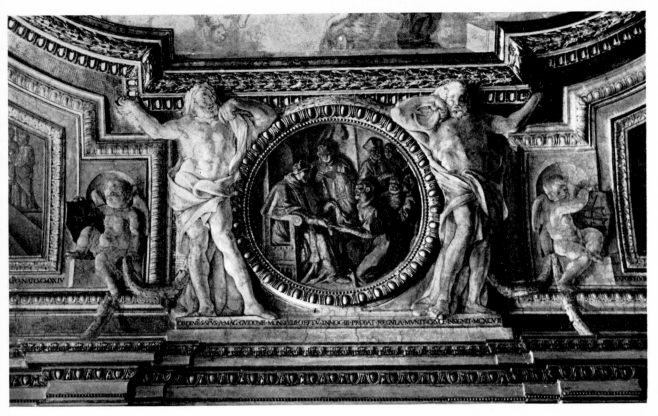

1. Abbatini: *Pope Innocent III approving the rule of the Order of S. Spirito*. Fresco, 1650. Rome, S. Spirito in Sassia

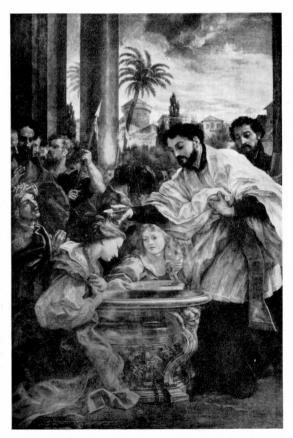

2. Baciccio: *S. Francis Xavier baptizing*. 1705–9. Rome, S. Andrea al Quirinale

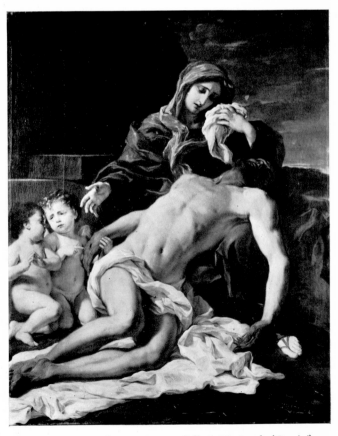

3. Baciccio: *Pietà*. 1667. Rome, Galleria Nazionale (Corsini)

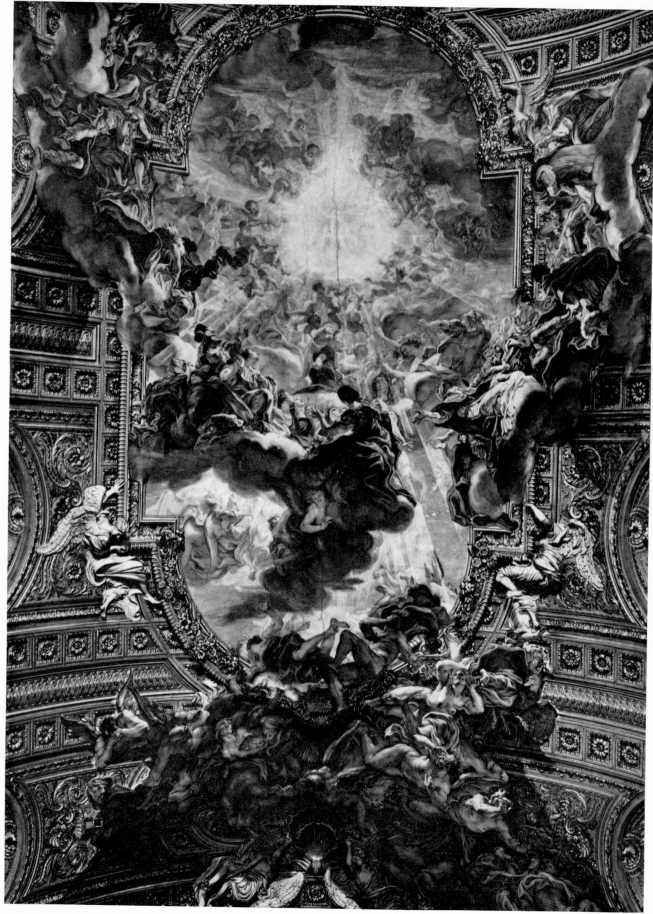

4. Baciccio: *The Triumph of the Name of Jesus*. Ceiling fresco, 1676–9. Rome, Gesù

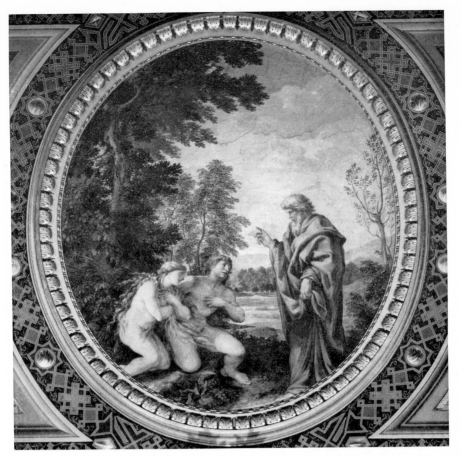

5. Baldi and Gaspar Dughet: *The Creation of Adam and Eve*. Fresco, 1657.
Rome, Palazzo del Quirinale

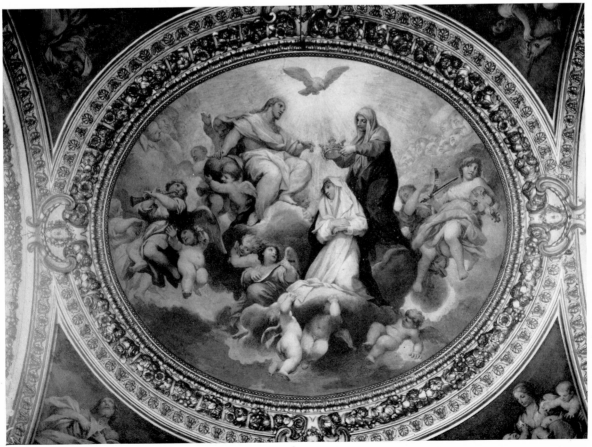

6. Baldi: *S. Rose crowned by the Virgin*. About 1671. Rome, S. Maria sopra Minerva

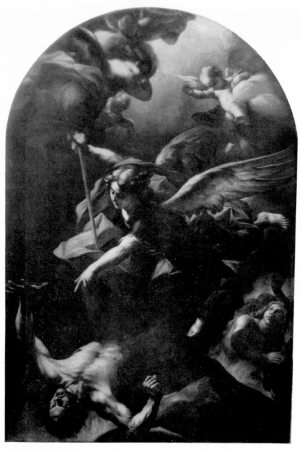

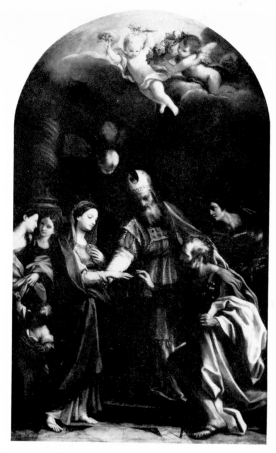

7. Beinaschi: *S. Michael overcoming Lucifer*. After 1675.
Rome, S. Bonaventura sul Palatino

8. Berrettoni: *Sposalizio*. About 1675.
Frascati, Scolopi

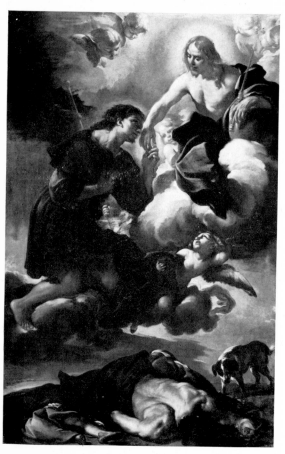

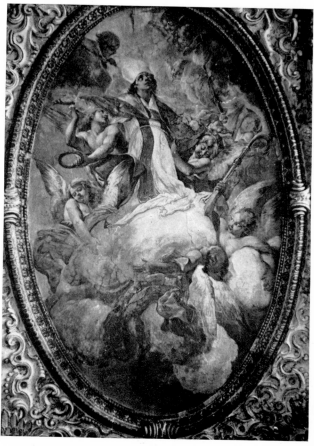

9. Brandi: *S. Roch received into Heaven*. Before 1674.
Rome, S. Rocco

10. Brandi: *S. Erasmus in glory*. Ceiling fresco, 1663–6.
Gaeta, Duomo, crypt

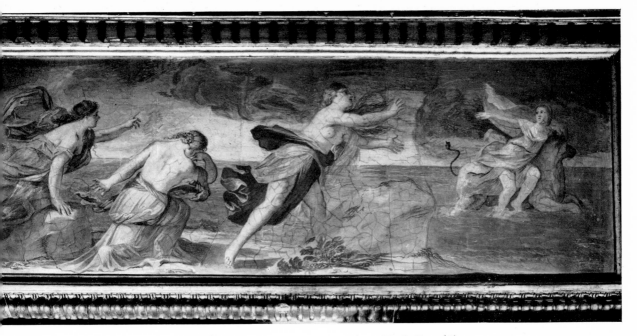

11. Brandi: *Europa*. 1646–53. Rome, Palazzo Doria-Pamphily

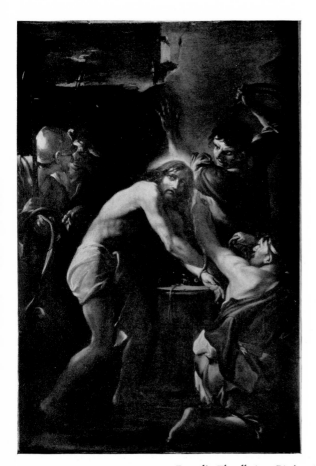

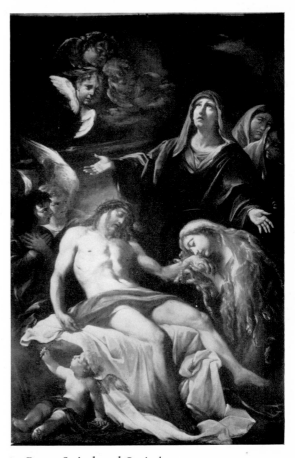

12–13. Brandi: *Flagellation; Pietà*. 1675–82. Rome, S. Andrea al Qurinale

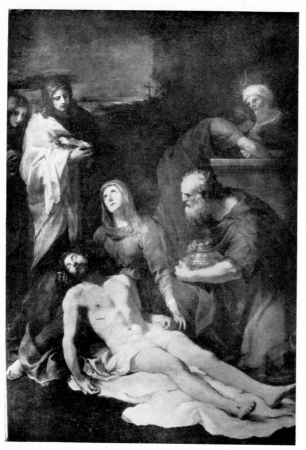

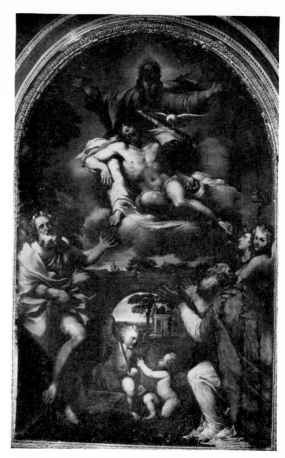

14. Camassei: *Pietà*. About 1631.
Rome, S. Maria della Concezione

15. Canini:
The Holy Trinity with SS. Bartholomew and Nicholas.
1644. Rome, S. Martino ai Monti

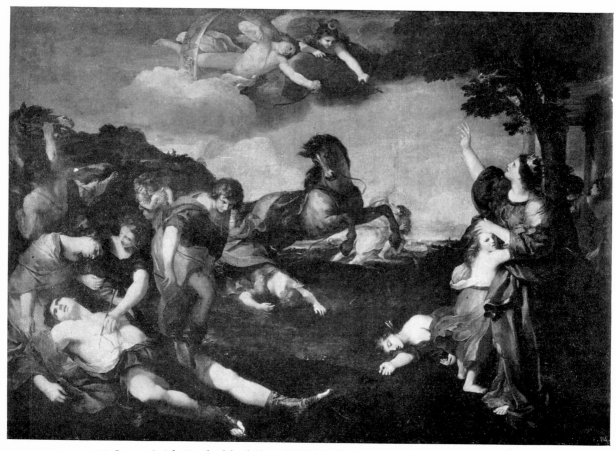

16. Camassei: *The Death of the children of Niobe*. Before 1644. Rome, Galleria Nazionale

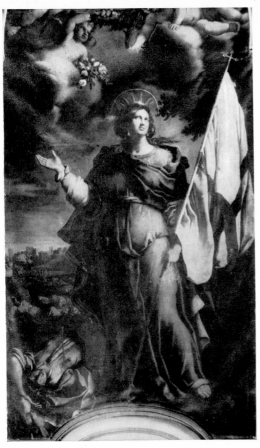

17. Cerrini: *S. Ursula with a banner.* 1642.
Rome, S. Carlo alle Quattro Fontane

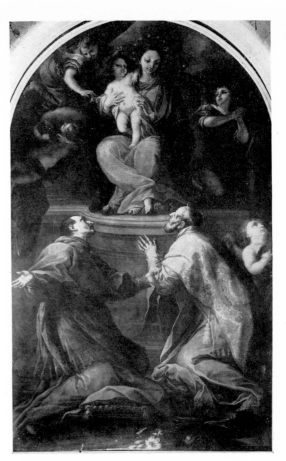

18. Cesi: *SS. Charles Borromeo and Filippo Neri
kneeling before the Virgin and Child.*
Rome, Propaganda Fide

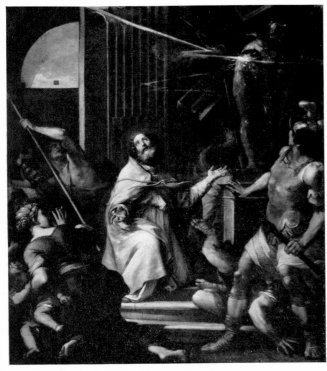

19. G. Chiari:
Idols destroyed by a thunderbolt at S. Stephen's prayer. 1695–6.
Rome, S. Silvestro in Capite

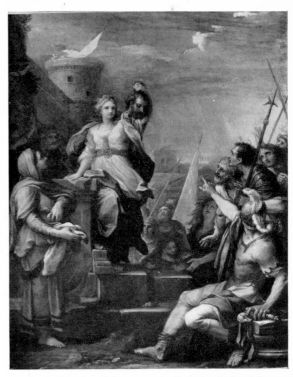

20. G. Chiari: *Judith returning with the head of Holofernes.*
1712. Rome, Museo di Roma

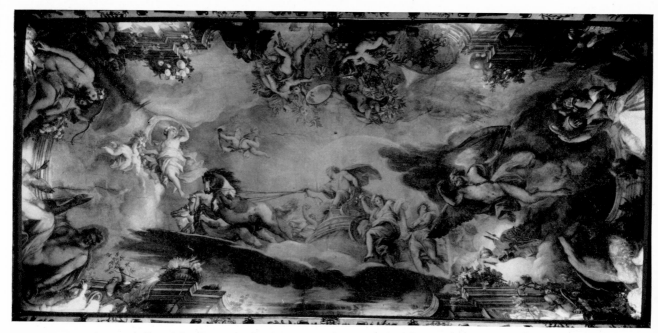

21. G. Chiari: *Apollo with his chariot, Aurora, the Seasons and Time.* Ceiling fresco, after 1693. Rome, Palazzo Barberini

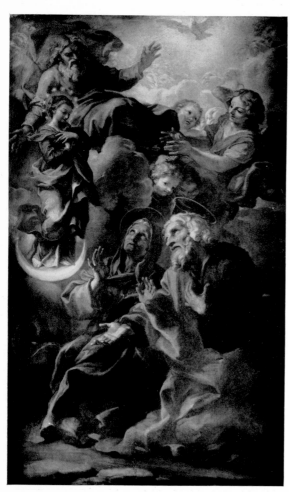

22. Cortese: *SS. Joachim and Anne see a vision of the Virgin immaculately conceived.* 1661–3. Rome, S. Prassede

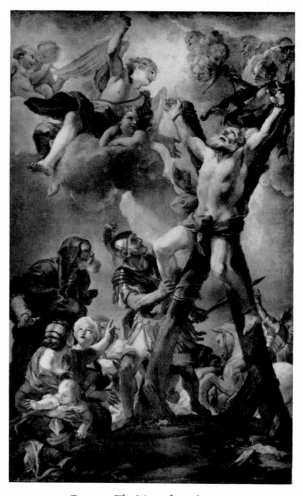

23. Cortese: *The Martyrdom of S. Andrew.* 1668–9. Rome, S. Andrea al Quirinale

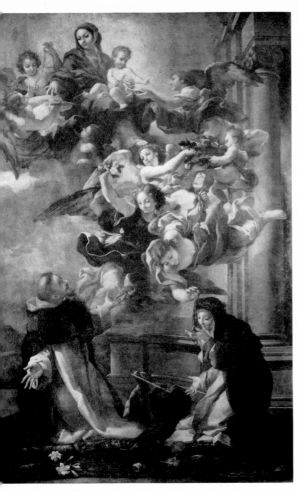

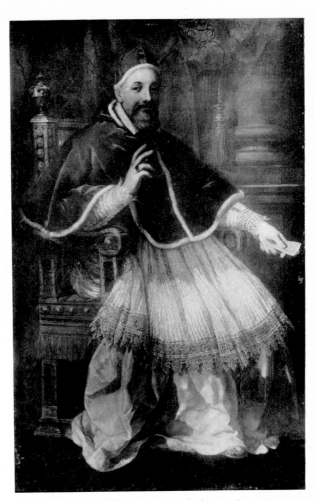

24. Cortese: *Madonna del Rosario*. 1666.
Monteporzio Catone, S. Gregorio

25. Pietro da Cortona: *Urban VIII*. Before 1630.
Rome, Museo di Roma

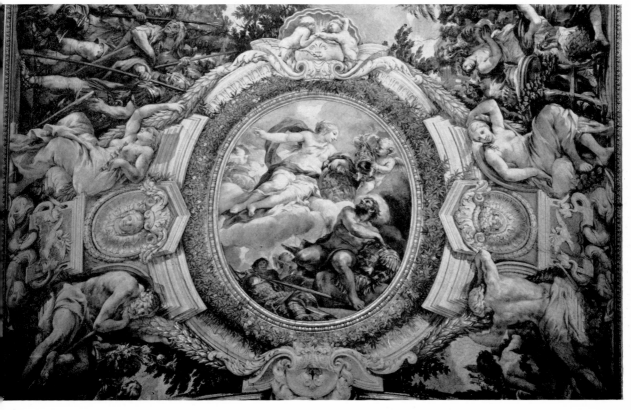

26. Pietro da Cortona: *Scene from the Aeneid*. Fresco, 1651–4. Rome, Palazzo Pamphily

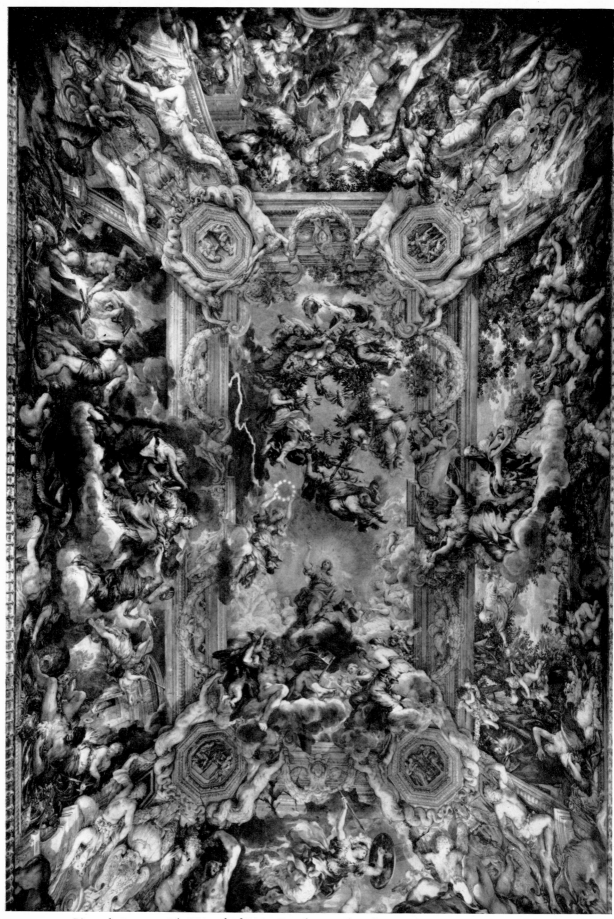

27. Pietro da Cortona: *The Triumph of Divine Providence*. Ceiling fresco, 1633–9. Rome, Palazzo Barberini

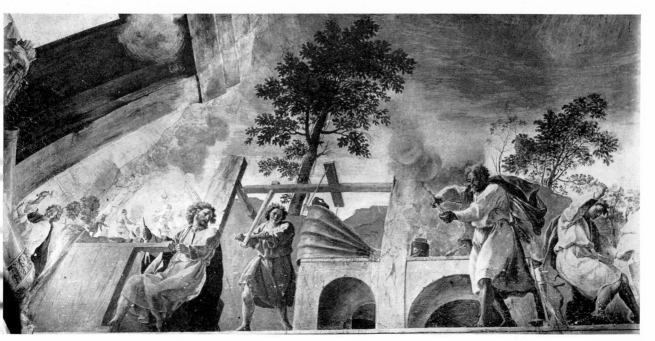

28. Cozza: *The Element of Fire*. Ceiling fresco, 1658–61. Valmontone, Palazzo Doria-Pamphily

29. Cozza: *Madonna del Riscatto*. 1660.
Rome, Collegio Nepomuceno

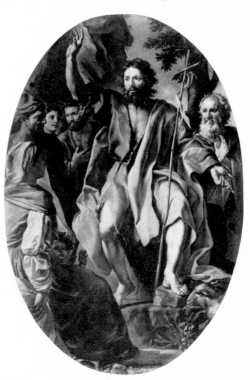

30. Cozza: *S. John preaching*. 1675.
Rome, S. Marta

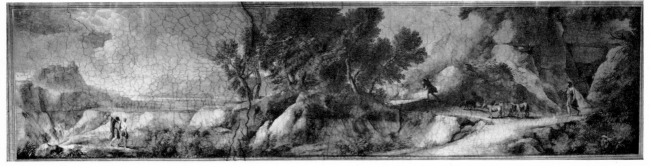

31. Dughet: *Landscape*. About 1648–50. Rome, Palazzo Doria-Pamphily

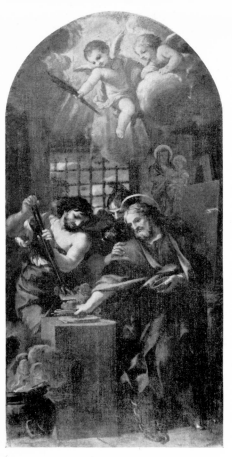

32. Ferri: *The Martyrdom of S. Lazarus.*
Rome, Accademia di S. Luca

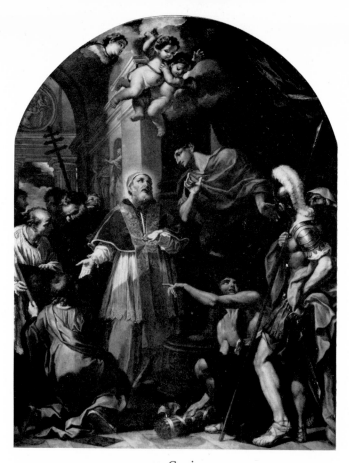

33. Garzi:
S. Sylvester showing the portraits of SS. Peter and Paul to Constantine.
After 1675. Rome, S. Croce in Gerusalemme

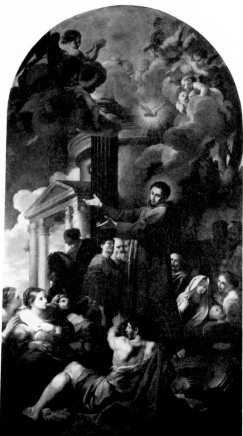

34. Garzi: *S. Francis preaching.* Probably 1695–6.
Rome, S. Silvestro in Capite

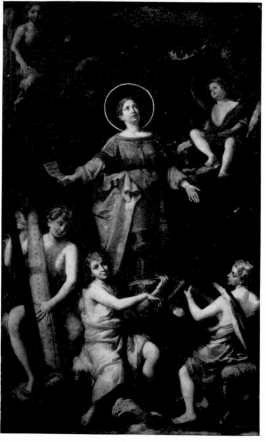

35. Gherardi: *S. Cecilia and Angels.* Before 1692.
Rome, S. Carlo ai Catinari

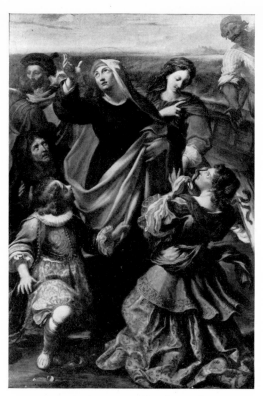

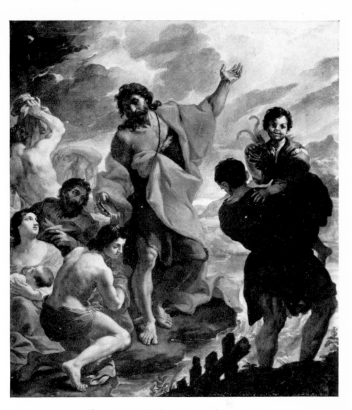

36. Ghezzi: *SS. Paula and Eustochium
embarking from Ostia for the Holy Land.* 1676.
Rome, Galleria Nazionale

37. Ghezzi: *S. John baptizing.* About 1696–7.
Rome, S. Silvestro in Capite

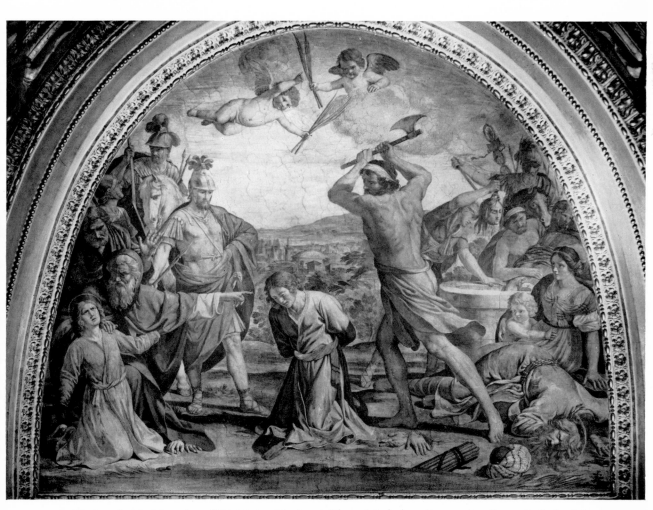

38. G. Gimignani: *The Martyrdom of SS. Marius, Martha, Audifax and Ambachum.* Fresco, 1641. Rome, S. Carlo ai Catinari

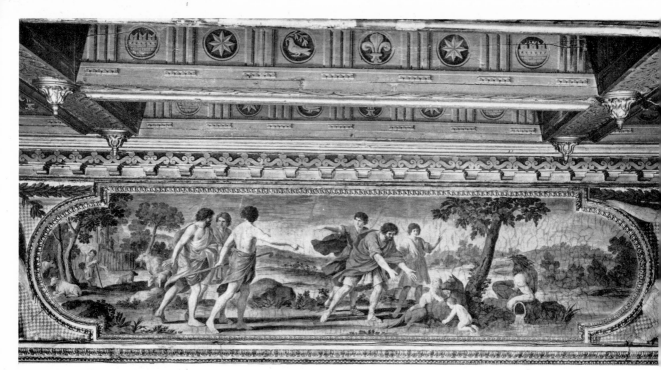

39. G. Gimignani: *Romulus and Remus*. Fresco, 1649–53. Rome, Palazzo Doria-Pamphily

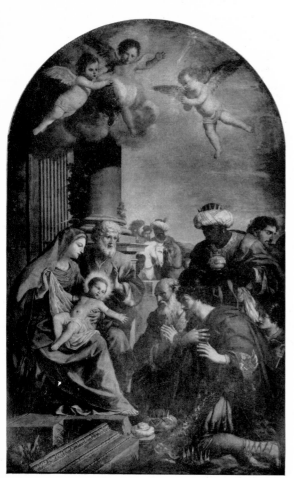

40. G. Gimignani: *The Adoration of the Kings*. 1634.
Rome, Propaganda Fide

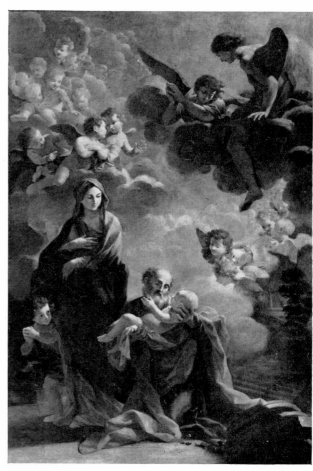

41. L. Gimignani: *The Rest on the Flight*. 1665.
Ariccia, Collegiata

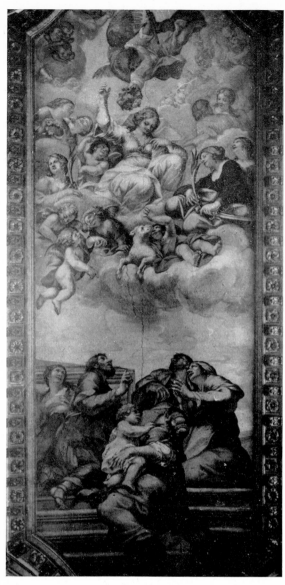

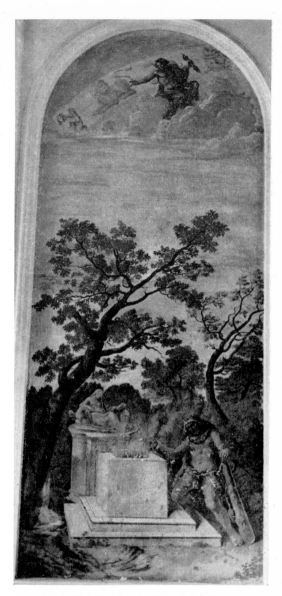

42. Gismondi: *S. Agnes in glory with worshippers below*.
Fresco, about 1664. Rome, S. Agnese in Piazza Navona

43. Grimaldi: *Hercules sacrificing*. Fresco, 1644–6.
Rome, Villa Doria-Pamphily

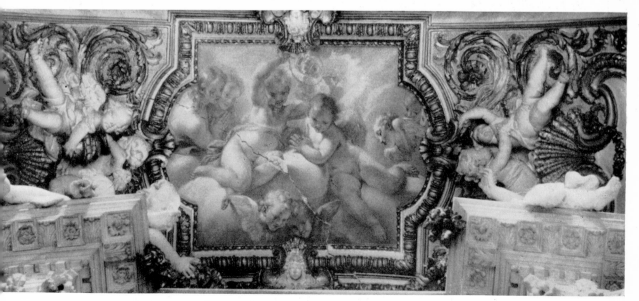

44. Luti: *Putti in adoration*. Fresco. Before 1721. Rome, S. Caterina a Magnanapoli

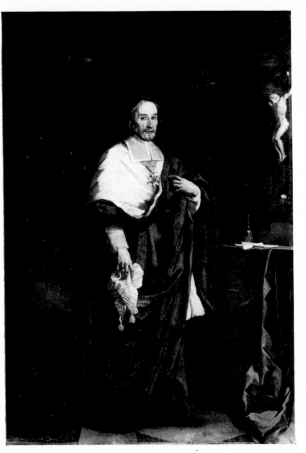

45. Maratti: *Cardinal Antonio Barberini*.
Probably early 1660's. Rome, Galleria Nazionale

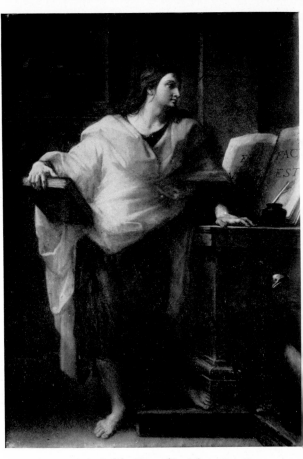

46. Maratti: *S. John Evangelist*. After 1671. Rome,
Galleria Nazionale

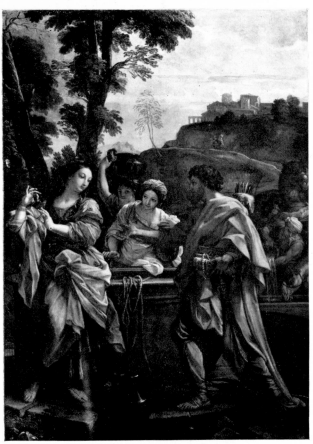

47. Maratti: *Rebecca and Eliezer*.
Rome, Galleria Nazionale (Corsini)

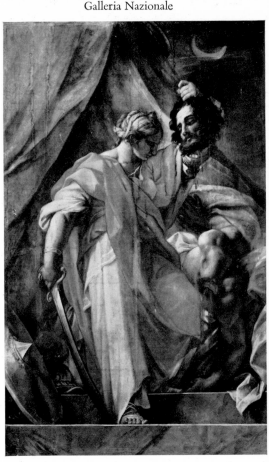

48. Maratti: *Judith with the head of Holofernes*.
Vatican, Loggia della Benedizione

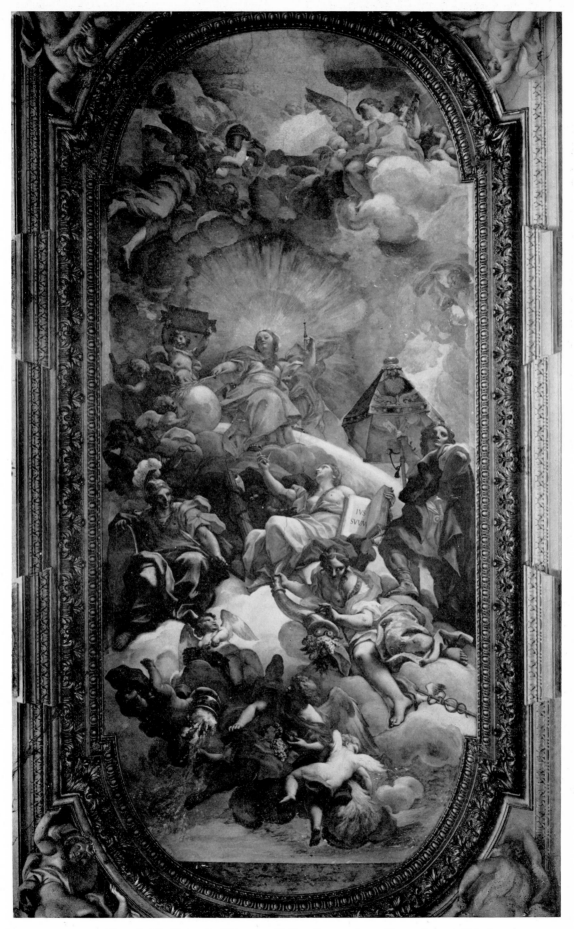

49. Maratti: *The Triumph of Clemency*. Ceiling fresco, 1674–7. Rome, Palazzo Altieri

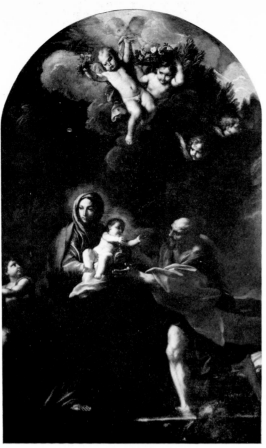

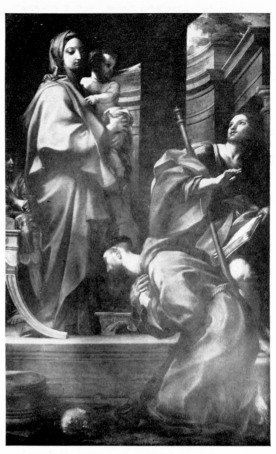

50. Maratti: *The Flight into Egypt.* 1664.
Rome, Galleria Nazionale (Corsini)

51. Maratti: *The Virgin and Child with SS. Francis and James.*
1686–9. Rome, S. Maria di Montesanto

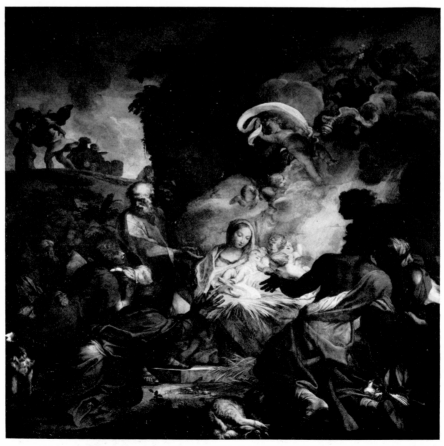

52. Maratti: *The Adoration of the Shepherds.* 1657. Rome, Palazzo del Quirinale

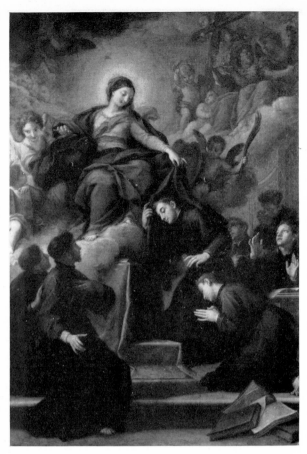

53. Masucci:
Madonna with the seven founders of the Servite Order.
About 1728. Rome, S. Marcello

54. Mei: *Holy Family, the Child treading on skull and snake.*
1659. Rome, S. Maria del Popolo

55. Mola: *The Conversion of S. Paul.* Fresco, 1650's. Rome, Gesù

56. Morandi: *Madonna del Rosario*. 1686. Rome, S. Sabina

57. Morandi: *Christ on the Cross*. Rome, Galleria Nazionale

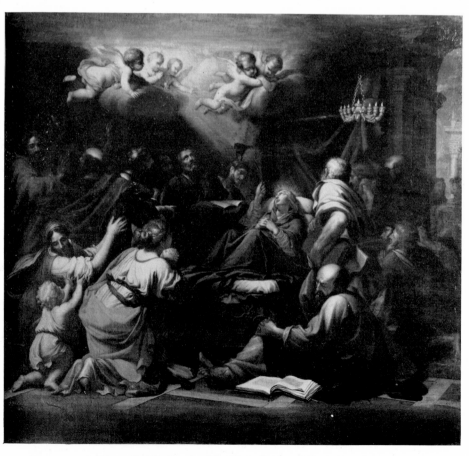

58. Morandi: *The Death of the Virgin*. Rome, Galleria Borghese

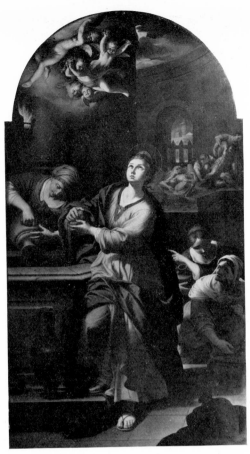

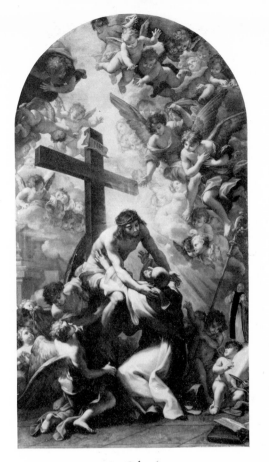

59. Muratori: *SS. Prassede and Pudenziana
gathering up the bones of martyrs.* 1735.
Rome, S. Prassede

60. Odazzi:
S. Bernard's vision of the Crucified Christ.
About 1710. Rome, S. Bernardo alle Terme

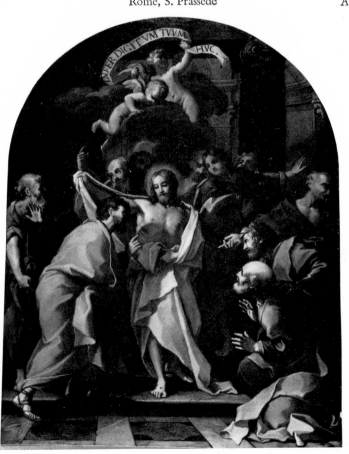

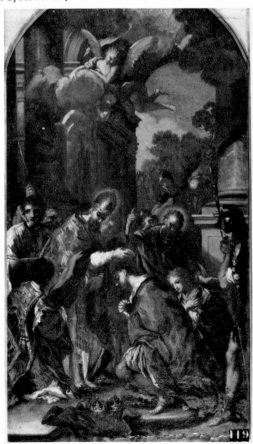

61. Passeri: *The Incredulity of S. Thomas.*
Between 1675 and 1686. Rome, S. Croce in Gerusalemme

62. Passeri: *S. Sylvester baptizing Constantine.*
Modello, about 1711.
Rome, Accademia di S. Luca

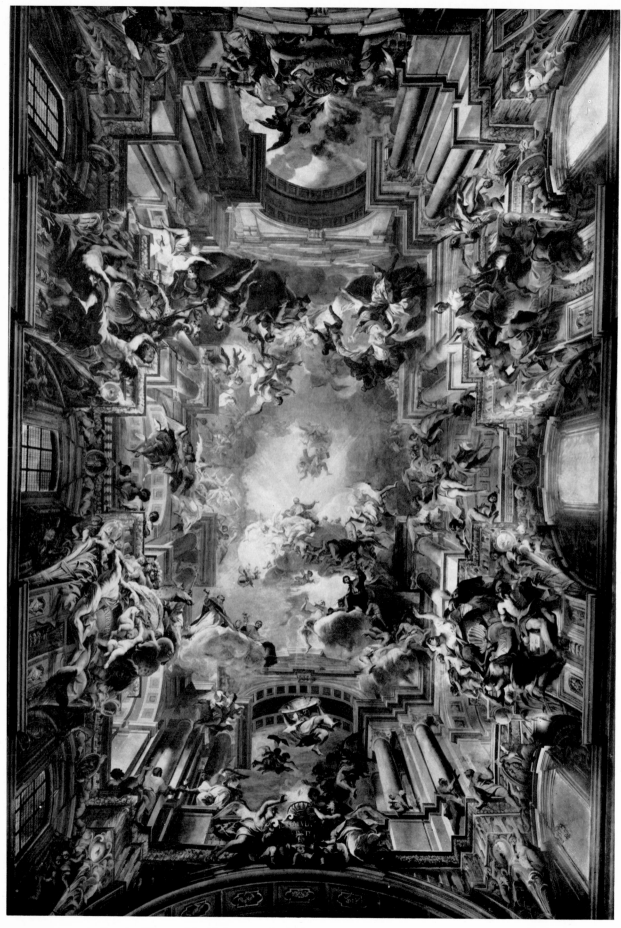

63. Pozzo: *Allegory of the missionary work of the Jesuits.* Ceiling fresco, 1691–4. Rome, S. Ignazio

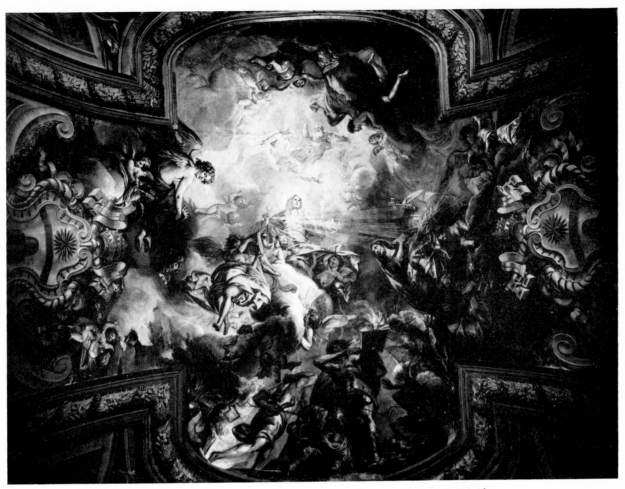

64. Puccini: *S. Bridget in glory*. Ceiling fresco, before 1700. Rome, S. Brigida

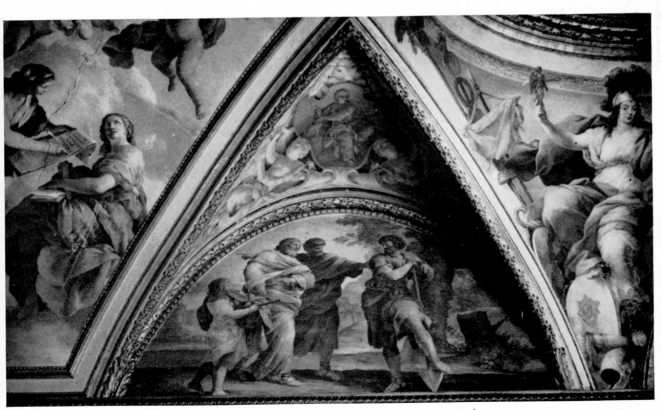

65. Romanelli: *Cincinnatus called from the plough*. Fresco, 1653. Rome, Palazzo Lante

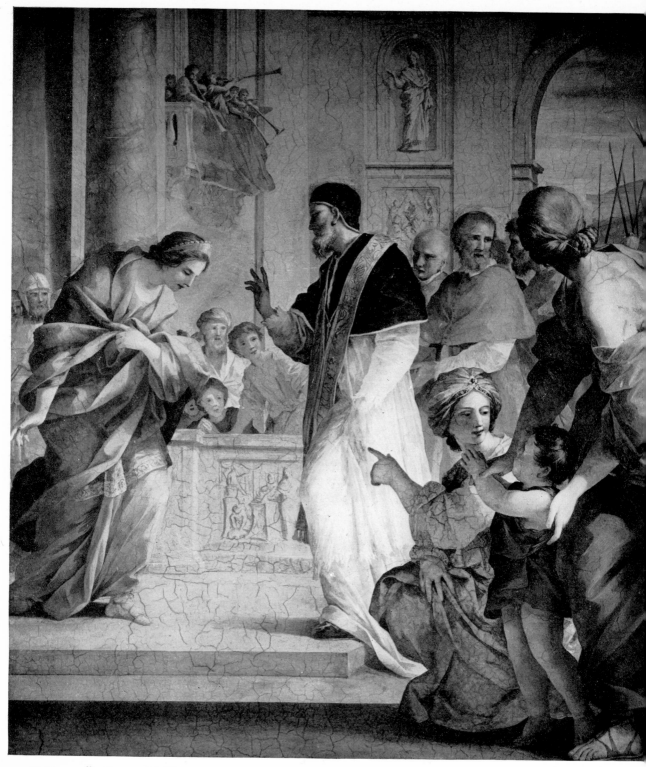

66. Romanelli: *Countess Matilda receiving Pope Gregory VII at Canossa*. Fresco, 1637–42. Vatican, Sala della Contessa Matilda

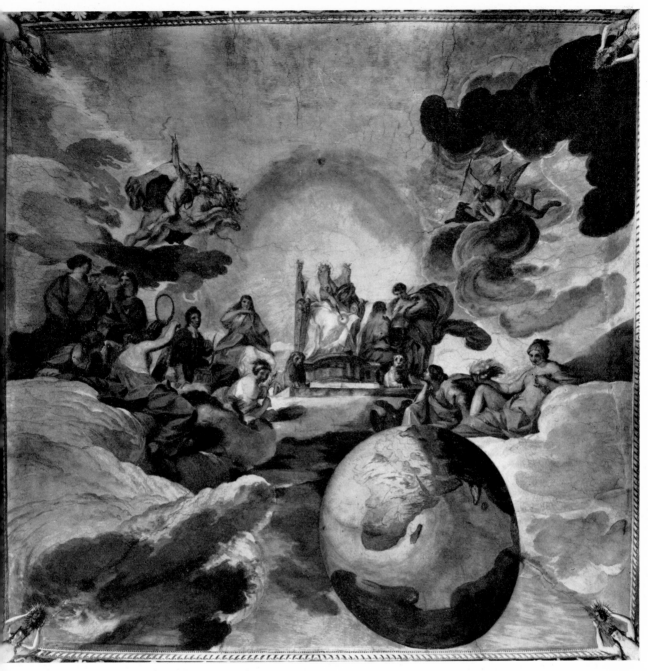

67. Sacchi: *La Divina Sapienza.* Ceiling fresco, 1629–31. Rome, Palazzo Barberini

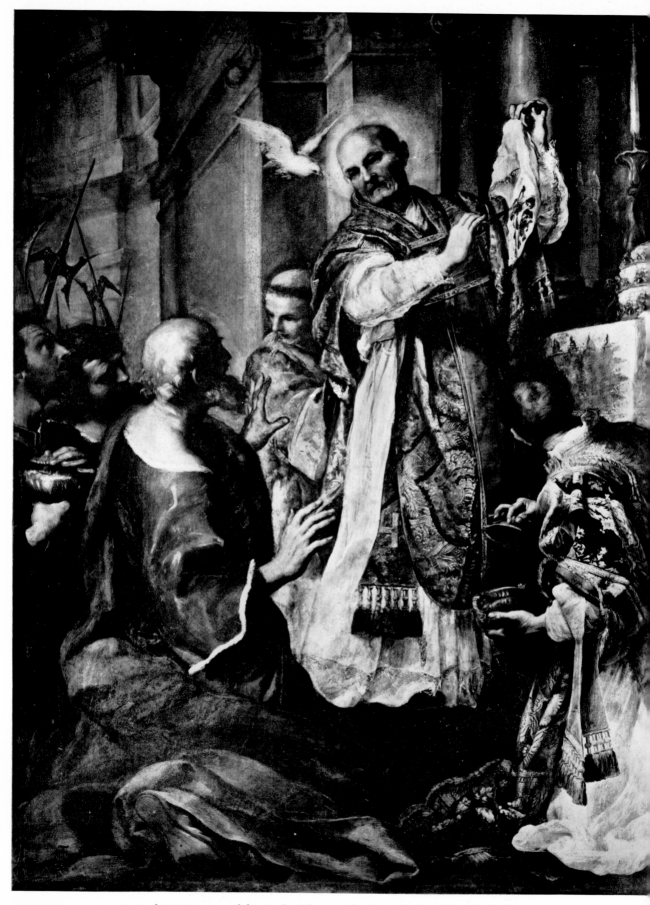

68. Sacchi: *S. Gregory and the miracle of the corporal.* 1625–7. Vatican, Canonica di S. Pietro

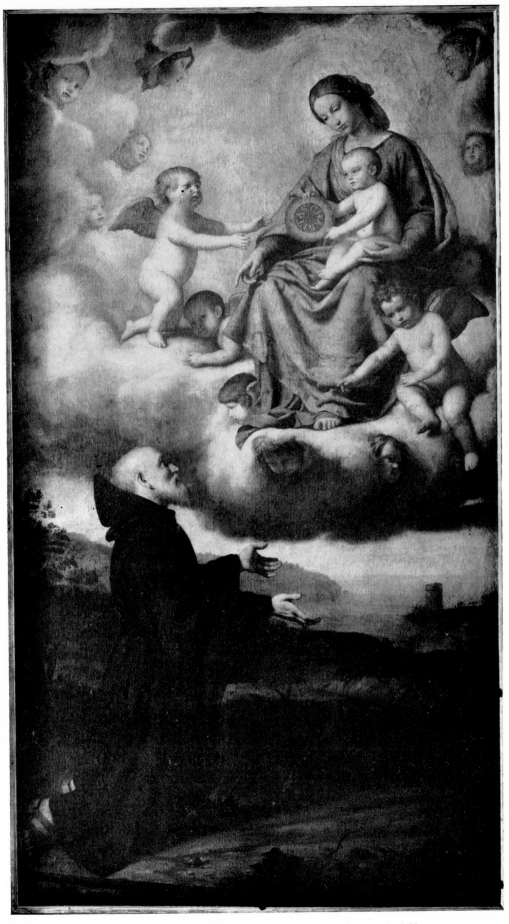

69. Sassoferrato: *S. Francis de Paul kneeling before the Madonna and Child.* 1641.
Rome, S. Francesco de Paola

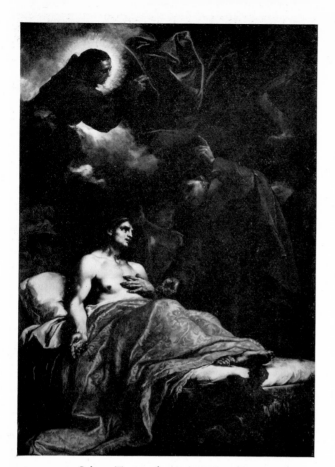

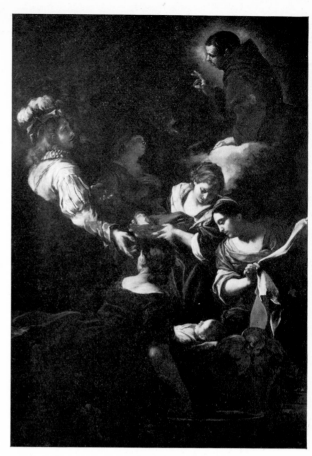

70–71. Seiter: *Two posthumous miracles of S. Pasquale Baylon at a deathbed and at a scene of birth.* Between 1679 and 1686.
Rome, S. Maria in Araceli

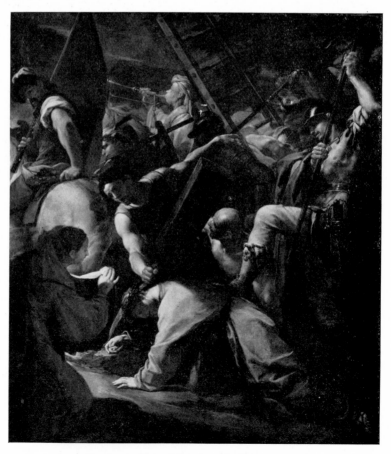

72. Trevisani: *Christ falling beneath the Cross.* 1695–6.
Rome, S. Silvestro in Capite

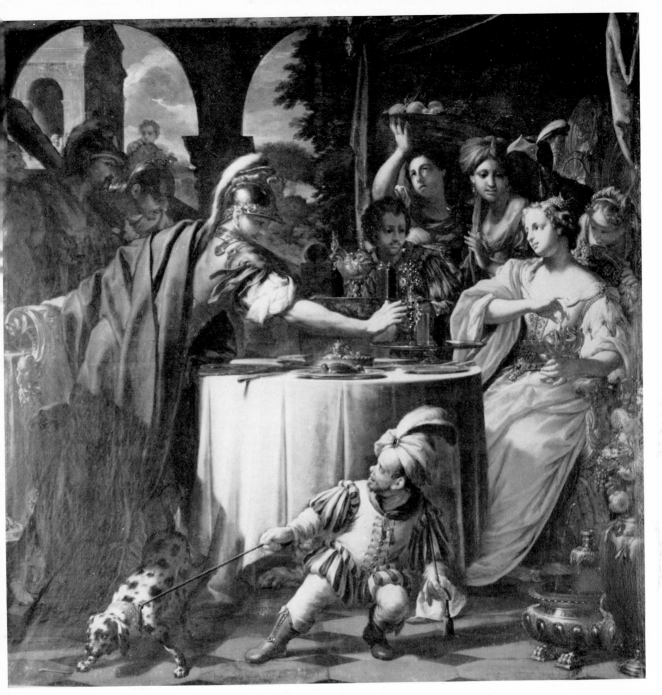

73. Trevisani: *The Feast of Anthony and Cleopatra*. After 1717. Rome, Galleria Spada

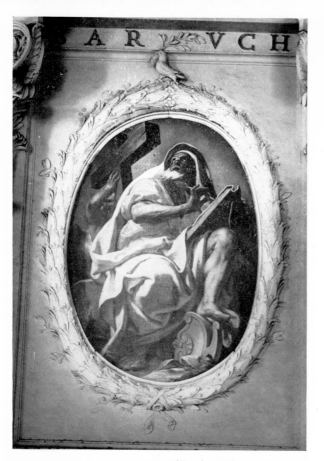

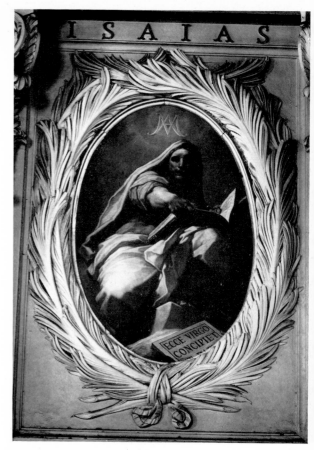

74–75. Trevisani: *Baruch*; Luti: *Isaiah*. 1718. Rome, S. Giovanni in Laterano

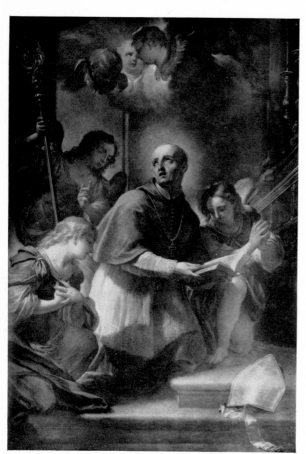

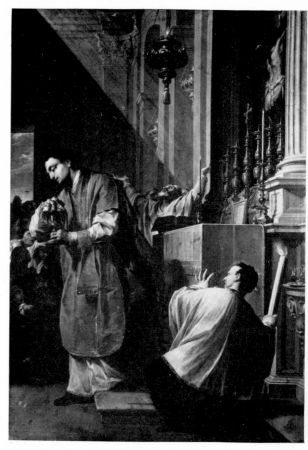

76. Trevisani: *S. Toribio, Bishop of Lima*. About 1726. Rome, S. Anastasia

77. Trevisani: *The Miracle of Bolsena*. Bolsena, S. Cristina

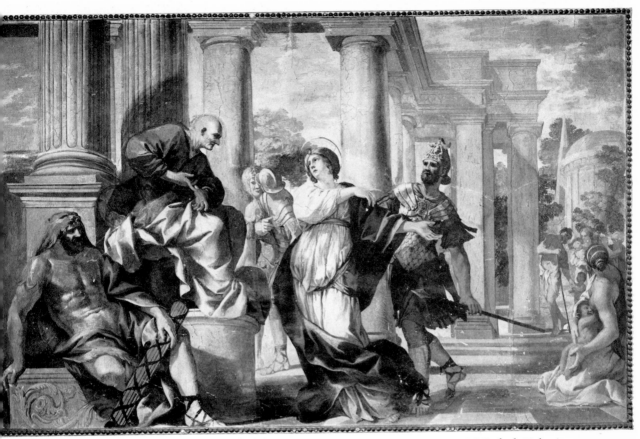

78. Ubaldini: *S. Gertrude professing her faith before a judge*. Fresco, about 1665. Rome, S. Nicola da Tolentino

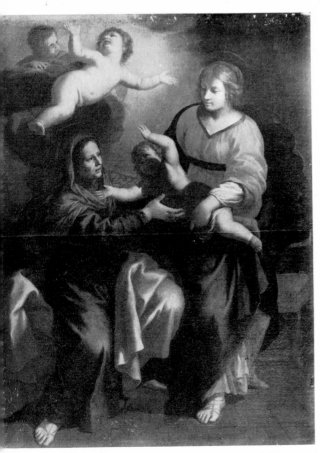

79. Ubaldini: *S. Anne with the Madonna and Child*.
Early 1660's. Rome, S. Isidoro

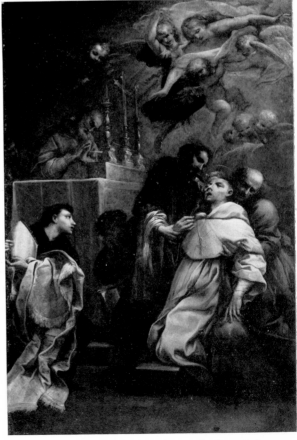

80. Vanni: *The Death of S. Thomas of Villanueva*. 1665.
Ariccia, Collegiata

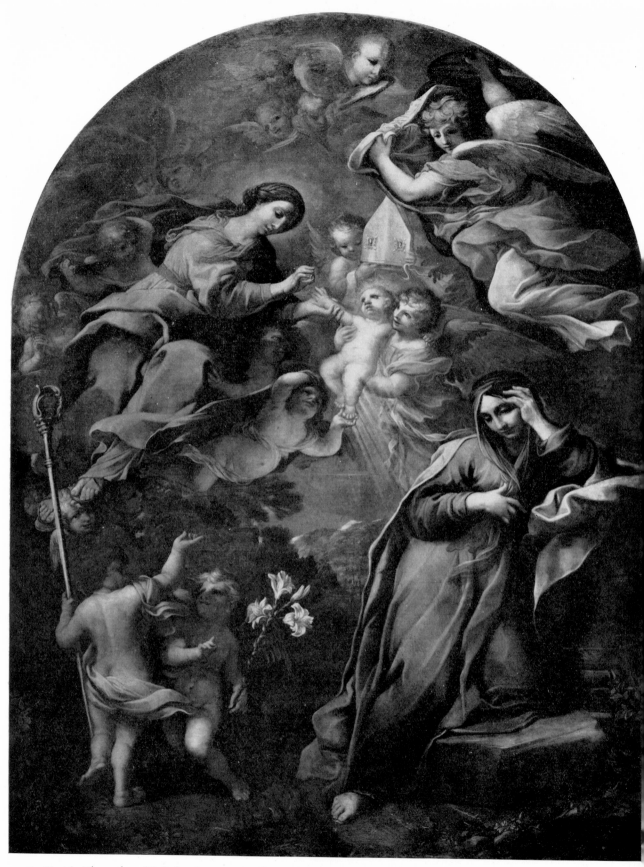

81. Vanni: *The mother of S. Robert has a vision of her son being adopted as the Virgin's spouse.* Rome, S. Croce in Gerusalemme

TOPOGRAPHICAL INDEX

Albano. DUOMO. Morandi.

Anagni. S. ANTONIO ABATE. Maratti.

Ariccia. PALAZZO CHIGI. Baciccio; Brandi; G. Chiari; G. Gimignani; Lauri; Maratti; Mei; Mola; Morandi.

 COLLEGIATA. Cortese; G. Gimignani; L. Gimignani; Mei; Vanni.

 S. MARIA DI GALLORO. Cortese; G. Gimignani.

Aspra Sabina, see **Casperia.**

Bagnaia. VILLA LANTE. Romanelli.

Bassano di Sutri. PALAZZO ODESCALCHI. Baldi.

Bolsena. S. CRISTINA. Trevisani.

Bomarzo. PALAZZO BARONALE. Bonifazi.

Cantalupo. PALAZZO CAMUCCINI (collection dispersed). Masucci.

Casperia. SS. ANNUNZIATA. Sassoferrato.

Castelfusano. VILLA GIÀ CHIGI. Camassei; Cortona; Sacchi.

Castel Gandolfo. S. TOMMASO DE VILLANOVA. Cortese; Cortona; G. Gimignani.

Castel S. Pietro. S. PIETRO. Cortona.

Frascati. GESÙ. Pozzo.

 SCOLOPI. Berrettoni.

 VILLA FALCONIERI. Berrettoni; Calandrucci; Ferri; Grimaldi.

 VILLA MUTI. Cortona.

Gaeta. DUOMO. Brandi.

 SS. ANNUNZIATA. Brandi.

Genzano. S. MARIA DELLA CIMA. Cozza; Sassoferrato.

Lanuvio. COLLEGIATA. Baciccio.

Magliano Sabina. S. LIBERATORE. Piastrini.

Marino. DUOMO. F. Rosa.

Monteporzio Catone. S. GREGORIO. Brandi; Cortese; Ferri.

Monterotondo. COLLEGIATA. Maratti; Piastrini.

Narni. DUOMO. Trevisani.

Nettuno. S. FRANCESCO. Sacchi.

Oriolo Romano. PALAZZO GIÀ ALTIERI. Morandi.

Palestrina. DUOMO. Odazzi.

Palombara Sabina. S. PIETRO. Brandi.

Poli. S. PIETRO. Brandi.

Rieti, DUOMO. Romanelli.

 S. ANTONIO DEL MONTE. Gherardi.

 MUSEO CIVICO. Beinaschi; Gherardi.

Rome. Museums and Galleries. ACCADEMIA DI S. LUCA. Baciccio; Baldi; G. Chiari; Cortese; Cortona; Ferri; Garzi; Ghezzi; G. Gimignani; L. Gimignani; Luti; Maratti; Masucci; Mola; Passeri; P. dei Pietri; Sassoferrato; Seiter; Trevisani.

GALLERIA NAZIONALE. (Pictures are so constantly moved from the Palazzo Barberini to the Palazzo Corsini and the ultimate destination is so uncertain that I list all under 'Galleria Nazionale'.)

Abbatini; Baciccio; Brandi; Camassei; Cerrini; Cortese; Cortona; Cozza; Ferri; Garzi; Gherardi; Ghezzi; Grimaldi; Luti; Maratti; Mola; Morandi; Passeri; Pellegrini; Pietro dei Pietri; Pozzo; Romanelli; Sacchi; Sassoferrato; Trevisani.

BORGHESE. Cortona; Grimaldi; Morandi; Romanelli; Sacchi.

CAPITOLINA. Baciccio; Borghesi; Cortona; Maratti; Mola; Romanelli; Testa.

COLONNA. Cerrini; Dughet; Luti; Maratti; Mola; Sassoferrato; Trevisani.

DORIA. Brandi; Cortona; Ferri; Grimaldi; Mola; Romanelli; F. Rosa; Sacchi; Sassoferrato; Trevisani.

QUIRINALE. Cortona.

MUSEO DI ROMA. Baciccio; G. Chiari; Cortona; Lauri; Morandi; Sacchi.

SPADA. Baciccio; Baldi; Cerrini; G. Chiari; Ferri; Luti; Mola; Muratori; Romanelli; Testa; Trevisani.

PALAZZO VENEZIA. Ferri; Maratti; Sassoferrato.

Rome. Churches, Convents, Oratories. S. AGATA DEI GOTI. Gismondi.

S. AGATA IN TRASTEVERE. Puccini; Troppa.

S. AGNESE A PIAZZA NAVONA. Baciccio; Ferri; Gismondi.

S. AGOSTINO. Abbatini; Brandi; Romanelli; F. Rosa.

S. AMBROGIO DELLA MASSIMA. Cozza.

S. ANASTASIA. Baldi; F. Chiari; Mola; Trevisani.

S. ANDREA DELLE FRATTE. Baldi; Cozza; L. Gimignani; Lenardi; Marini; Odazzi; Trevisani.

S. ANDREA AL QUIRINALE. Baciccio; Brandi; G. Chiari; Cortese; Maratti; Odazzi; Pozzo.

S. ANDREA DELLA VALLE. Preti.

S. ANTONIO DEI PORTOGHESI. Calandrucci.

SS. APOSTOLI. Baciccio; G. Chiari; Luti; Muratori; Nasini; Odazzi.

SS. BAMBINO GESÙ. Muratori.

S. BARBARA DEI LIBRAI (desuete). Garzi.

S. BERNARDO ALLE TERME. Odazzi; Sacchi.

S. BIBIANA. Cortona.

S. BONAVENTURA SUL PALATINO. Beinaschi; Calandrucci.

S. BRIGIDA. Puccini.

ORATORIO DEL CARAVITA. Baldi.

S. CARLO AI CATINARI. Brandi; Ciarpi; Cortona; Cozza; Gherardi; G. Gimignani; Preti; Romanelli; Sacchi.

S. CARLO AL CORSO. Beinaschi; Brandi; F. Chiari; Garzi; L. Gimignani; Maratti; Mola; F. Rosa; Troppa.

S. CARLO ALLE QUATTRO FONTANE. Cerrini; Romanelli.

S. NICOLA DA TOLENTINO. Baciccio; Borghesi; Coli-Gherardi; Cortona; Ferri; Ubaldini.

SS. NOME DI MARIA. Masucci.

S. ONOFRIO. Trevisani.

S. PANTALEO. Gherardi.

PANTHEON. Camassei; Cozza.

S. PAOLO ALLA REGOLA. Calandrucci; Garzi; Puccini.

S. PIETRO IN MONTORIO. Abbatini; Romanelli.

S. PIETRO IN VATICANO: see under Vatican.

S. PRASSEDE. Cortese; Ferri; Muratori; Piastrini.

S. PRISCA. Odazzi.

PROPAGANDA FIDE. Baldi; Camassei; Cesi; G. Gimignani; L. Gimignani; Pellegrini.

S. PUDENZIANA. Baldi; L. Gimignani.

SS. QUATTRO CORONATI. Cortese.

RE MAGI, see PROPAGANDA FIDE.

S. ROCCO. Baciccio; Brandi; Cozza; F. Rosa.

S. SABINA. Morandi; Odazzi; Sassoferrato.

S. SALVATORE IN LAURO. Cortona; Ghezzi.

SCOLOPI. Brandi.

S. SEBASTIANO FUORI LE MURA. Passeri; Trevisani.

S. SEBASTIANO ALLA POLVERIERA. Camassei.

S. SILVESTRO IN CAPITE. Brandi; G. Chiari; Ciarpi; Garzi; Ghezzi; L. Gimignani; Trevisani.

S. SILVESTRO AL QUIRINALE. Baldi; G. Gimignani.

S. SPIRITO IN SASSIA. Abbatini.

SPIRITO SANTO DEI NAPOLETANI. Muratori; Passeri.

S. STEFANO DEL CACCO. Morandi; Odazzi.

STIMMATE DI S. FRANCESCO. Brandi; Garzi; Muratori; Odazzi; Trevisani.

SS. SUDARIO. Baldi; Cesi; Gherardi.

S. TOMMASO IN PARIONE. Passeri.

SS. TRINITA DEI MONTI (Convento). Pozzo.

SS. TRINITA DEI PELLEGRINI. Cortese.

SS. VINCENZO E ANASTASIO. F. Rosa.

Rome. Palazzi. PALAZZO ALTEMPS. Romanelli.

PALAZZO ALTIERI. Berrettoni; Canuti; F. Chiari; Cozza; Maratti.

PALAZZO BARBERINI. Camassei; G. Chiari; Cortona; Maratti; Sacchi.

PALAZZO BORGHESE. Dughet; Lauri.

PALAZZO DELLA CANCELLERIA. Nasini.

PALAZZO DE CAROLIS. Luti; Muratori; Odazzi; Procaccini; Trevisani.

PALAZZO CAVALLERINI. G. Gimignani; L. Gimignani.

PALAZZO CHIGI. Baciccio.

PALAZZO COLONNA. G. Chiari; Coli-Gherardi; Dughet; Muratari; Trevisani.

PALAZZO DEI CONSERVATORI. Cortese.

PALAZZO COSTAGUTI. Dughet; Mola; Romanelli.

PALAZZO DEL DRAGO. Odazzi.

PALAZZO DORIA AL CORSO. Dughet.

PALAZZO DORIA-PAMPHILY, see PALAZZO PAMPHILY.

PALAZZO LANTE. Calandrucci; Romanelli.

PALAZZO MASSIMO ALLE COLONNE. Maratti.

PALAZZO MATTEI DI GIOVE. Cortona.

PALAZZO DI MONTECITORIO. Vanni.

PALAZZO MUTI-BUSI. Dughet.

PALAZZO NARI. Gherardi.

PALAZZO ODESCALCHI. Troppa.

PALAZZO DELL' OSPEDALE DI S. SPIRITO. Cozza.

PALAZZO PALLAVICINI. Baldi; Brandi; Canuti; Cerrini; G. Chiari; Cortona; G. Gimignani; L. Gimignani; Luti; Maratti; Masucci; Sacchi; Sassoferrato; Trevisani.

PALAZZO PAMPHILY (Piazza Navona). Brandi; Camassei; Cortona; Dughet; G. Gimignani.

PALAZZO PATRIZI. Dughet; Romanelli.

PALAZZO PECCI-BLUNT. Dughet.

PALAZZO DEL QUIRINALE. Baldi; Canini; Cesi; F. Chiari; Cortese; Colombo; Dughet; Ferri; Grimaldi; Lauri; Maratti; Masucci; Mola; Murgia.

EUR: PALAZZO DELLA PREVIDENZA SOCIALE. Romanelli.

PALAZZO ROSPIGLIOSI, see PALLAVICINI-ROSPIGLIOSI.

PALAZZO SACCHETTI. Cortona.

PALAZZO SANTACROCE. Grimaldi.

PALAZZO SENATORIO. Cortona; Trevisani.

PALAZZO TAVERNA. Brandi.

PALAZZO DEL VICARIATO. Sacchi.

Rome. Various Locations. VILLA ALBANI. Maratti.

VILLA DORIA. Grimaldi.

Coll. G. BRIGANTI. Cortona.

Coll. CONTE A. BUSIRI-VICI. Baciccio; Maratti; Mola.

Coll. INCISA DELLA ROCCHETTA. Baciccio; Mola; Romanelli; Sacchi.

MINISTERO DELL' AERONAUTICA. Trevisani.

BIBLIOTECA VALLICELLIANA. Romanelli.

CASA DI S. IGNAZIO (Casa Professa). Pozzo.

CASSA DEPOSITI E PRESTITI. Baldi; Brandi; Cozza.

COLLEGIO FRATI MINORI. Pozzo.

COLLEGIO INNOCENZIANO. Cozza.

COLLEGIO NAZARENO. Baciccio.

COLLEGIO NEPOMUCENO. Cozza.

COLLEGIO DI PROPAGANDA FIDE. Borghesi.

COLLEGIO ROMANO (now in S. IGNAZIO). Cortese; Sacchi.

DIREZIONE GENERALE DEL FONDO PER IL CULTO. Baciccio.

PII STABILIMENTI DI S. MARIA IN AQUIRO. Cozza.

OSPEDALE DI S. SPIRITO. Cozza.